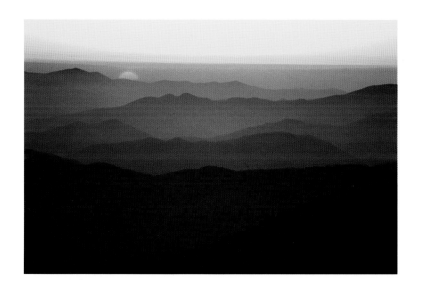

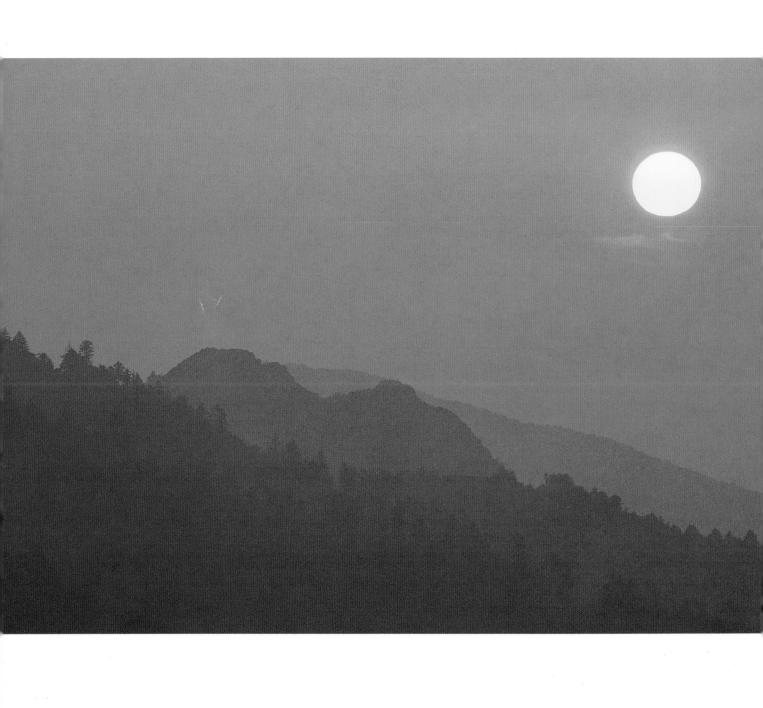

GREAT SMOKY MOUNTAINS NATIONAL PARK

Photography by Ken Jenkins

Essays by Carson Brewer

Commentary by Howard Baker

GRAPHIC ARTS CENTER PUBLISHING™

International Standard Book Number 1-55868-126-4
Library of Congress catalog number 93-70511
Photographs © MCMXCIII by Ken Jenkins
Text © MCMXCIII by Carson Brewer
Published by Graphic Arts Center Publishing Company
P.O. Box 10306 • Portland, Oregon 97210 • 503/226-2402
No part of this book may be reproduced by any
means without the permission of the publisher.
President • Charles M. Hopkins
Editor-in-Chief • Douglas A. Pfeiffer
Managing Editor • Jean Andrews
Designer • Robert Reynolds
Production Manager • Richard L. Owsiany
Typographer • Harrison Typesetting, Inc.
Cartographer • Ortelius Design
Color Separations • Agency Litho
Printing • Dynagraphics, Inc.
Binding • Lincoln & Allen
Printed in the United States of America

To my wonderful wife and best friend, Vicki,
whose dedication to my every endeavor has made
this book, as well as my photography career,
proceed in a very pleasant way.

KEN JENKINS

CONTENTS

◄ ◄ From Clingmans Dome, situated between Tennessee and North Carolina in the Great Smoky Mountains National Park, the view is a panorama of mountain after mountain stretching as far into the distance as the eye can see.
◄ A favorite destination of Great Smokies hikers is the double-peak formation called the Chimneys. Sugarland Mountain is visible behind the Chimneys.
► Adult female bears, or sows, usually den high in hollow trees. About every other year, they give birth to two or three cubs in their winter dormant period.

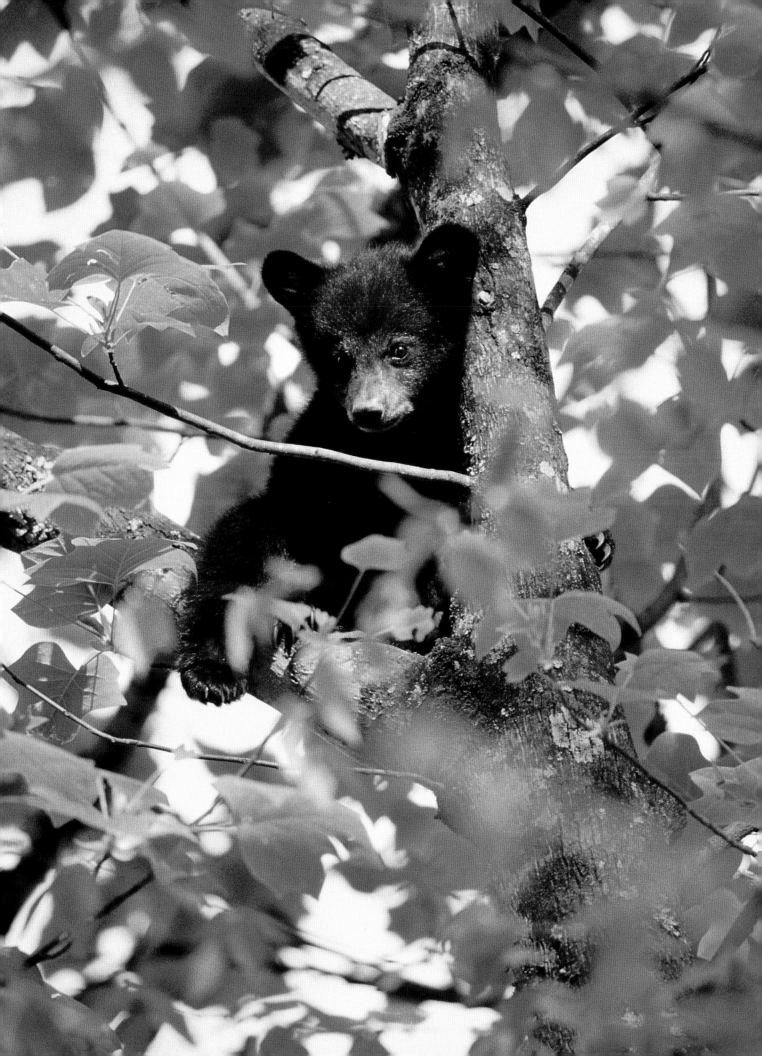

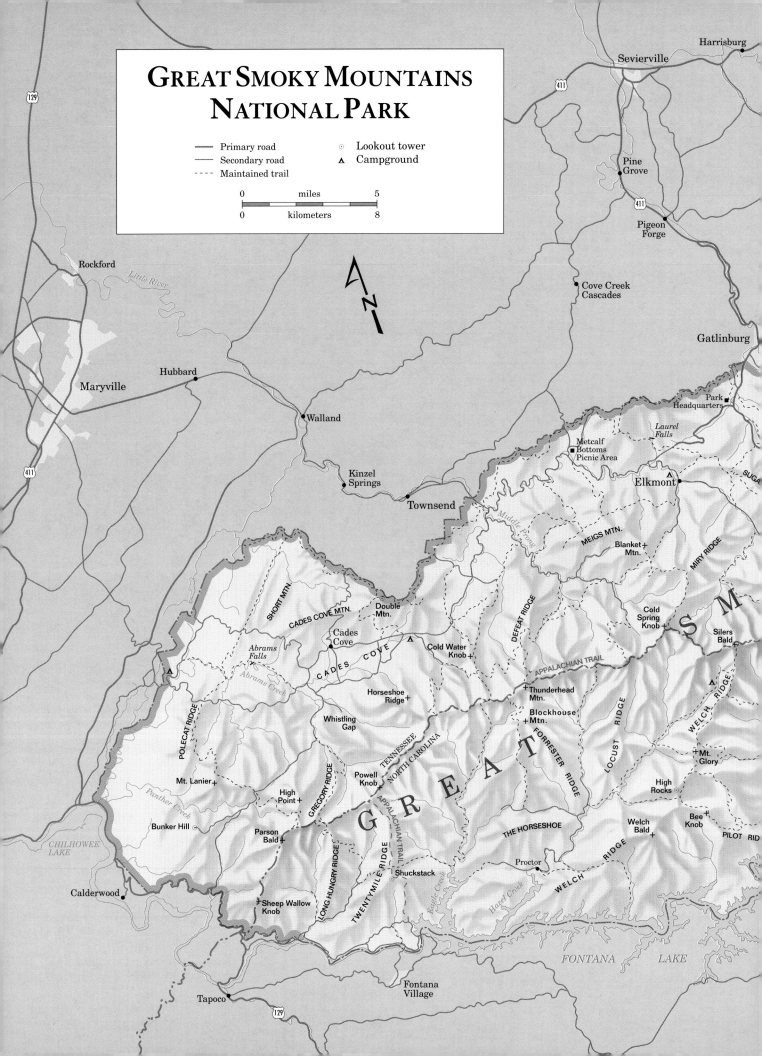

GREAT SMOKY MOUNTAINS NATIONAL PARK

—— Primary road
—— Secondary road
---- Maintained trail

⊙ Lookout tower
▲ Campground

0 — miles — 5
0 — kilometers — 8

129

Harrisburg

Sevierville

411

Pine Grove

411

Pigeon Forge

Rockford

Little River

Cove Creek Cascades

Gatlinburg

Maryville

Hubbard

Park Headquarters

Walland

Laurel Falls

Metcalf Bottoms Picnic Area

Kinzel Springs

Elkmont

Townsend

SUGA

Middle Prong

MEIGS MTN.

MIRY RIDGE

Blanket + Mtn.

SHORT MTN.

CADES COVE MTN.

Double Mtn.

Cold Spring Knob +

S M

Cades Cove

DEFEAT RIDGE

Silers Bald +

Abrams Falls

CADES COVE

Cold Water Knob +

APPALACHIAN TRAIL

Abrams Creek

Horseshoe Ridge +

+ Thunderhead Mtn.

POLECAT RIDGE

Whistling Gap

Blockhouse + Mtn.

LOCUST RIDGE

FORRESTER RIDGE

WELCH RIDGE

+ Mt. Glory

Mt. Lanier +

Panther Creek

High Point +

GREGORY RIDGE

Powell Knob +

TENNESSEE
NORTH CAROLINA

G R E A T

High Rocks ⊙

Bee Knob +

Bunker Hill ⊙

CHILHOWEE LAKE

Parson Bald +

APPALACHIAN TRAIL

THE HORSESHOE

Welch Bald +

PILOT RID

Calderwood

LONG HUNGRY RIDGE

TWENTY MILE RIDGE

Shuckstack

Eagle Creek

Proctor

WELCH RIDGE

+ Sheep Wallow Knob

Hazel Creek

Tapoco

Fontana Village

FONTANA LAKE

129

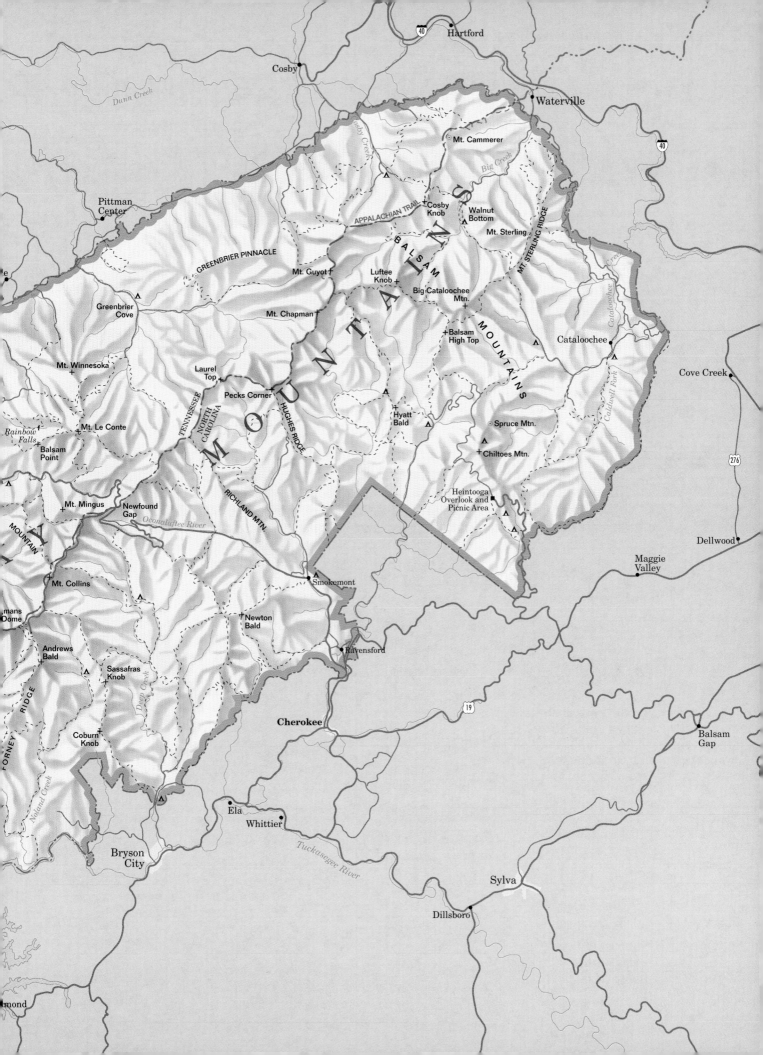

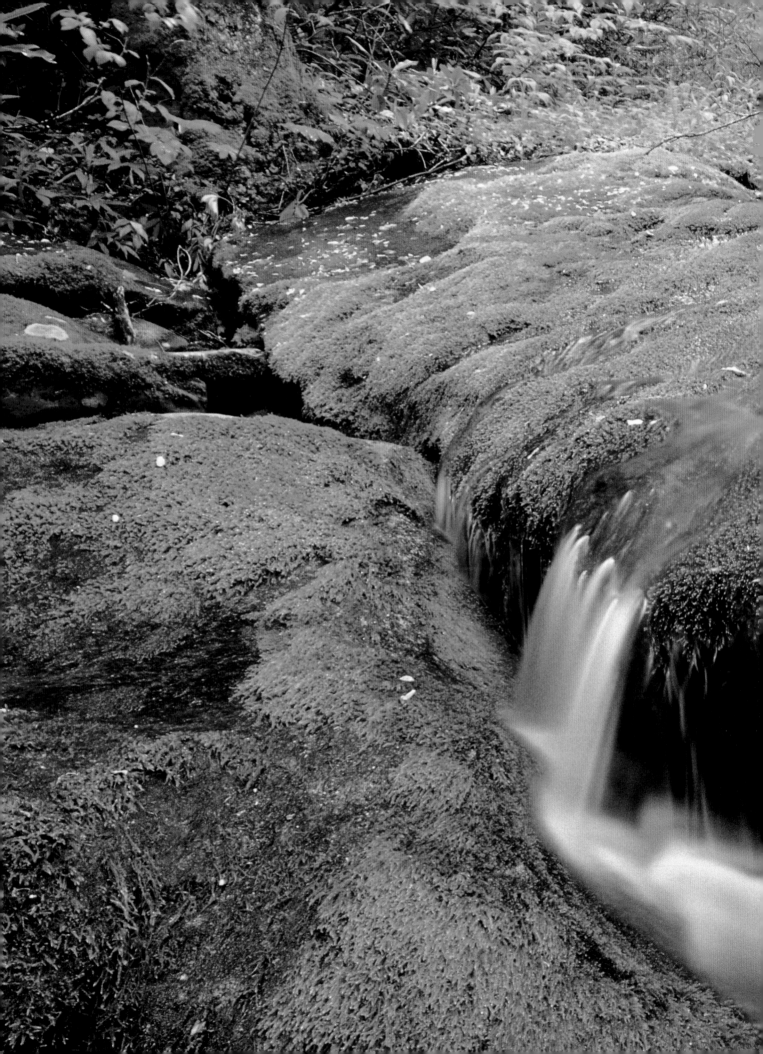

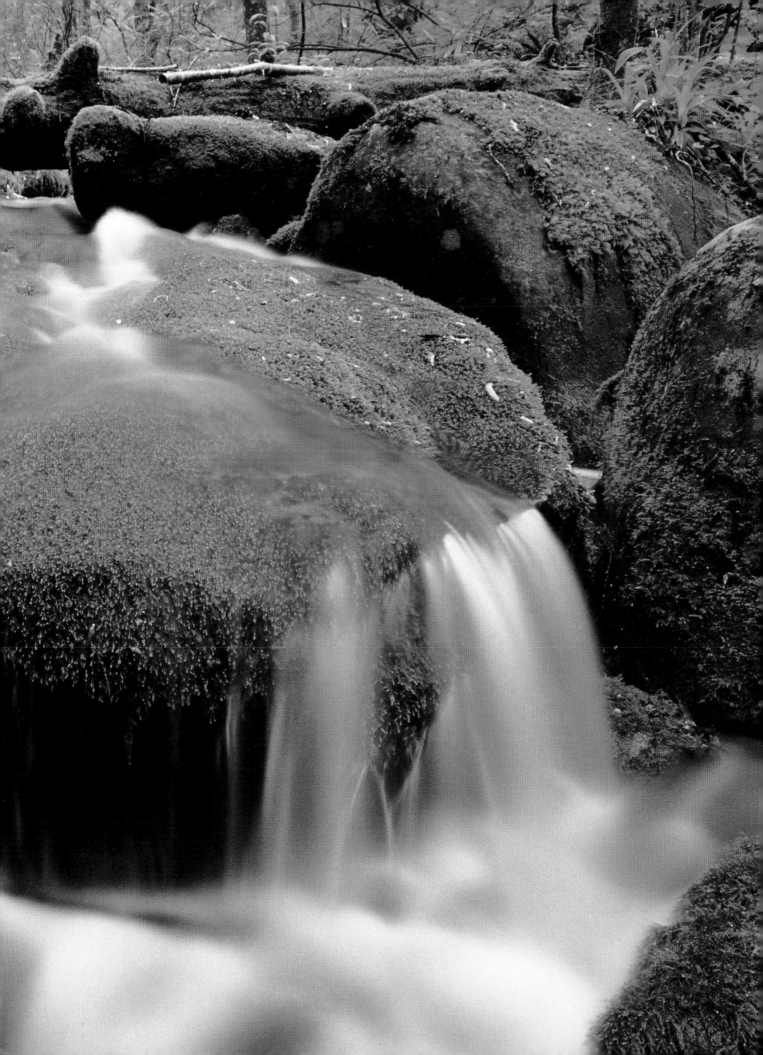

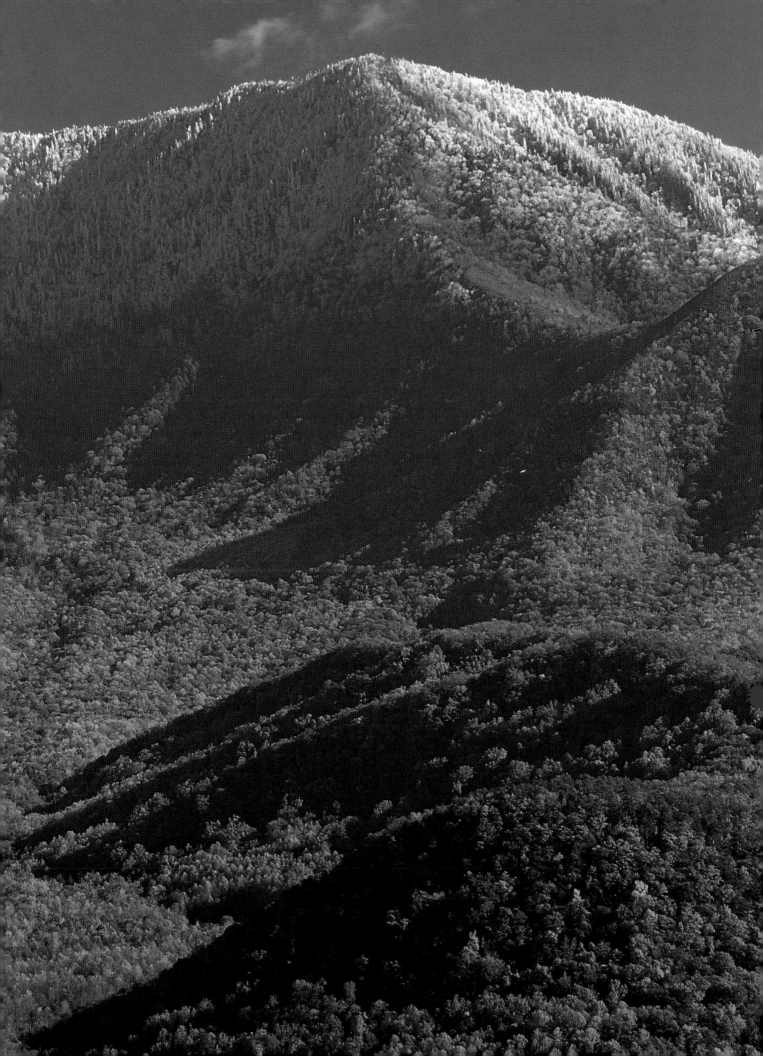

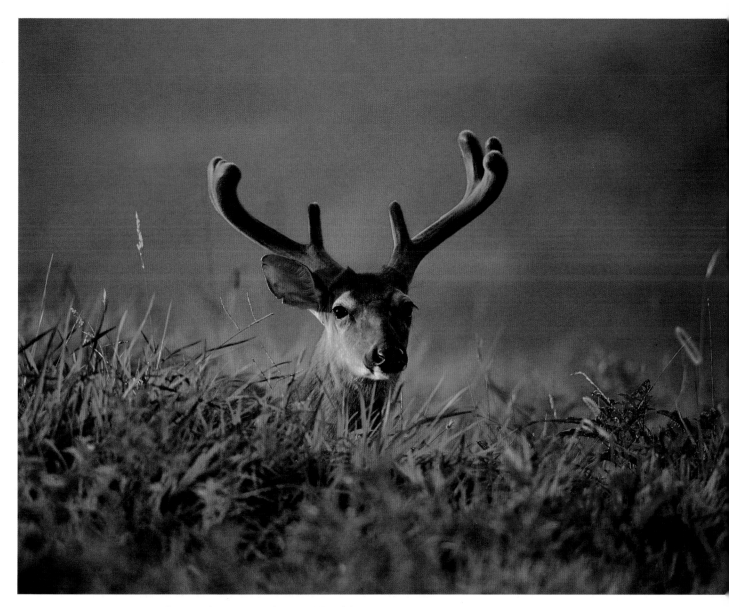

◀ ◀ Roaring Fork cascades over and around boulders in the streambed. The highest constant-flow spring that feeds Roaring Fork is the Basin Spring on Mount Le Conte. The spring also is the source of water for Le Conte Lodge.
◀ The third week of October is generally the best week for seeing fall colors in the Great Smokies. On Mount Le Conte, winter snow has already arrived.
▲ Bedded down in high grass, a white-tail buck deer takes time off from browsing in an open meadow. Hundreds of deer feed in open areas in early morning and at dusk. They spend most of the daylight hours in the woods.

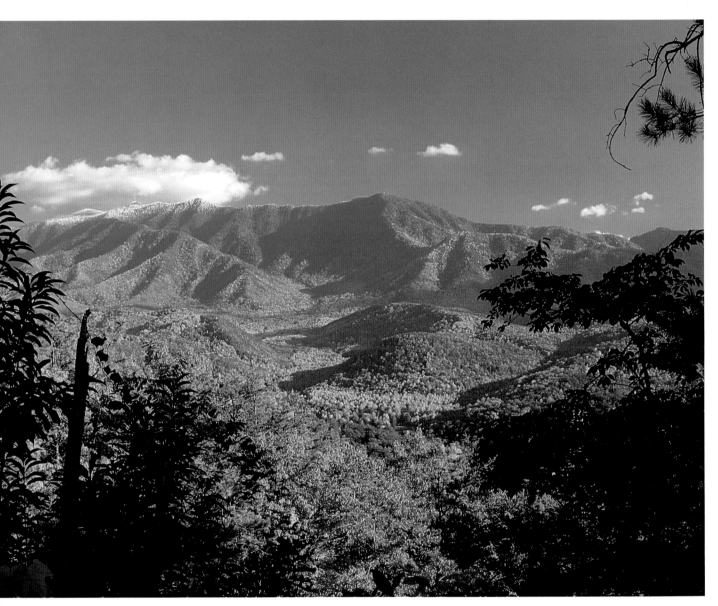

▲ Fall colors in lower elevations and hoarfrost on Mount Le Conte mark the loveliness of autumn. From the top of Mount Harrison, the view extends across the valley of West Prong of the Little Pigeon River, to the peaks of Le Conte.

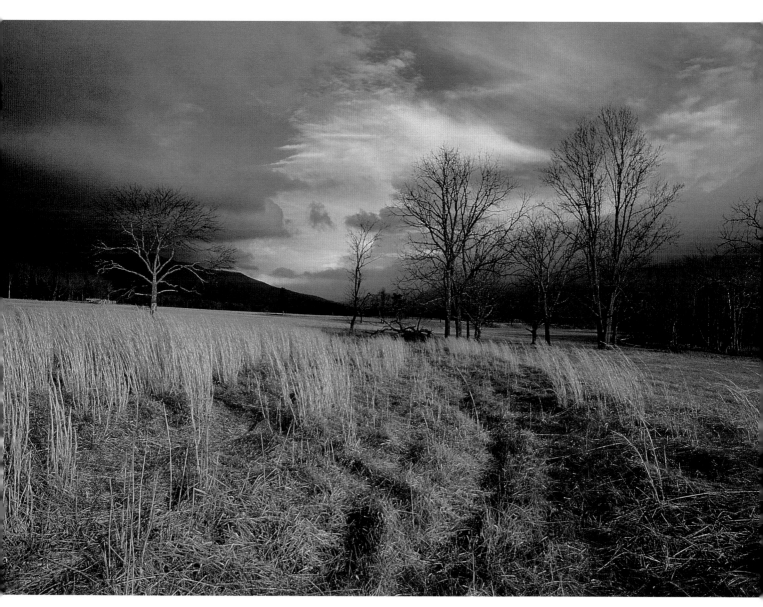

▲ Grassy meadows are a feature throughout the Smoky Mountains wherever man has pushed the forest back. Eventually, unless constant efforts are put forth keep the forest at bay, it will take back all that once belonged to it.

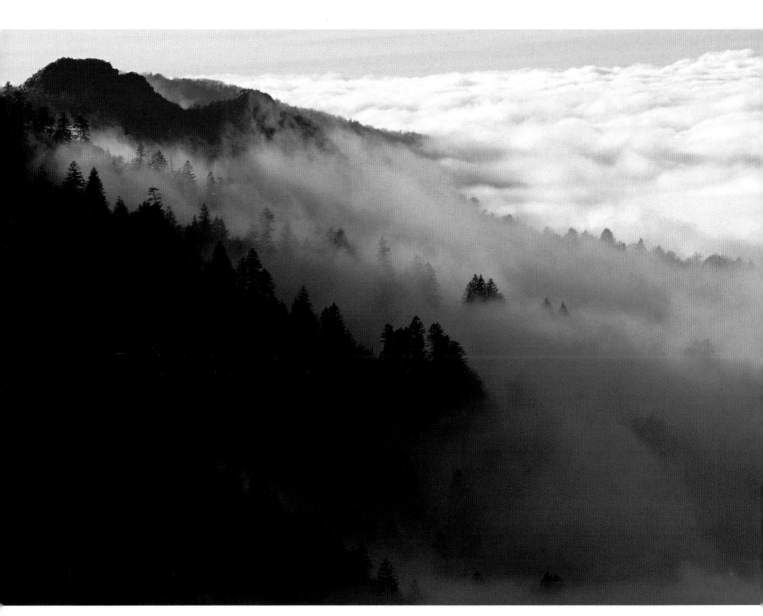

▲ Cotton clouds fill the narrow valleys and rise nearly even with the knife-edge crests of ridges in the Great Smokies. Such views, common on early mornings and after summer storms, are part of the beauty of the Smokies.

K en Jenkins and Carson Brewer are both natives of East Tennessee and, as such, are residents of "the center of the universe"—or at least that is the way I see it.

Ken grew up in the shadow of the Great Smoky Mountains about fifteen miles from the park boundary and has photographed the area extensively since the age of twelve when he received his first camera.

Carson Brewer, who lives outside Knoxville, the capital city of the Tennessee Valley, wrote for *The Knoxville News-Sentinel* for more than forty years. He is a noted and distinguished columnist, and is an expert on the lore—both past and present—of this region.

Readers will forgive me for noting that the Tennessee Valley is roughly eighty miles wide, lush and green, bounded on the southeast by the Great Smoky Mountains and on the northwest by the Cumberland Mountains and loaded with Republicans—and a few patriotic Democrats.

In any event, Jenkins obviously has an artist's feel for the grandeur of this unique region and more especially for the Great Smoky Mountains National Park. His photographs are far more than pictorial representations of the flora, the fauna, and the landscape. Instead, they are a visual expression and an extension of his appreciation of their inherent beauty.

Carson Brewer truly has a writer's appreciation of the history and traditions of the park, its people, and its geography. Both have a highly developed sense of place.

With these qualities, it is no surprise, then, that this blending of extraordinary photography and excellent writing combine to produce a volume that will appeal to a wide audience.

HOWARD H. BAKER, JR.
Former U. S. Senator
and White House Chief of Staff

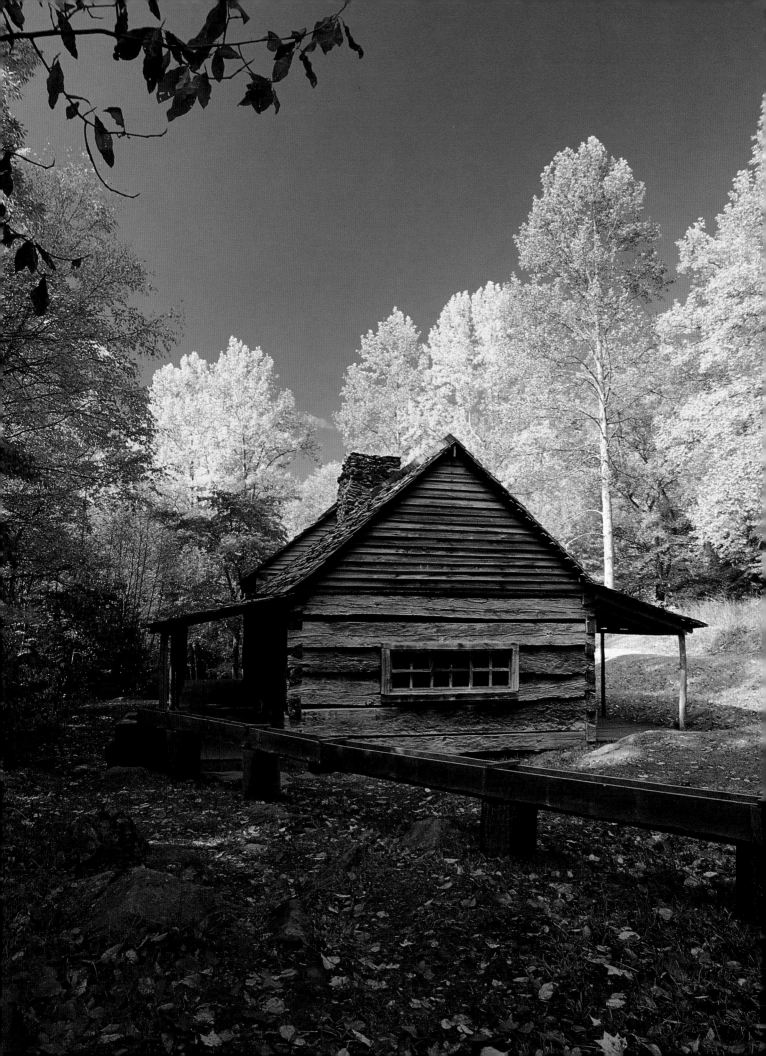

Old Cherokee storytellers told how the Great Smokies and the other Southern mountains were formed: the Great Buzzard, flying over the soft, mushy earth, grew tired and dropped so low that his wings gashed the earth and made the valleys; when he raised his wings, the mountains were created.

Geologists of the 1900s tell a different story about the creation of the Southern Appalachians. They say that the continent of Africa crashed into the coast of eastern North America about two hundred million years ago and crumpled up the earth into mountains and valleys. Africa later backed off. University of Tennessee geology professor Don W. Byerly says that, earlier, other land masses had crunched into the eastern rim of the continent and left similar mountains. This last one, the one two hundred million years ago, left the mountain configuration generally as it is today, except that the mountains have eroded to lower elevations.

No one witnessed either the Great Buzzard or the continental collision, but geologists say they have physical evidence to support their claim.

Millions of years later, people got around to naming every wrinkle of the area crumpled by the collision. One of the highest wrinkles is the Great Smoky Mountains, which extend from the Little Pigeon River on the northeast about fifty-eight miles to the Little Tennessee River on the southwest. The Great Smokies are part of the Unakas, which are part of the Blue Ridge, which is part of the Appalachians. The crest of the Great Smokies became part of the boundary between Tennessee and North Carolina, and nearly all of the Great Smoky Mountains became Great Smoky Mountains National Park, a place that would have made the Great Buzzard proud.

It is a great wild garden of a place—a garden watered by some of the most generous rainfall on the continent, drained by hundreds of rivers and creeks and branches that rush down the mountains in white-foamed fury, then pause here and there in pools so clean and calm you can count the pebbles ten feet down. It is a garden of high mountains and deep valleys, clothed in the autumn splendor of a thousand variations and combinations of red and yellow and orange and purple-black; a place spangled with billions of wildflowers; a place that is home to the black bear, the brook trout, the boomer squirrel, the white-tailed deer, the wood thrush, the winter wren, and even—for a brief span—humans.

The humans did not arrive on the scene until about twelve thousand years ago, give or take a millennium. These were descendants of those earliest Americans who crossed the temporary land bridge from Siberia to Alaska and whose progeny spread thinly over both North and South America. Apparently, these Paleo-Indians were only visitors to the Great Smokies area, not residents. Except for occasional finds of their fluted-point tools, we would not know they had ever been here at all.

The first Europeans to come into the region almost certainly were Hernando de Soto and his cruel band of six hundred who, in 1540, killed Natives and, worse, spread smallpox and other diseases against which Natives had no immunity. De Soto's party probably did not set foot in the Great Smokies, but they saw some of the high places such as Mounts Guyot, Le Conte, and Cammerer and Clingmans Dome. They visited, like a plague, and moved on.

When the English and French explorers and traders came into the region in the late seventeenth and eighteenth centuries, they found Cherokees living in it. Cherokee towns were on both sides of the Little Tennessee River, some at the very edge of what became the southwestern border of Great Smoky Mountains National Park.

Other Cherokee villages near what is now the park were on the Tuckasegee River and its tributary, the Oconaluftee, near the present towns of Cherokee and Bryson City. The only Indian villages actually located inside the present-day park boundaries were on the fertile bottoms of the Oconaluftee, near the Oconaluftee Visitor Center. But the Cherokees spent considerable time in the park's Cades Cove, in Tennessee, where they had hunting camps.

The Cherokees, as well as the early settlers of European extraction, did not live in the mountains. That was not necessary, since land was

◄ *The Noah (Bud) Ogle cabin, near Cherokee Orchard Road, is one of dozens of pioneer mountain homes preserved as historic structures in the park.*

abundant. They lived on broad river bottoms and cultivated potatoes, pumpkins, melons, beans, corn, peas, and tobacco on soil rich with centuries of silt washed out of the mountains and left by floods on the lowlands.

Cherokees crossed the mountains mostly to hunt, or to visit someone on the other side. Two Indian trails crossed the Great Smokies. One went out of Cades Cove up Forge Creek, then up Ekaneetlee Branch to the top of the mountain at Ekaneetlee Gap, then down the North Carolina side of the mountain along the Ekaneetlee Creek to Eagle Creek and down the Eagle to the Little Tennessee River. One can still walk the portion of that old trail on the Tennessee side. The portion along Forge Creek is part of the Gregory Ridge Trail to Gregory Bald. But the portion of the old trail that goes up Ekaneetlee Branch is not maintained. It lives on only as a manway, faintly marked by the footfalls of those who want this ancient route preserved. The Carolina portion of the trail died long ago.

The other Cherokee trail over the mountain followed the Oconaluftee River up the Carolina side of the mountain nearly to the crest, then meandered west to Indian Gap. It went down the Tennessee side from Indian Gap to the beginning of Road Prong Creek, which it followed to West Prong of Little Pigeon River, then followed West Prong to the vicinity of Gatlinburg. Nineteenth-century settlers turned this route into the first crude road over the Smokies. Horses, mules, and oxen pulled wagons over it. Herdsmen drove cattle and hogs to market over it. Only the 3.5-mile portion of the route from Indian Gap down to West Prong still exists. It is a delightful hiking trail, and as you walk it, you wonder how long humans have traveled this route.

The region around the Great Smokies was the frontier in the late 1700s and early 1800s. Arrows and bullets sometimes flew between Cherokees and settlers. Every treaty left Cherokees with a little less land and settlers with a little more.

Few settlers were in the Great Smokies before 1800. But families named Mingus, Enloe, Beck, Dillard, Sherrill, Reed, and others built cabins and planted corn on the broad bottoms along

Oconaluftee River in 1802 or 1803. (Mingus Mill still grinds corn, as a demonstration for visitors, inside the park.)

William Ogle came from South Carolina to West Prong of Little Pigeon, in Tennessee, in 1803. He called it the "Land of Paradise," but he did not live to dwell in it. (Others later called it Gatlinburg.) With the help of Cherokees, he cut, hewed, and notched logs for a cabin he intended to build when he returned with his family. But he never returned. He sickened and died in South Carolina. His widow Martha and five sons, two daughters, one son-in-law, and Martha's brother used the logs to build the first house in that area. Others soon followed and built cabins far up the stream on lands now inside the park.

Brothers William and Middleton Whaley left their homes in North Carolina in the early 1800s and crossed the Great Smokies to find sites for new homes in Tennessee. They crossed the crest at Dry Sluice Gap. No Whaley now alive knows why they used that route. (The first quarter-mile down the Tennessee side to the valley of Porters Creek is nearly vertical.) But because they did cross there, lots of Whaleys were destined to live in Greenbrier Cove, where Porters Creek joins Middle Prong of Little Pigeon, and where William built his house (Middleton built his on down in the Glades, outside the present park.)

Ownbys followed Whaleys into Greenbrier Cove. Later, a map of the Greenbrier Cove community, as it appeared at some point between 1904 and 1922, named the families living in each of its twenty-six houses. Eleven of them were Whaleys and ten were Ownbys. That twenty-six-home community produced 225 pupils for the elementary school. That is an average of more than eight children per house. It is even more remarkable when you presume that some of the parents who headed those twenty-six families were too young to have school-age children, and others were too old.

The community also had four grist mills, three cemeteries, two stores, two blacksmith shops, two churches, and one school. By about 1915, the two schoolhouse rooms were no longer large enough. Pupils overflowed into both churches

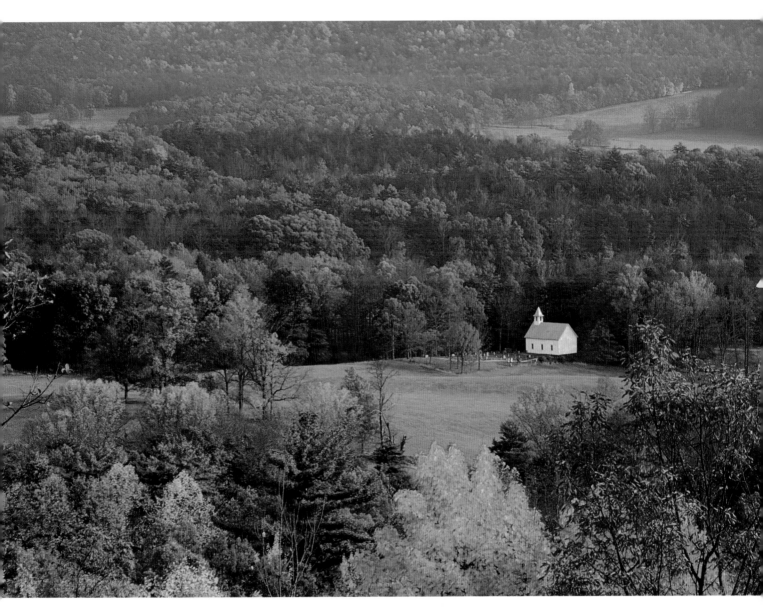

▲ Patterned after the earlier Hyatt Hill Baptist Church, the Cades Cove Methodist Church was built in 1902. The Methodists did not intend to have segregated seating or entrances, but they installed two front doors, simply because the other church had been built that way. In the Baptist church, one door was for men; the other, for women. Men sat on one side of the center aisle and women on the other. Both churches seated approximately forty people.

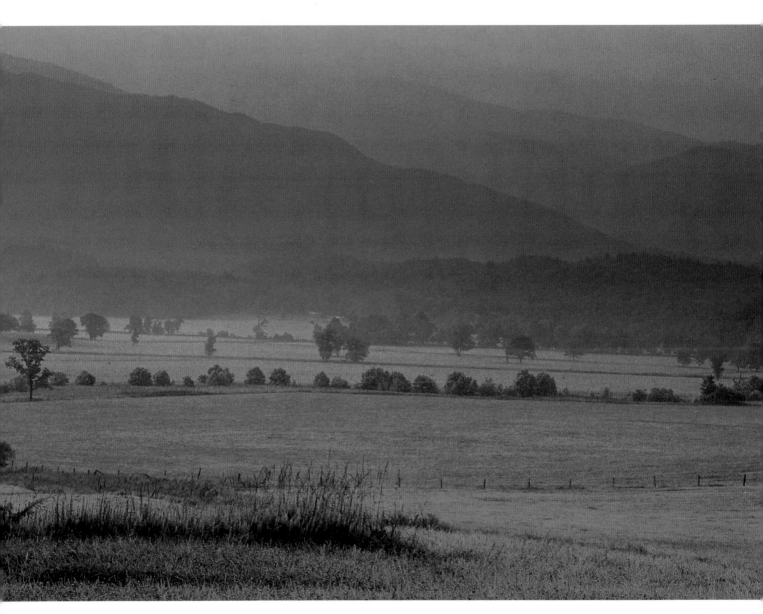

▲ In 1818, a year before settlement in the area was legal, John Oliver built the first cabin in Cades Cove, in sight of Gregory Bald in the distance across the cove. Cattle, horses, and deer still graze in the open meadows of the cove.

and into a one-room building formerly occupied by Katherine Brown (Granny) Whaley. Called Granny's College, it was Greenbrier's postgraduate school—for eighth graders.

John Oliver generally is credited with having been the first permanent settler in Cades Cove. He came in 1818, a year before a treaty with the Cherokees made settlement in the cove legal. Families named Tipton, Shields, Jobe, and Cable soon followed.

Big families were common among those early settlers. Fathers needed sons to clear the forest and cultivate the land. One woman who had lived on Chambers Creek, on the Carolina side of the mountain, told me of a woman who bore seventeen children, with no twins among them. It was common for men to father more children than that, but they usually did so with a succession of wives who died young of child bearing, hard work, and poor medical care.

Before the land could be cultivated in parts of the Smokies, rocks that lay on, or just under, the surface, had to be gathered and piled or used in construction of stone fences. Beautiful stone fences still stand along the Old Settlers Trail, just inside the northern border of the park, east of Gatlinburg. Ordinarily, the men and boys loaded these stones onto a sled, which would be pulled by mule to the fence under construction.

Ollie McCarter Ramsey, born in 1904, told me that her father, Tyson McCarter, used to say that his "boys were all girls." With no brothers, Ollie and her four sisters carried the stones boys would have carried if there had been boys. The Tyson McCarter barn and springhouse still stand in the park as historic structures. Nearby are ruins of the house where Ollie was born.

Up the creeks and small, fast rivers the settlers moved—up the Little, the Little Pigeon, and the Oconaluftee rivers and up creeks named Big, Cosby, Webb, Deep, Cataloochee, Hazel, and countless others. They turned the rich bottoms along the streams into cornfields and gardens. Some found little flat areas on the hillsides, which they called "benches," where they planted tiny cornfields. After all the flatland was taken, some started cultivating the hillsides, which was

disastrous, for the rains came and washed away the disturbed topsoil. The crop yields dropped dramatically year by year, until the farmer moved to another hillside.

Most farmers did not cultivate crops higher than about the three-thousand-foot elevation, nor did they live higher than that. But there were a few exceptions. One was the Russell Gregory family. His descendants say Gregory moved to Gregory Bald sometime before the Civil War. He built a two-story house well below the 4,949-foot summit of the bald. His family grew various crops there and herded cattle in the area. One spot is still called the Rye Patch because that is what Gregory grew there. Potatoes and cabbage do well in high, cool areas.

After four years on the bald, Gregory and his family had enough of high-country, cold-winter living. They moved down to Cades Cove, but Gregory continued to herd livestock on the bald during summers.

During the Civil War, Gregory came down from the bald to spend a night with his family, but bushwhackers from North Carolina killed him the next morning. In this border country between the Union and the Confederacy, it was not unusual for marauding bands—sympathetic to one side or the other and not bound by ordinary rules of war—to rob and murder. According to tradition, one group of East Tennesseans, tired of such raids, moved far up into the wilderness of Thunderhead Prong of the Great Smokies to start a new community, called New World. New World is still shown on some maps.

Gregory is one of eight grassy (or once-grassy) balds in the western half of the Smokies. The easternmost one is Andrews, two miles south of the Forney Ridge Parking Area at the end of the Clingmans Dome Road. The others are scattered along the crest. From east to west, they are a small unnammed bald west of Double Springs Gap, then Silers Bald, Spence Field, Little Bald, Russell Field, Gregory Bald, and Parson Bald.

Livestock owners who kept cattle, horses, and sheep in the lowlands during the cold months, often took them to the mountains and paid herders to care for them in summer. Tom Sparks

charged 25 cents per animal to herd sheep from spring until about Labor Day on Spence Field. He charged $1.00 per season per head of cattle if the owner furnished the salt for them, and $1.10 if Tom furnished the salt. He cared for some one thousand sheep, six hundred cattle, and one hundred horses and mules, which grazed along the mountain crest from Russell Field east across Little Bald, Spence Field, and Thunderhead Mountain. Sheep tended to stay near the top of the mountain, but cattle often browsed down the forested mountains, below the balds.

Granville Calhoun, who lived most of his 103 years on Hazel Creek and who herded cattle many summers in the mountains, once said he and other herders estimated that sixteen hundred cattle, not counting other livestock, grazed in the Smokies each summer from Double Springs Gap westward to Parson Bald.

Nathan (Nath) Burchfield, of part-Cherokee ancestry, herded at Gregory and Parson balds. He also gathered muscadine grapes, turned the grapes into wine, and the wine into brandy. One man who sampled it said it was "the best stuff I ever drank." Another, who spent a night in Burchfield's cabin, recalled that the herder gave him a sack of salt for a pillow.

Grazing livestock on the mountaintops was not without risk. Late spring cold spells and summer lightning storms both killed animals.

"My father lost twenty-four sheep in a lightning storm, nineteen in one bunch on Spence Field and five at the Russell Field," Clyde Martin once said. To save the wool, they first tried to skin the sheep. That did not work well, so they pulled the wool from the dead sheep.

Bone Valley Creek, a tributary to Hazel Creek, got its name from the scattered bones of cattle that froze to death in a late spring storm in the 1800s. Late snows sometimes covered the grass, leaving poisonous mountain laurel leaves as the only green things cattle could find to eat. Bears occasionally killed sheep and cattle, and bobcats sometimes took lambs.

The earliest settlers apparently were too busy to write about what they found. For instance, Russell Gregory wrote no description of the bald he lived on that later bore his name. Was it covered with trees when he first saw it? Or was it a place of tall grass and flowers?

What was the origin of the grassy balds? Are they natural? Or did man make them?

Some argue that settlers cleared the balds for grazing and that cattle, sheep, and horses kept them clear of trees. Others say the Cherokees created the balds by burning the forest from them to improve the blueberry crop. Others argue that the balds are natural, that man had nothing to do with creating them.

Dr. Edward E. C. Clebsch of the University of Tennessee bored holes years ago in Gregory's soil, trying to find evidence that long-ago fires had consumed trees that once grew there. His results were negative. No cinders, no ash.

Keith Langdon of the National Park Service a few years ago obtained a copy of the old field notes of William Davenport, who in 1821 surveyed the line between Tennessee and North Carolina, from Davenport Gap, near the eastern end of the Smokies, south to the Georgia line. He went right down the crest, across the site of every bald except Andrews.

Nowhere in his notes did Davenport hint at a bald until he reached what came to be called Gregory Bald. Then he mentioned "the top of the bald in sight of Tellessee Old Town" (the former Cherokee town of Tallassee beside the Little Tennessee). After another mile, they came to "a Red oak . . . in the edge of the second bald spot." This would have been Parson Bald.

Davenport's notes should be reasonable proof that settlers did not create Gregory and Parson balds—but if one is to use them for that purpose, one also must accept them as evidence that the other state-line balds in the Great Smokies did not exist in 1821.

Much of Davenport's writing is pretty dull, consisting mostly of a listing of trees he blazed to mark the boundary. It is interesting that when he reached the area that became Spence Field, he marked numerous beech trees. Wild grass often grows in beech forests. This could have given settlers the idea to clear the beech forest and make of it a grassy bald like Gregory and Parson.

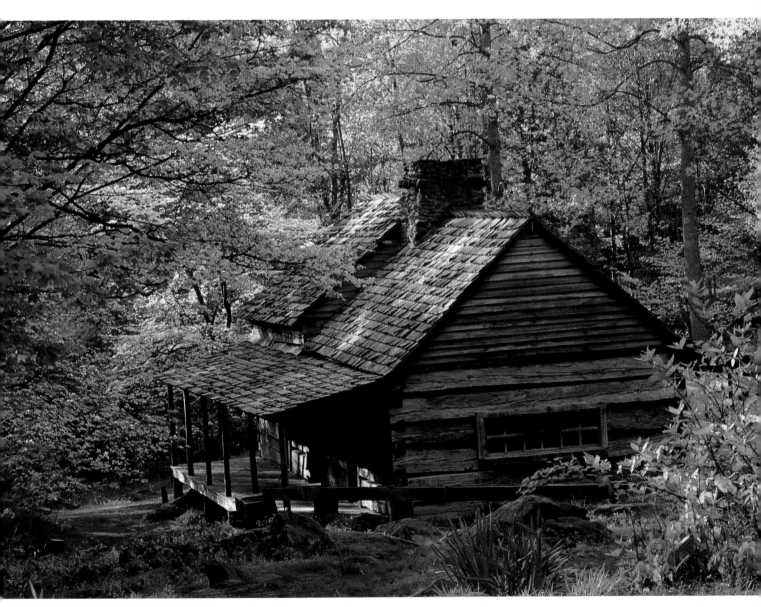

▲ Near Gatlinburg, in the park, dogwood blooms grace the Noah (Bud) Ogle cabin. The Ogle family was first to live in what is now Gatlinburg. They built the first house in the early 1800s, but this house was constructed later.

► ► Wild golden-glow blooms at the Andrews Bald trailhead at the Forney Ridge Parking Area, near Clingmans Dome. This particular wildflower grows at nearly all elevations in the park, while some others, such as the Canada mayflower and witch-hobble, grow mostly at middle to high elevations.

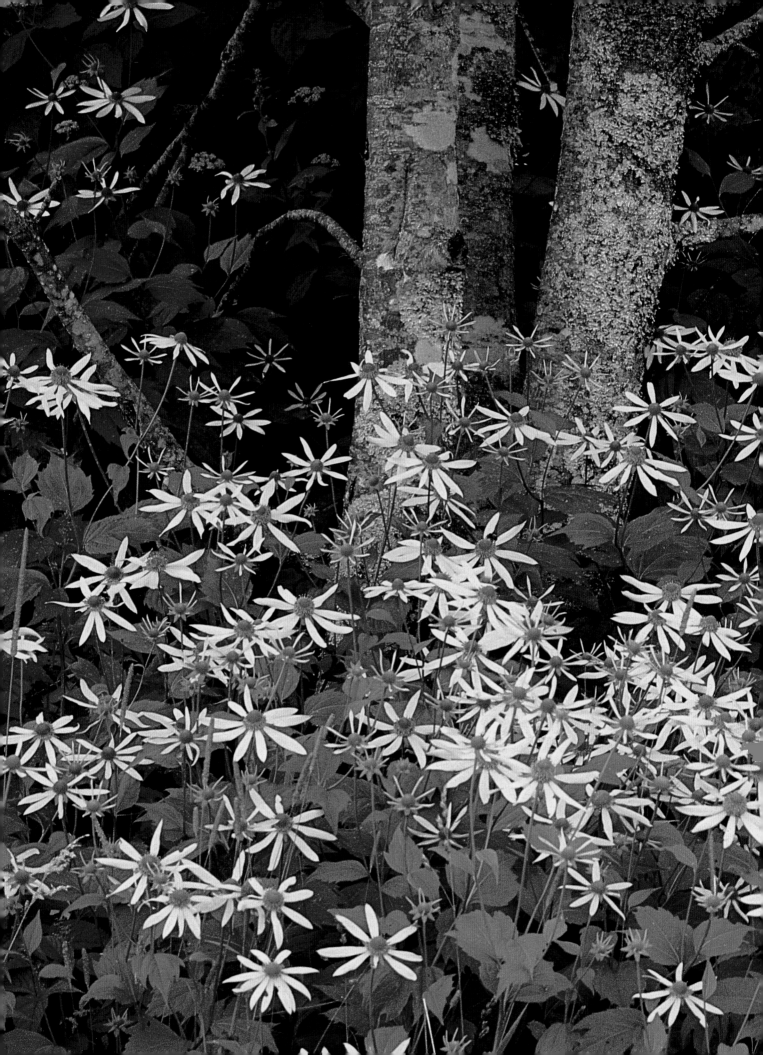

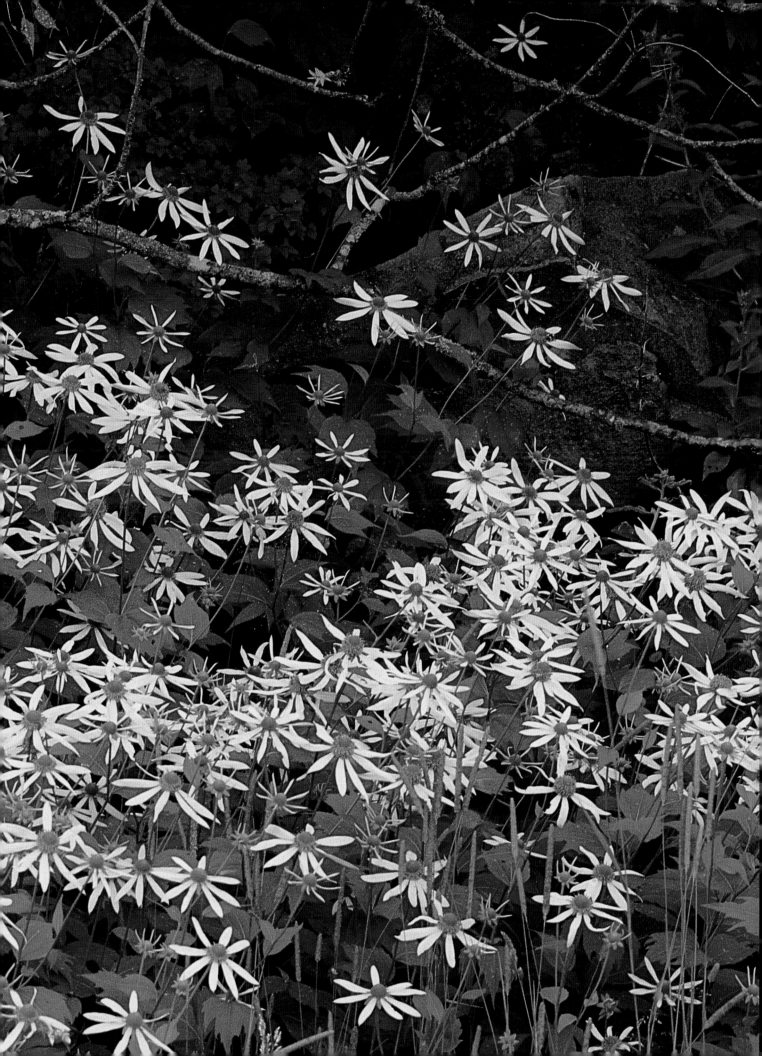

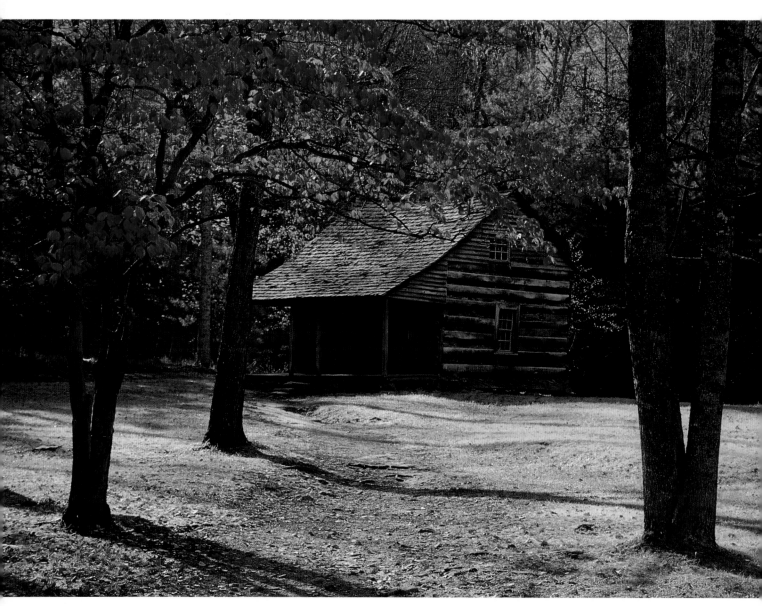

▲ Dogwoods provide leaf color in autumn and white flowers in spring. Dogwood anthracnose, a fungus ailment believed to have been brought to this country from Asia, has killed many of the dogwoods in recent years.

One other hint that Gregory was bald prior to settlement times is found in *Myths of the Cherokee,* written by James Mooney as part of the Nineteenth Annual Report of the Bureau of American Ethnology, published in 1900 by the Government Printing Office. Mooney's book is much more than a listing of Cherokee myths; it also is the best history of the Cherokees up to that time. Mooney wrote that Gregory, for the Cherokees, was *Tsistuyi* (the Rabbit Place), where rabbits had their townhouse and where lived their deer-sized chief, the Great Rabbit.

It is reasonable to suppose that the Cherokees made Gregory their *Tsistuyi* because there was something different about it, probably because it was a small island of grass in a sea of trees.

Mooney came to Cherokee, North Carolina, for much of his research. There lives the Eastern Band of the Cherokee, on the reservation just south of the park. He talked with the Cherokee leaders and medicine men and got from them a collection of legends, medicinal herb remedies, tribal history, and customs.

Most of the Eastern Band, now numbering more than ten thousand, live on the fifty-six-thousand-acre reservation.

The mountaineers of the nineteenth and early twentieth centuries made little money, taking most of their living from a few acres of corn, a garden, milk and butter from two or three cows, meat from hogs that ate what they could find in the woods. (They found a great deal when chestnuts and acorns fell in the fall.) They also ate the meat of deer, bears, squirrels, rabbits, wild turkeys, ruffed grouse. They gathered wild strawberries, blackberries, blueberries, hickory nuts, walnuts, hazelnuts, chinquapins, and chestnuts. Many had small orchards of apple and peach trees. Apples did well on the cool lower north slopes of the Smokies. They caught tasty brook trout from the higher streams and less choice fish from the lower ones. Their sweetenings were honey—either from their own hives or from wild bee trees—maple syrup and maple sugar made from sugar maple sap, and sorghum molasses from their own sorghum cane. Some of them, but probably fewer than half, had sheep whose wool they sheared. A few, especially in Cades Cove, grew flax and even a little cotton. From these they made much of their clothing. Most children wore no shoes from the last frost in spring until the first one in autumn. One woman told me of one Hazel Creek family whose children went shoeless through an entire year.

What little money they had they made by selling things: a few cattle, a little corn, or—more significant—moonshine liquor. They sold pelts of mink, opossum, raccoon, muskrat, and fox; they dug ginseng and sold the dried roots to dealers, who sent it to Hong Kong. From there, it was sold all over the Orient to those who believed it had medicinal properties, including aphrodisiac ones. Ginseng trade between the Southern Appalachians and the Orient has been uninterrupted for centuries. The price paid the diggers in 1992 reached $260 per pound.

Most mountain families kept a few chickens. They ate the eggs and some of the chickens. They took other chickens to the nearest country store and traded them for such necessities as coffee, salt, soda, baking powder, nails, hammers, other tools, and a few articles of clothing.

It was not until big logging companies came into the Southern Appalachians in the late 1800s that mountain men had a steady source of cash. They became loggers.

The J. J. English Company logged the watershed of the Middle Prong of Little River between 1880 and 1900. Unlike the big companies that came after it, the English firm did not take down the whole forest; it selectively cut large trees, mostly big tulip trees, and left most of the forest standing with little damage.

One method the J. J. English Company and some other companies used in getting logs out of the rugged mountains was the splash dam. A splash dam was a wooden dam built across a mountain stream. After water backed up behind it in a small lake, the loggers rolled logs into the lake and then dynamited the dam. The released water carried the logs far downstream. The dams sometimes were rebuilt at the same spot.

J. J. English left such a splash dam on Lynn Camp Prong of Middle Prong. More than ninety

years old, it is still there in Lynn Camp, at the exact spot where Marks Creek enters Lynn Camp. It is one of the most visible relics of the logging era of the Great Smokies.

In 1901, U. S. Secretary of Agriculture James Wilson wrote a "Report of the Secretary of Agriculture in Relation to the Forests, Rivers and Mountains of the Southern Appalachian Region," which President Theodore Roosevelt transmitted to Congress in late 1901 or early the next year. In it, Wilson said of the Great Smokies: "This segment of the Unakas is the largest mountain mass in the Southern Appalachians, and it contains the largest area of continuous forest with the smallest number of clearings." Wilson said that less than 10 percent of the Great Smokies had been cleared and that the clearings were "few and small, and lie chiefly some miles distant from the crest of the ridge." Roosevelt suggested that a "national forest reserve" be established, not necessarily in the Great Smokies, but somewhere "in this hard-wood region."

Unfortunately, nothing was done about preserving the forests of the Smokies for decades to come. It is truly a pity, because by the time preservation came, the clearings amounted to far more than 10 percent.

Lumber companies in the Great Smokies in the early 1900s were mostly clear-cutters; they cut every tree big enough to saw. Some little ones that remained were damaged. Fire often followed the loggers, for they left treetops that dried out and were easily ignited—sometimes by lightning, sometimes by humans.

Logging and fires also damaged streams. Silt from logging roads spilled into them, covering what had been clean spawning beds. With trees gone that once shaded streams, some became too warm for brook trout. Gone were many of the great chestnuts and oaks that had provided food for bears, wild turkeys, deer, squirrels, white-bellied mice, chipmunks, and other creatures.

Many people show little appreciation for what is nearby and familiar to them. Generally, East Tennesseans and North Carolinians did not seem to think that the Great Smokies were exceptionally lovely. Sometimes, comparison helps.

By chance, such a comparison was made. In 1923, a Knoxville couple, Mr. and Mrs. W. P. Davis, visited national parks in the West. According to the story, Mrs. Davis told her husband that the Great Smokies were just as beautiful as the parks they were seeing. And she persuaded him to start a park movement for the Smokies.

Unfortunately, Davis was not the kind of charismatic person who inspires others to action. People listened to him politely but did little else. Carlos C. Campbell, who became an ardent park booster and author of *Birth of a National Park,* a book about establishment of the park, was at first unenthusiastic. He wrote that he was "irritated" at having to listen to Davis. But the chamber did appoint a committee, and among those on it was David C. Chapman. At first, Chapman was pretty much like the others—unenthusiastic. But by chance, he saw the Great Smokies through the eyes of respected outsiders: Wilson's report on the Southern Appalachians and Roosevelt's letter of transmittal.

He read Wilson's assertion that the Smokies comprise "the largest mountain mass in the Southern Appalachians." From Roosevelt's letter, he read: "Under the varying conditions of soil, elevation, and climate many of the Appalachian tree species have developed. Hence it is that in this region occur that marvelous variety and richness of plant growth which have led our ablest business men and scientists to ask for its preservation. . . ."

This converted Chapman, and he converted others. The movement for a Great Smokies park accelerated, but by then other communities in the East wanted parks. A committee appointed by the secretary of the interior evaluated some of the proposed areas. It reported in December 1924 that the Great Smokies was best.

The committee reported that the Smokies area "surpasses any other region in scenic grandeur" and mentioned these features: "the height of mountains, depth of valley and unexampled variety of trees, shrubs and plant life."

But it did not recommend that a national park be established immediately in the Great Smokies. Instead, it gave that recommendation

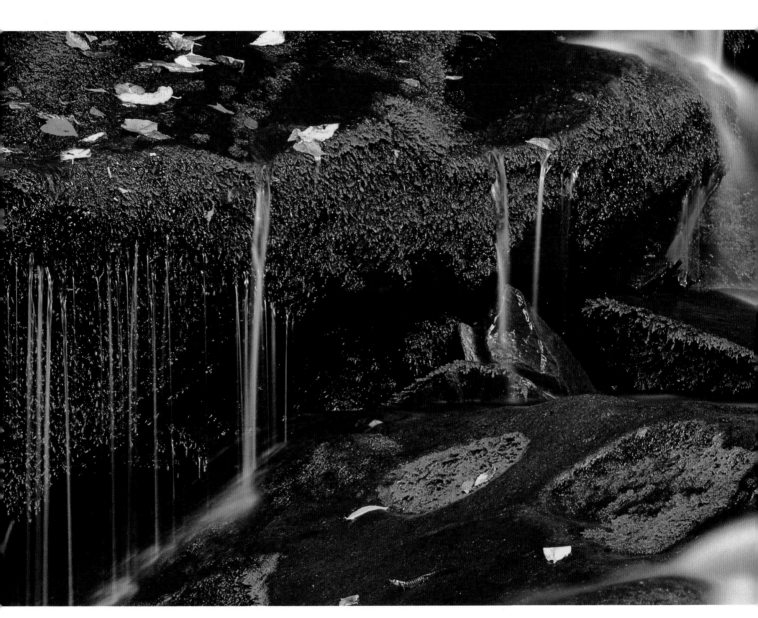

▲ Rainfall may exceed one hundred inches per year at such high places as Mount Le Conte and Clingmans Dome in the Great Smokies. Generous rainfall is one of the reasons for the park's abundant, lush plant growth.

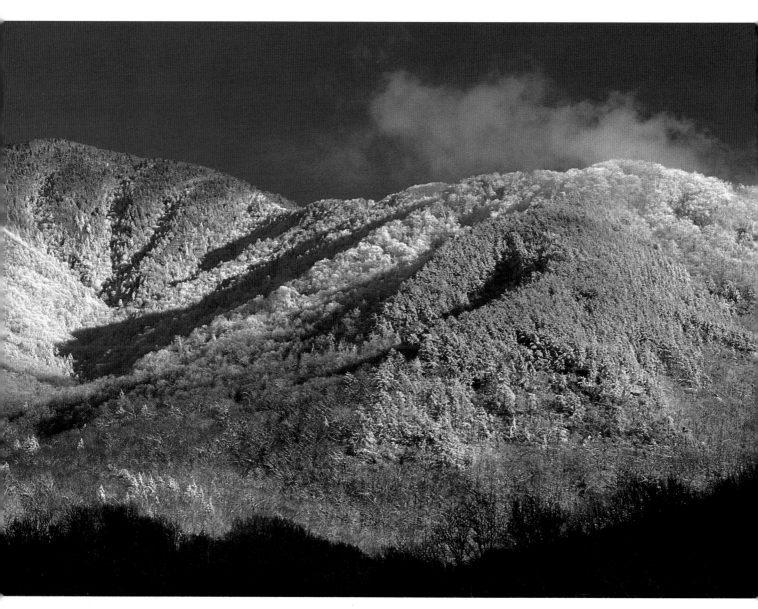

▲ Bull Head Mountain, as seen from the Carlos Campbell Overlook, on the Newfound Gap Road, wears a cover of snow. The Bull Head got its name from someone who thought it was shaped like the head of a buffalo bull. The Bull Head Trail, one of the trails to Mount Le Conte, passes this way.

for the mountains of Virginia, for what became Shenandoah National Park. The reason given was Shenandoah's accessibility to more people. However, both areas became national parks: the Smokies in 1934, and Shenandoah in 1935.

Why did it take so long to establish the park? The biggest reason was money—or the lack of it. All national parks up to then were established on lands already owned by the U. S. government. Every square foot of the Great Smokies was in private ownership. The Aluminum Company of America and a dozen big logging companies owned the great bulk of it. (ALCOA had bought up land along the Little Tennessee for dams and lakes to provide electric power for its aluminum operations at Alcoa, Tennessee.) A subsidiary copper company owned considerable acreage in North Carolina. Hundreds of individuals, mostly small farmers, owned the rest of the land.

At that time, the federal government was willing to accept the land as a gift from the two states, but it would buy none of it. The legislatures of the two states appropriated some of the money. So did the city of Knoxville. Individuals, including school children, contributed.

Altogether, it was not enough. Park advocates were pessimistic. Then John D. Rockefeller, Jr., agreed to contribute five million dollars from the Laura Spelman Rockefeller Foundation, a fund his father had established in memory of the senior Rockefeller's wife. In his book, Campbell credits Chapman and Arno B. Cammerer, associate director of the National Park Service, with persuading Rockefeller to make the gift.

Because of this and other services performed by the two, the park now has a mountain named Cammerer and another named Chapman. There is also a Mount Davis for Davis and a Davis Ridge for Mrs. Davis. Mounts Squires and Kephart honor two North Carolina leaders in the park movement, Mark Squires and Horace Kephart. Kephart was a writer who came to the Great Smokies in 1904. He authored *Our Southern Highlanders,* probably the best book ever written about Southern mountaineers. He was an effective leader in the park movement. For the rest of his life, he lived in or near the Great Smokies.

With the Rockefeller gift, sufficient money was available to buy the minimum amount of land for a park. Later, under the presidency of Franklin D. Roosevelt, the federal government did contribute some funds for buying land. Still later, a federal agency, the Tennessee Valley Authority, contributed forty-four thousand acres to the park. This was land TVA had bought during World War II in connection with the construction of Fontana Dam and impoundment of the lake behind it. TVA found it cheaper and simpler to buy the land between the new lake and the park boundary than to build a new road to replace an old one covered by the lake.

The forty-four thousand acres from TVA contained some copper company land but not all of it. There remained 2,344 acres owned by the Tennessee Copper Company. Finally, in June 1983, the government and the owner agreed on a price for it, and it became part of the park.

Little high-grade copper ore was found on the mountain, but copper-bearing land extended all the way to the top of the Smokies. Granville Calhoun, in 1905, found copper at the top of the mountain at Silers Bald, but it was never mined.

The park now contains more than 520 thousand acres, including nearly ninety-five hundred acres in the Foothills Parkway, an unfinished two-lane scenic highway which circles—but does not touch—the Tennessee part of the park.

Nobody polled the people who lived on land designated for the park to learn whether they wished to leave or stay. But some obviously wanted to stay.

One was John Oliver, great-grandson of the John Oliver who was Cades Cove's first settler. He resisted selling his three-hundred-acre cove farm to the state for inclusion in the park. Three times his lawsuit with the state went to the Tennessee Supreme Court. He finally lost. He moved from the cove on Christmas Day 1937, taking his furniture, farm tools, and machinery—and enough memories, bitter and sweet, to last him the rest of his life.

I visited the old man in June 1958. I followed a road south out of Townsend to its end at a white house at the head of a small green cove. The farm

he bought to replace the one in Cades Cove extended right up to the park boundary.

He was eighty then, a tall, spare man with a straight back and a full head of white hair. He wore clean, faded, blue-denim bib overalls.

"I hear you are the man who stocked the first rainbow trout in Abrams Creek," I said.

"That's right," he said. "I also was responsible for the first ones that were put in Little River."

He explained: in 1907, he wrote his congressman and requested rainbow fingerlings be sent to him. The little fish reached Townsend via Little River Railroad. He was late going to Townsend to get them, so the express agent, afraid they might die, dumped them into Little River. Oliver had to wait until 1908 to get his fingerlings for Abrams Creek, which drains Cades Cove. A little too warm for the native brook trout, Abrams became an outstanding rainbow stream.

Discussing his choice of a farm to buy after leaving the cove, he smiled and said, "They told I bought against the park for another lawsuit."

He also said, perhaps a little proudly, that Dave Chapman once described him as being "very intelligent and mighty . . . stubborn."

Did he still feel strongly about having to leave his land?

"You never outlive those things." he said.

Not everyone left. Those who accepted less money for their land than the appraised value were given life leases. They could continue living on the land until they died, but their descendants could not. Part of their agreement was that they would maintain the land, now the park's property, according to rules laid down by the National Park Service. A person who was as independent as John Oliver would have no part of this—and many were like him.

Of those who accepted life leases, many chafed under NPS restrictions and eventually left. A few stayed; one was Lem Ownby.

I first learned about Lem in July 1968, when I hiked from the Sinks, on Little River, to the village of Elkmont. About a half-mile from my destination, I saw a clearing to my left, and in the clearing a small, unpainted house. Dogs barked. I left the trail and went down to the house.

It stood within a few yards of Jakes Creek. A worn path linked the house to a spring where cold, clean water flowed. There, I met Lem and his three dogs, the favorite of which was Shep.

Shep kept bears away from Lem's 116 bee hives and killed the rattlesnakes that invaded the forty-four acres Lem had sold but continued to dwell on. He said snakes sometimes bit Shep.

He said, "I bile cocklebur leaves and soak a rag in them and put it on the bite. The swelling goes down. I guess it'd work on humans, but I don't know anybody who ever tried it."

His wife, Mimmie, had died recently. Another time I visited, he spoke kindly of Mimmie.

"I had a good woman. A smart woman, one who'd save. She didn't throw it out the back door as fast as you could carry it in the front."

Lem was born a mile or two downstream, below the confluence of Jakes Creek and Little River, about where the Elkmont Campground is now. His father, Tom Ownby, moved the family up to Jakes Creek in 1891. They moved into a log house the father had built. On the same spot in about 1908, the Ownbys built the four-room house that Lem lived in the rest of his life.

Lem's bees flew off into the forest, gathering nectar from blooms of tulip poplars, basswoods, and sourwoods. Lem made up to two thousand dollars some years on the honey he sold.

Lem did not like to leave Jakes Creek. Two or three times, illnesses forced him into Knoxville hospitals. He refused to drink hospital water. Relatives brought him water from his spring.

Lem's sight was poor the first time I saw him, and it grew worse. As age advanced, his activities declined and the number of bee hives dwindled. His clearing shrank; forest advanced toward his house as he ceased cultivating the land. His life wound down with serenity. He was totally blind the last few years of it. During these years, a nephew, Roy Ownby, and his wife lived in a temporary home near the old man.

He died in January 1984, about a month before his ninety-fifth birthday. He had lived for more than ninety-two years in the same place, beside the singing waters of Jakes Creek. He was the last of the life lessees of the park.

▸ *Because of the abundant sugar maple trees that grow there, the valley of the West Fork of the Little Pigeon River is sometimes called Sugarland Valley.*

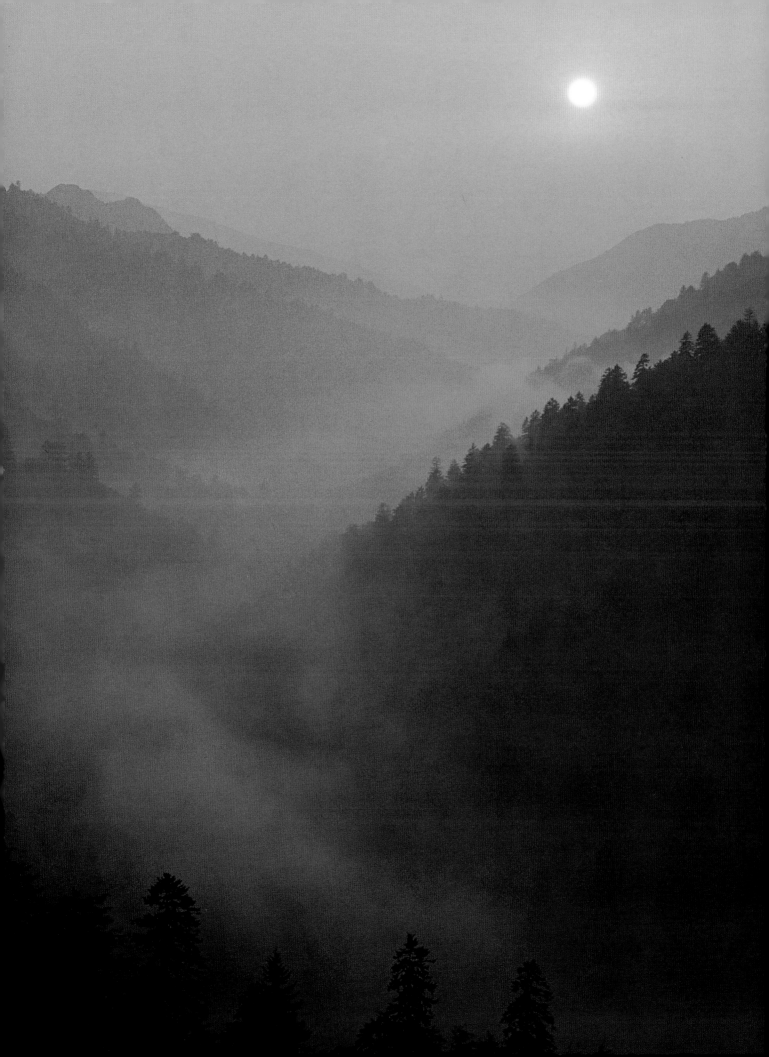

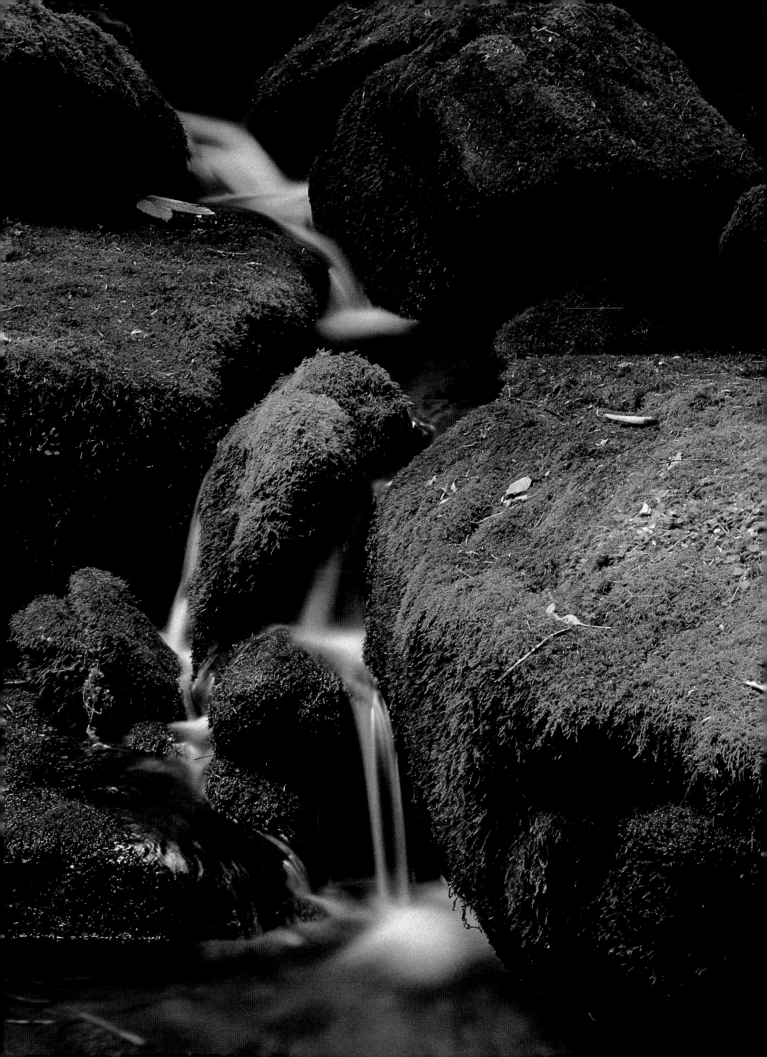

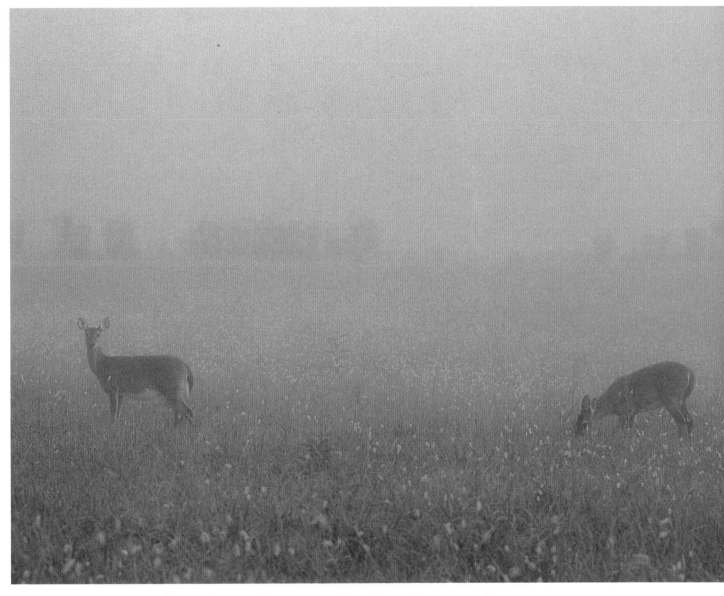

◄ Le Conte Creek cascades around moss-covered boulders. Fishermen used to catch brook trout in Smokies streams, but fishing for brookies is banned now because the population of the lovely little fish grew dangerously low. ▲ In her first pregnancy, a doe will generally have one fawn; in each pregnancy thereafter, she will usually have two. Deer live throughout the park.

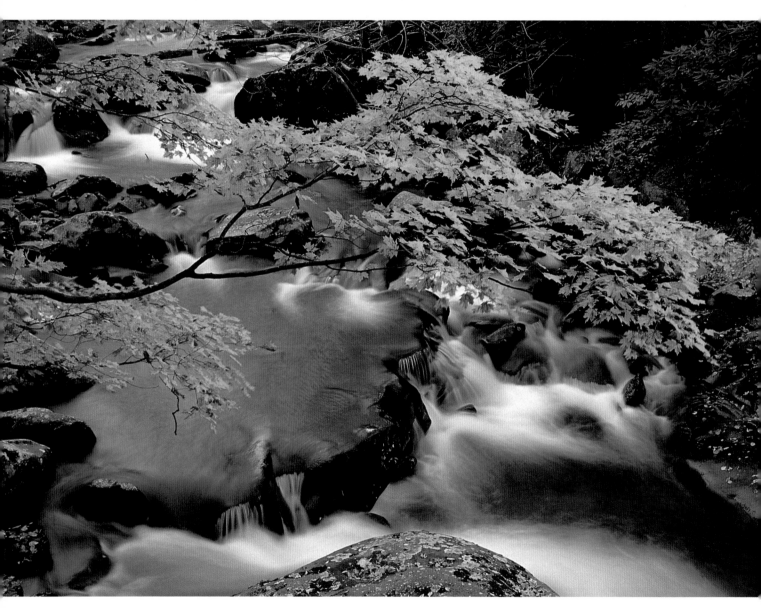

▲ Fishermen near Tremont take rainbow and brown trout from Middle Prong of Little River, which joins the main prong of the river near Townsend. Many swimmers enjoy the large pool at the confluence of the two streams.
▶ Many consider Le Conte the most spectacular mountain in the national park. Lying entirely in Tennessee, Le Conte is a few miles north of the main ridge of the Great Smokies. It is linked to the main ridge by Boulevard Ridge.

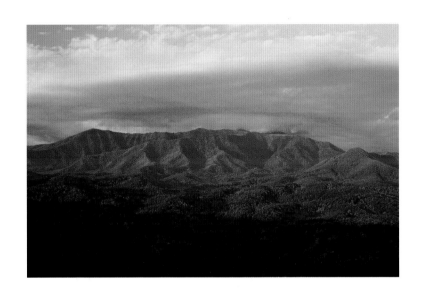

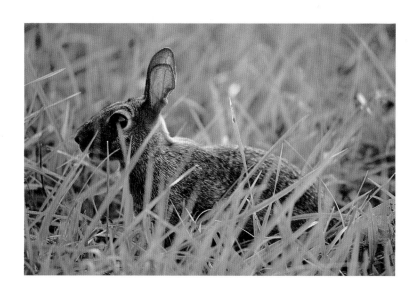

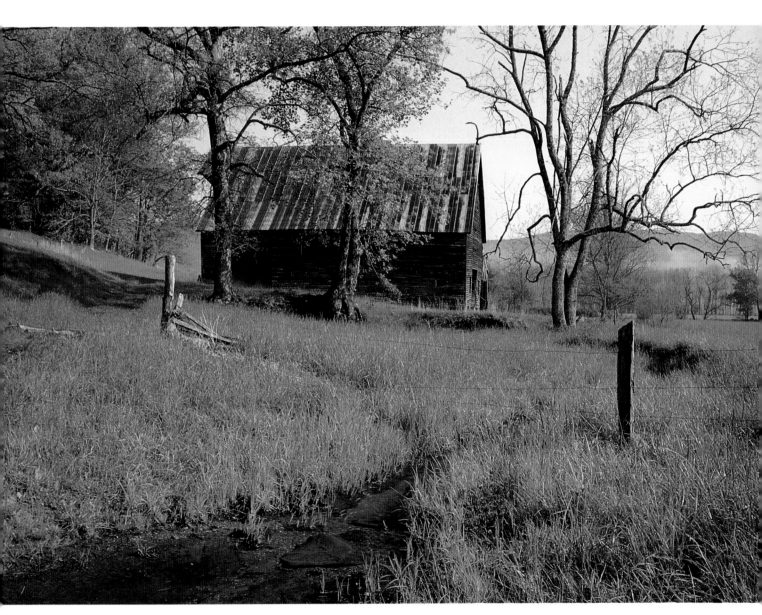

◄ Cottontail rabbits, numerous in many areas of the park, are a major part of the diet for foxes. Hawks, coyotes, red wolves, and bobcats also prey on them.
▲ Barns in the once-settled parts of the Smokies sheltered cattle, mules, and horses. Chickens found places to nest in them; farmers cured tobacco and stored hay in them. Some farmers, however, stored corn in separate corn cribs.
► ► Some people liked living in the Smokies partly because of the protective high mountains affording privacy. But some felt imprisoned by the mountains.

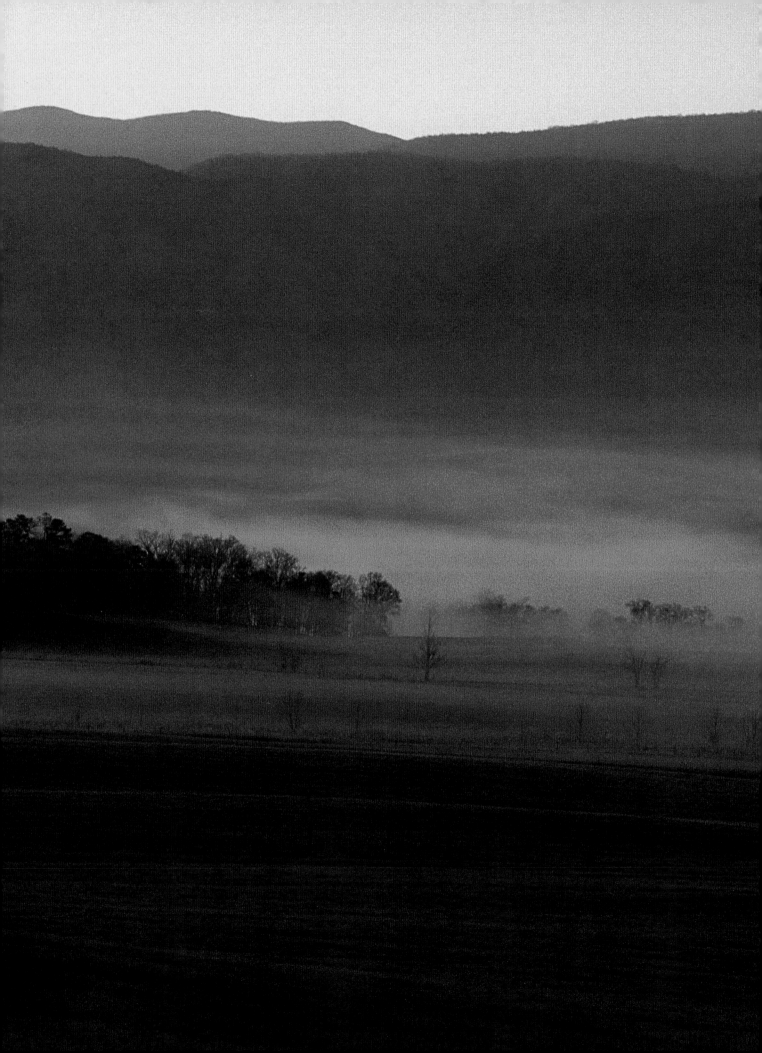

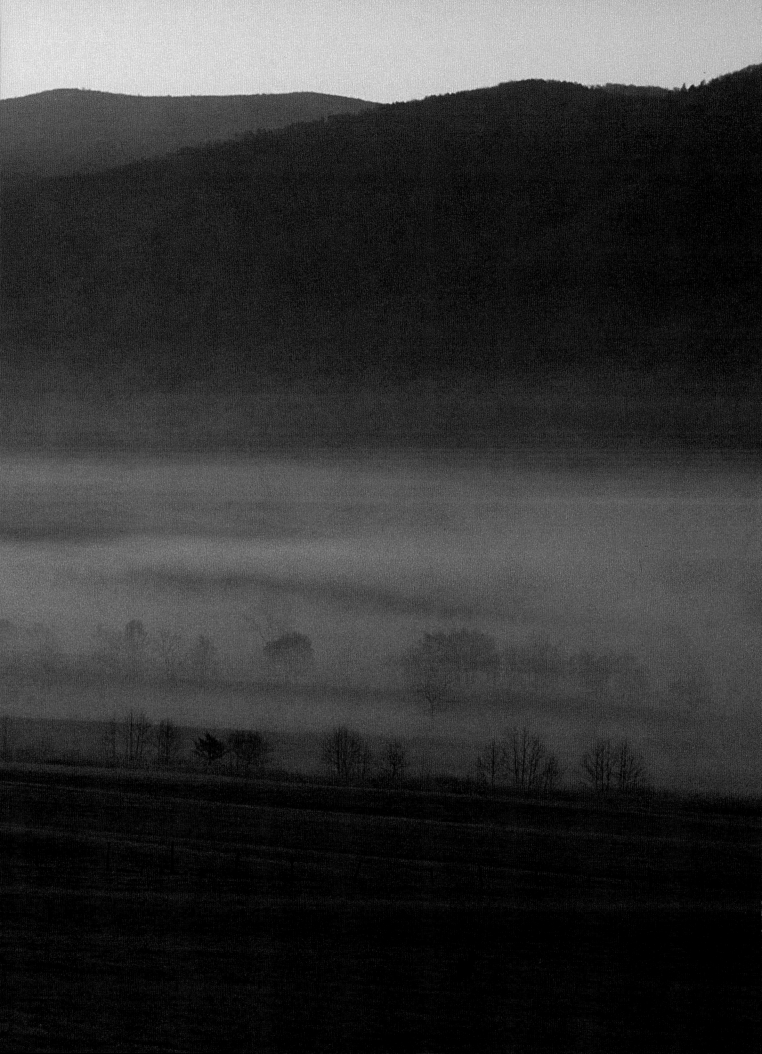

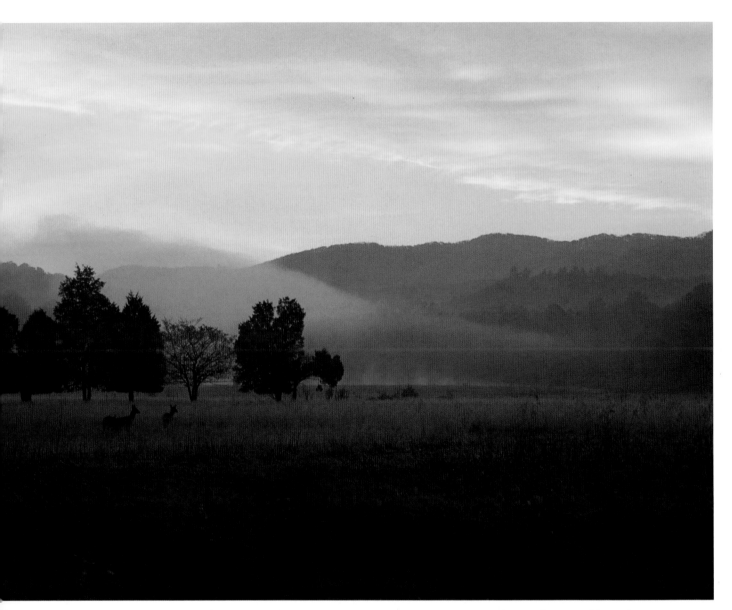

▲ Two does graze in an open meadow at dawn along a farm road branching from Sparks Lane, which was named for the Sparks family who once lived in Cades Cove. Sparks and Hyatt lanes run north-south across the cove and connect the inbound and outbound legs of the eleven-mile, one-way loop road around the cove. A motorist who decides he wants to shorten the eleven miles can take a shortcut across the cove on either of the lanes.

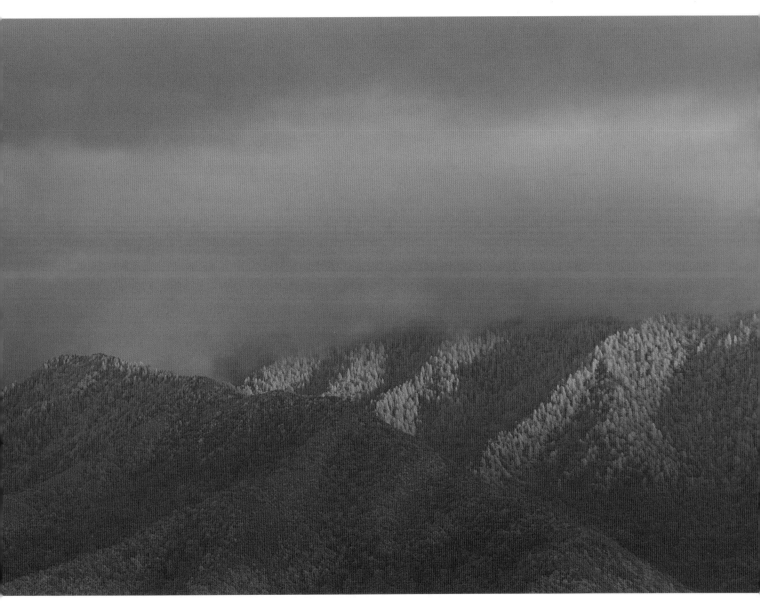

▲ Cold, clouds, mist, and sun combine with hoarfrost on Mount Le Conte. Hoarfrost, also called rime, is actually frozen fog. It sometimes forms so heavily around tree trunks that its icy knives are more than an inch long.
► ► A few scattered blooms of flame azalea mark the edge of Andrews Bald, on the North Carolina side of the Great Smokies. The dead tree is a Fraser fir, probably killed by balsam wooly adelgids, a European pest that has killed nearly all the adult firs in the park since the early 1960s.

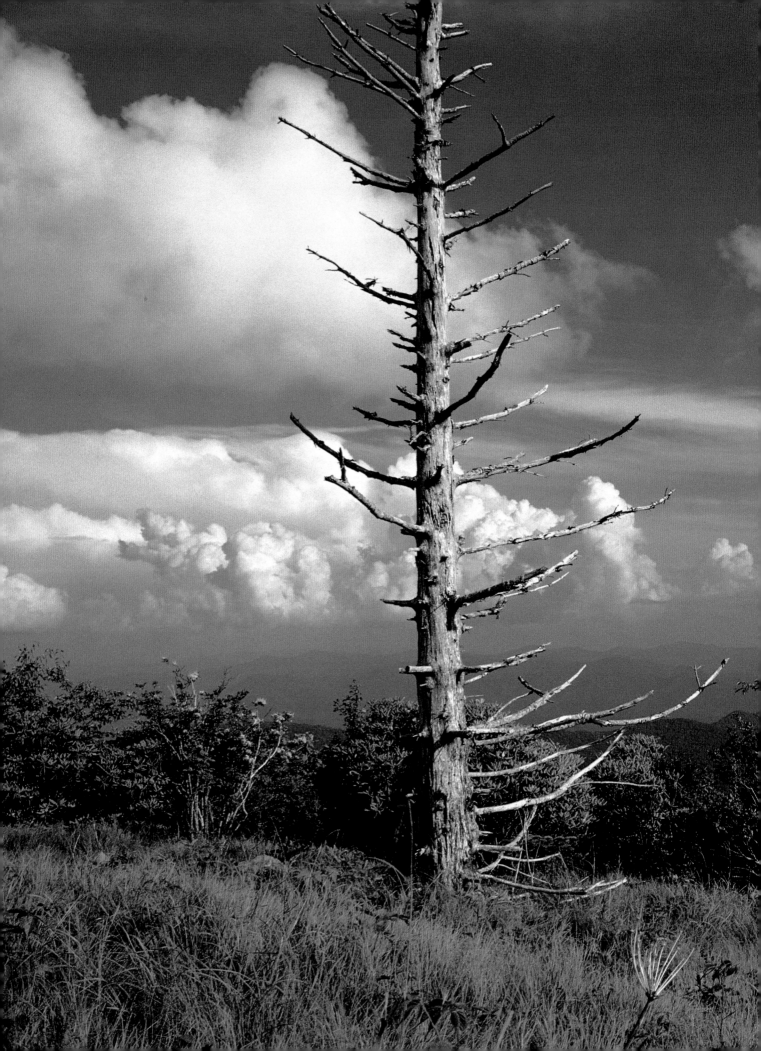

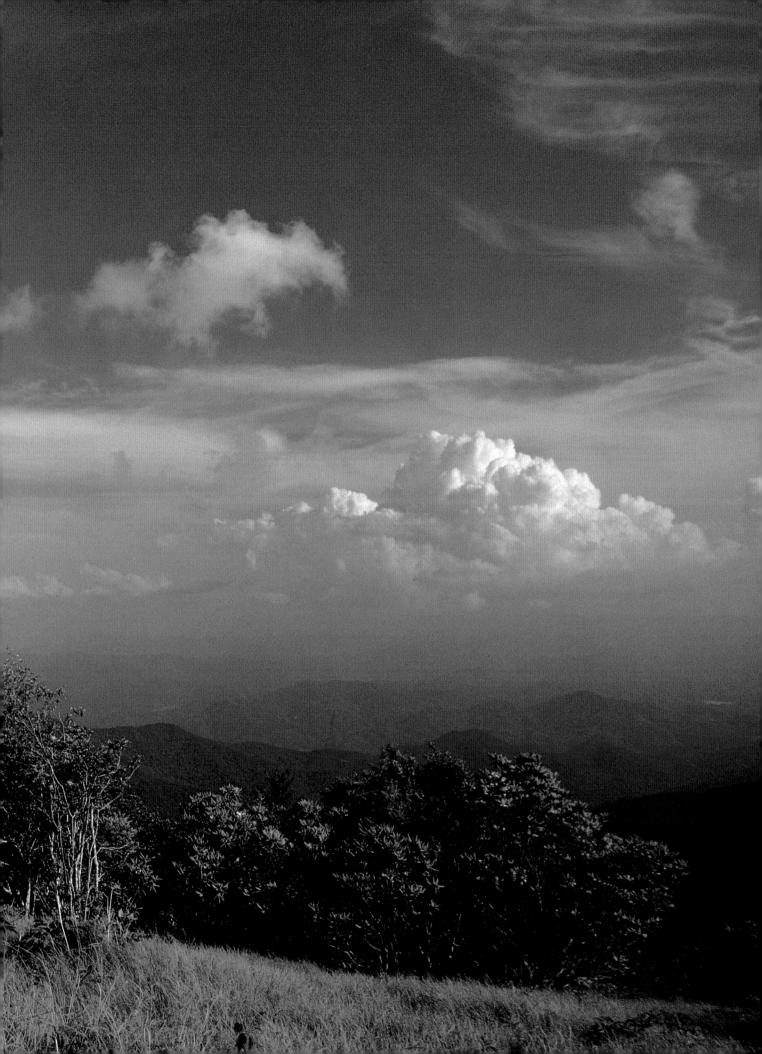

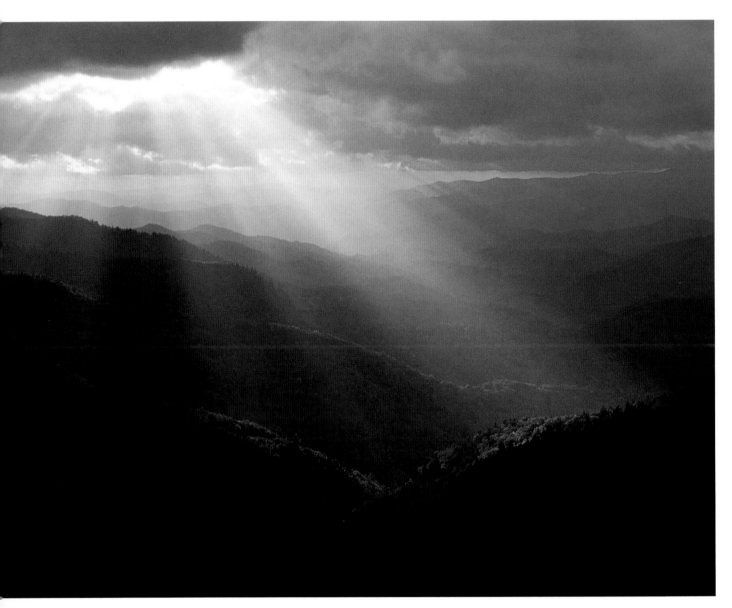

▲ Some 140 species of trees grow in Great Smoky Mountains National Park, more than grow in any other United States national park in North America.
▶ When a death occurred in Cades Cove, church bells at the Methodist Church signaled the message. The bell tolled one ring for each year the person had lived. Friends stopped work and went to make necessary preparations.

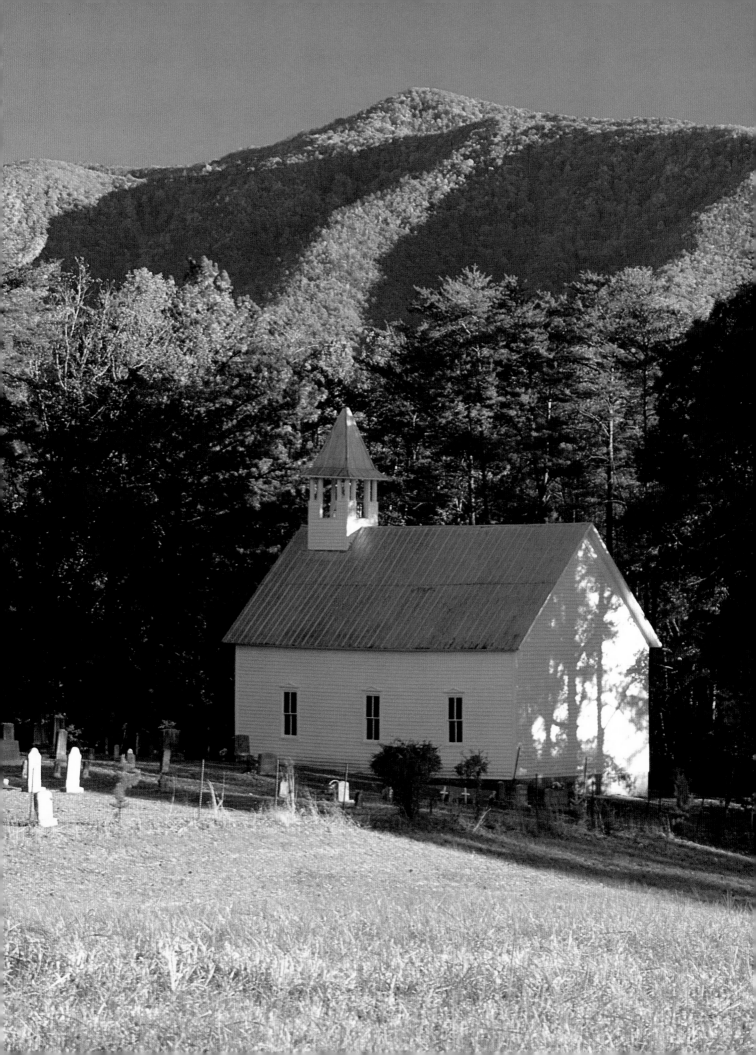

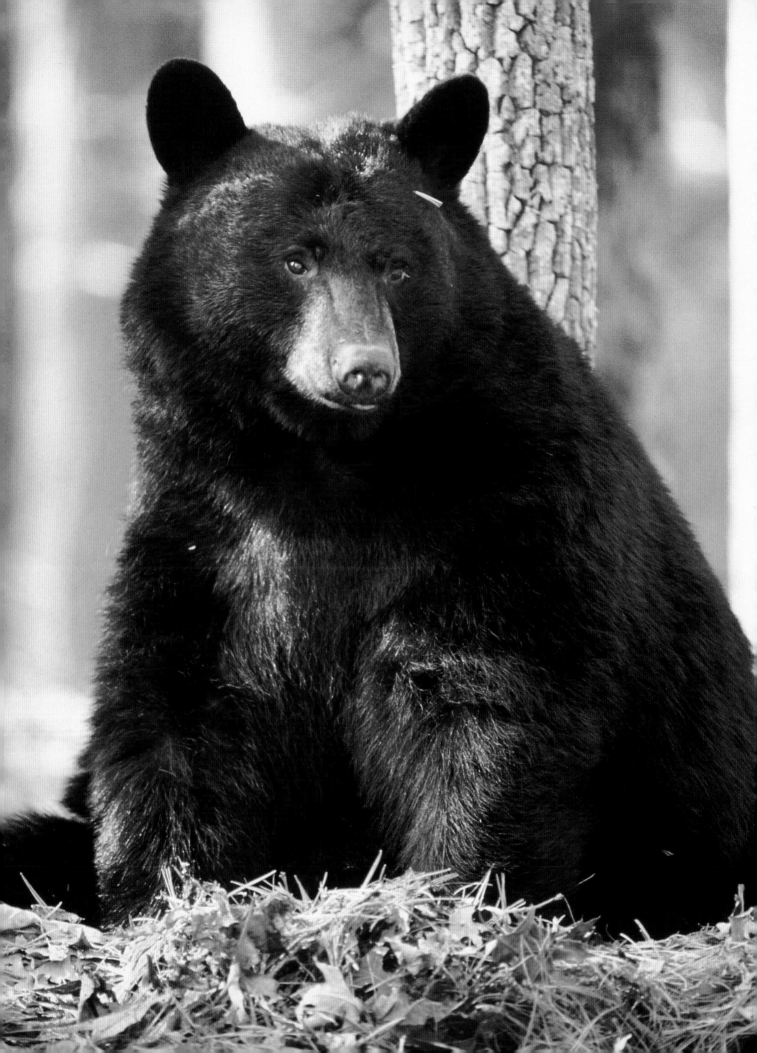

The forest and the land were not alone in bearing wounds when the Great Smokies passed from private ownership to the care of the National Park Service (NPS). The creatures also were in trouble. Overhunting and illegal hunting, along with the wreckage by logging of more than half their habitat, had left some animals almost extinct in the park as well as in most of the Southern Appalachians.

J. F. Manley, who became forester for the park in 1933, said he spent the next nine years walking all over the Smokies. During that time, he said, he saw only one deer and four bears.

Dr. A. Randolph Shields, who grew up in Cades Cove and became a biology professor, said about thirty deer lived through that trying time in the mountains above the cove. The one deer Manley saw was just southwest of the cove. These are believed to have been the only deer in the park at that time.

But with hunting banned by the National Park Service and the forest given a chance to renew itself, wildlife rebounded. The time came in the next thirty years when a motorist driving around the eleven-mile Cades Cove Loop Road at dawn or dusk could count a hundred or more deer. The bear population also grew greatly.

The black bear is what visitors most want to see. He is half charismatic clown, half dangerous predator—and a most interesting fellow.

When autumn sunshine falls like a blessing on the Great Smokies forests and the harvest moon lights the nights, it is time for the bear to fill his belly with acorns. His clock tells him it is time to layer his body with fat before packing it in for his long winter snooze.

This time of acorn ripening brings the bears into their "fall shuffle," a term wildlife biologists apply to the abrupt autumnal change in bear routine. Searching for acorns, they abandon their home ranges if those ranges lack oaks, and go where the oaks are. If a late-spring frost has killed oak bloom at some altitudes, the fall shuffle is an anxious time, as the animals search desperately for the food they need to survive and reproduce.

They sometimes travel many miles in their search. Some leave the comparative safety of the park and go into adjacent national forests, where hunters may kill them; they also may go onto private lands where hunters or landowners may kill them, or where they may become losers in encounters with automobiles.

"Feeding frenzy" is another term for this time of bears and acorns; during this period, instead of foraging mostly at dawn and dusk, bears become twenty-four-hour eating machines.

The acorns provide most of a bear's nutrition for its winter sleep. Nearly 20 percent of an acorn is fat. It also is a source of carbohydrates. During the feeding frenzy, a bear's weight increases by 25 to 40 percent. Sandwiched between the feeding frenzy and denning is a period of up to a month of low activity, a transition between intense activity and no activity. Females usually den near mid-December, males a month later.

Some say bears "hibernate." Not so, according to others, who insist that bears do not shut down their systems to the degree necessary to call it hibernation. During this period, a bear's heartbeat slows from between forty and fifty per minute to between eight and ten per minute, and body temperature drops from about 102 degrees to 95. Body temperatures of true hibernators (snakes, chipmunks, woodchucks, and lizards) fall much lower. Some who dislike "hibernate" prefer to say a bear is "dormant" in winter.

Dormant black bears do not eat or drink, urinate or defecate. A tough, fibrous fecal plug forms in a bear's anus and remains until the animal expels it after leaving the den in spring. In spite of this cessation of intake and elimination, a bear's motor keeps on running during dormancy. It burns twenty-five hundred to four thousand calories per day. Although other animals, including humans, would lose bone weight and possibly develop osteoporosis during such a long period of immobility, the black bear maintains its bone weight during dormancy. It does this because of its unique ability to recycle the by-products of the metabolism of acorn fat. The females give birth and then produce milk for their cubs, which grow considerably from birth in January or February until their mother takes them out of the den two or three months later.

*Bears
& Other
Critters*

◄ *Bear 75 was banished from the Great Smokies for bad behavior. He traveled more than fifteen hundred miles in two years, trying to get back to the park.*

When normal adult female bears den, they are either pregnant or accompanied by cubs born the previous winter. They usually choose large standing hollow trees with entrances big enough to accommodate a bear. The entrance may be from ground level up to one hundred or more feet high. Winter winds may rock the cradle of cubs high in a big tulip tree. With no responsibility for cubs, male bears are less picky about dens. A male may winter on a bed of leaves under a fallen tree or a shelving rock.

Mike Pelton says the park's bear population fluctuates between about four hundred and six hundred. If anyone knows, Pelton does. He is a professor of wildlife science at the University of Tennessee. Since 1969, he and his students have studied bears in the Great Smokies and elsewhere. This is believed to be the world's longest continuous bear study. Nearly 800 bears (642 in the Great Smokies and 156 in adjoining national forests) have been involved.

The biggest single factor in the rise and fall of bear population is the acorn crop. During and after poor crops, the population drops because (1) some bears leave the park in search of food and are killed, (2) bears about eighteen months old need a great deal of food both for growth and for their dormant period, and they die if they do not get it, and (3) poorly nourished females produce no cubs or fewer cubs.

I once went with Pelton and a few students and friends to visit a denned mama and her cubs. Officially, she was No. 484. Unofficially, she was Zsa Zsa. She was seven years old, and Pelton had known her all her life.

En route to Zsa Zsa's den, we passed a big northern red oak which Pelton said was the den tree where Zsa Zsa was born. Her mother had worn one of the collar radios that Pelton and the students attach to bears they are studying so they can keep track of them in the wild.

The tree where Zsa Zsa was born is often used as a den tree. Pelton recalled when some of his students approached another den tree in the same area. They made too much noise and disturbed one of the yearling cubs in the tree. He came out of the den and down the tree and headed across country in snow. The students worried that the cub might not be able to take care of himself in the harsh weather. No worry was called for. They tracked him through the snow one and a half miles to this big northern red where he was born the previous winter. He climbed fifty feet to the den entrance and, presumably, went back to sleep.

We finally reached Zsa Zsa's current den tree, a large chestnut oak. Ideal for researchers who choose not to climb trees, this den has an arched walk-in entrance. Walk-in for a bear, that is, not for a human. Zsa Zsa and her cubs were sleeping a few inches below the outside ground level. A student needled Zsa Zsa with a sedative from a syringe attached to a yard-long stick. She never woke up and they soon pulled her outside onto a tarp where she lay limply.

She exemplified what a healthy, dormant mama bear should be. She still had plenty of fat, and her coat was glossy black. She had no sores or scars, and she was warm to the touch.

The cubs, two females and a male, still had their eyes closed. They probably were three to five weeks old. They woke up and started crying. It sounded a little like the crying of human infants. A woman in our group took them and held them inside her sweater. They soon ceased crying and went back to sleep.

Meanwhile, Pelton and the students began work on Zsa Zsa. They took off her old radio collar and strapped on a new one. They roped her feet together and suspended her from a scale. She weighed 135 pounds, up from 105 pounds three years earlier.

Pelton says most adult male bears in the park weigh from about 240 pounds to about 260. He thinks they would grow larger if they had more protein in their diet. He knows of black bears in North Carolina and the Pocono Mountains of Pennsylvania that have access to cornfields, and these sometimes grow to more than 700 pounds. Pelton speculates that Great Smokies bears grew larger before the chestnut blight killed chestnut trees in the park. Stories told by old-time bear hunters about big bears they killed support this idea. Chestnuts, instead of acorns, were then the

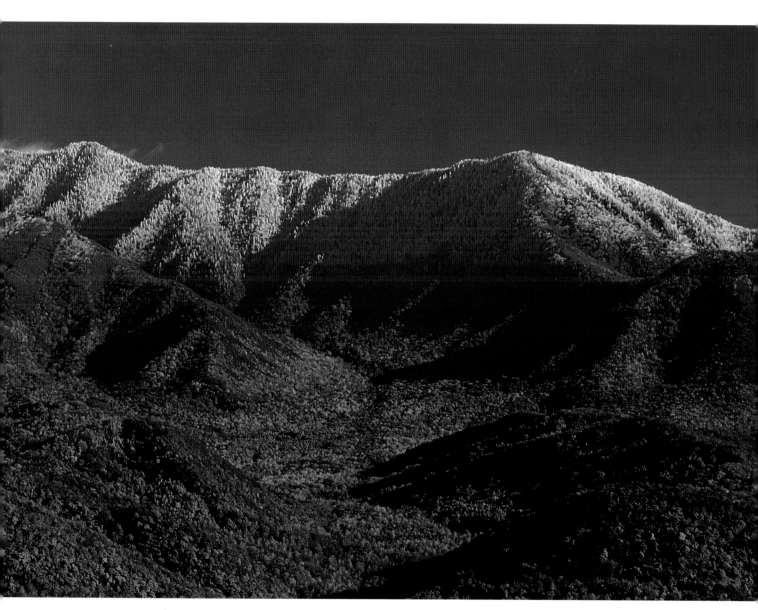

▲ Some eight million visitors from all over the nation and many foreign lands come to the Smokies each year—the months of July and October accounting for more than one million each. Families tend to visit in July, when the children are out of school; retirees come in October to enjoy the autumn colors.

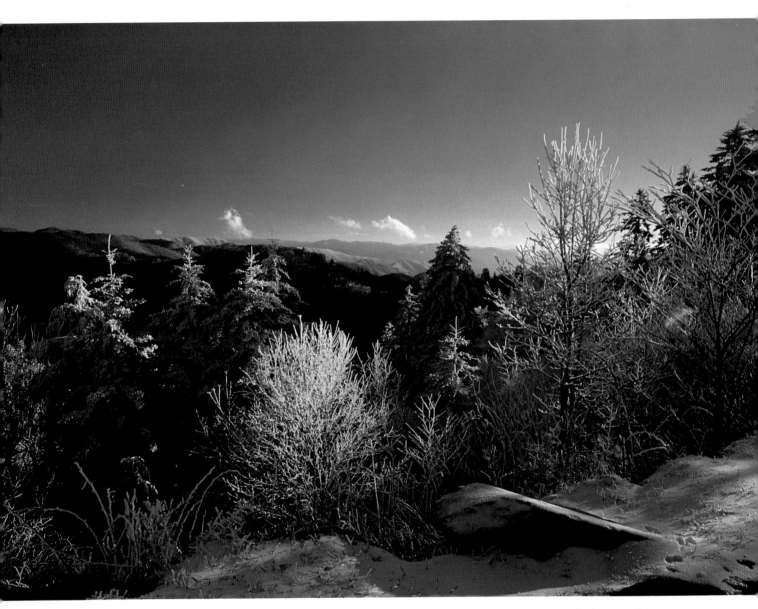

▲ Newfound Gap, atop the middle section of the Great Smokies, provides stunning winter grandeur, with every branch and twig wrapped in hoarfrost. The main road through the Smokies crosses here, linking Cherokee, North Carolina, with Gatlinburg, Tennessee. Snow and ice often force closures.

autumn food of choice for bears and many other animals. Actually, some park bears grew pretty large a few decades ago when they ate garbage from garbage cans by the roadsides and in picnic areas. The scales used by Pelton's people had a top limit of four hundred pounds, and some of the garbage eaters went off the scale.

The students measured Zsa Zsa every way conceivable, from her neck circumference to her teat length. They took blood samples, part of an effort to find a pregnancy test for bears. Neither the rabbit test nor any other known test works on bears. Pelton and the students hoped that data from the blood samples would show differences in levels of certain female hormones in pregnant and non-pregnant bears. (But they did not.)

When the time came to put Zsa Zsa and the cubs back into their den, she was still limp and loose. With minimal pushing and shoving, she flowed into the den, like a blob of furry Jell-O. The smallest student crawled into the den after her to make sure that her nose was unobstructed and that she was breathing normally.

Only one task remained. The sedative stops milk flow, so Zsa Zsa needed one more shot, a drug to restart the flow. It started; while Zsa Zsa slept, two cubs began a delayed lunch.

Male bears come out of their dens in March; females, in April and even as late as the second week in May. Again, there is a transition period of up to a month between dormancy and normal activity. Bears eat little during this period, partly because there is little to eat. Grass, grubs, and a plant called squaw-root constitute much of their diet. Squaw-root is a yellow parasite that grows mostly on the roots of oaks. Bears start eating serviceberries when they begin to ripen in June at low elevations, and they continue to eat them into August at high elevations. Huckleberries, blackberries, blueberries, dewberries, and wild cherries ripen in summer, and bears like all of them. They also partake enthusiastically of wild grapes that ripen in autumn. Oaks dropped few acorns in 1978. Some wild boars in the park starved that winter. Wildlife specialists expected bears to experience hardship, too. But the bears came through in fairly good condition. Pelton

decided the bears fared better than the boars because the bears had been able to climb trees and get to one of the best wild grape crops in years. Boars cannot climb trees.

Bears also eat hickory nuts, hazelnuts, and walnuts, but these are too few to be of much significance in the park. Actually, a bear will eat nearly anything that is edible and available. This includes yellow jacket larvae, grubs, beetles, and honey, as well as the flesh of other animals. In the 1940s and 1950s, a bear killed several cattle in Graham County, North Carolina, south of the park. Hunters who finally killed the bear estimated it weighed five hundred pounds. But instances of bears that kill and eat large animals are infrequent. Surprisingly, bears do not take fish from park streams, Pelton says.

The black bear is king of the wild creatures in the Great Smokies. Nearly sixty mammal species and nearly seventy of reptiles and amphibians live there, along with fifty-three fish species, more than one hundred bird species that breed in the park and more than twice that many that have been seen there. In earlier decades and centuries there were more. The woods bison probably has been gone since the early 1800s; the elk, since sometime in the 1800s; the fisher (a cousin of weasels), since sometime near 1850; the wolf, since the late 1800s or early 1900s; and the Eastern cougar, since. . . .

Well, it is hard to say how long the cougar (sometimes called panther, panter, mountain lion, and puma) has been gone from the Great Smokies. Or even that it is gone. During the past fifty years, there have been hundreds of reports of panther sightings in and near the park.

In 1978, Nicole Culbertson, working for the Uplands Field Research Laboratory in the Great Smokies, sought information from persons who reported seeing panthers in or near the park. She received 140 reports of sightings of panthers or panther tracks. She interviewed one hundred people and judged forty-eight of the reports to be reliable. She put a bit more faith in reports from park employees than in others. She thought they would be less likely to mistake a big red-bone hound or some other animal for a panther.

One park employee, Glen Branam, told her that he and a friend, hunting near the park in 1941, killed a panther kitten that weighed twenty-one pounds. Two or three days later, he said, they killed another kitten about the same size. They believed the two were from the same litter. Another park employee, J. R. Buchanan, said he and fellow worker Arthur Whitehead, saw panther tracks near Bunker Hill Fire Tower, in the western section of the park, in 1956 or 1957. Then they found the carcass of a deer they believed the panther had killed and covered with leaves and debris. Buchanan said he and Whitehead then went on to the fire tower and Buchanan climbed up into the tower cab. As he gazed out the window sometime later, he saw the panther return to its kill. In 1975, four park employees working together in the Cataloochee area of the park all saw a panther.

Dr. William T. Smith, a retired University of Tennessee chemistry professor, and his wife said they saw a panther on the Blue Ridge Parkway, near the park, in 1972. He said the animal bounded down a bank and crossed the parkway fifty to seventy-five feet in front of their car. It was daylight and they got a good look at it. They were 100 percent certain it was a panther.

Kim Delozier, the biologist in charge of the park's wildlife projects, says there is no doubt that many people have seen panthers in the park. However, he thinks (but is not certain) that the animals seen are not the old Eastern cougar. Well, what are they?

Delozier and other wildlife authorities speculate that people have bought Western cougar kittens as pets, then released them in the park after they grew too large to keep. Early in 1992, twenty-seven Tennesseans held state permits to keep pet panthers. Of course, persons from other states also could release panthers in the park.

Although he can point to no specific instance of a pet panther being released in the park, Delozier does tell of a bear that obviously had been somebody's pet showing up at Newfound Gap. Its claws had been removed. It was so hungry for human companionship that it was walking up to tourists and hugging their legs.

Whoever released that bear did it no favor, for a bear without claws cannot survive long in the wild. Delozier gave the bear to a zoo.

Two other animals once extirpated from the park are back in it. One of them, the beaver, came back without human help. However, park streams are not ideal for beavers, which like slow streams. Beavers left the area early this century and came back about twenty years ago. The other animal now back in the Great Smokies is the river otter. Extirpated in the 1920s, it came back in the 1980s, with the help of University of Tennessee and National Park Service people. It is doing well. It likes fast water. I once watched three of them cavorting near where I was trying to catch a trout. They seemed to be having more fun that anyone else in the park.

Wildlife officials in late 1992 released into the park two families of red wolves, each with two parents and four pups. The red wolf is endangered. Only about 130 of them existed in the summer of 1990. Officials think the species once lived in the Great Smokies region and that the park is a good place to move it back from the brink of extinction. The 1992 releases followed a disappointing trial release of one family in 1990. That one did not work out because the adult male had become too accustomed to humans and their domestic fowl. He was more interested in killing poultry than wild prey.

The European wild boar and the coyote came into the park in fairly recent times. The coyote apparently made it there without human help. Once confined to Western states, in recent years, coyotes have migrated into many Eastern states. Since the animals made it into the Great Smokies on their own, park officials decided not to dispute their right to be there. But they were not sure they liked coyotes. One reason is that coyotes tend to chase foxes out of their territories. (Both red and gray foxes live in the park.) But they warmed up a bit to the coyotes after they started finding boar hair in coyote scat.

No doubt about it, European wild boars are the most unwelcome animals ever to invade the park. Their ancestors were brought from the Ural Mountains that separate Europe and

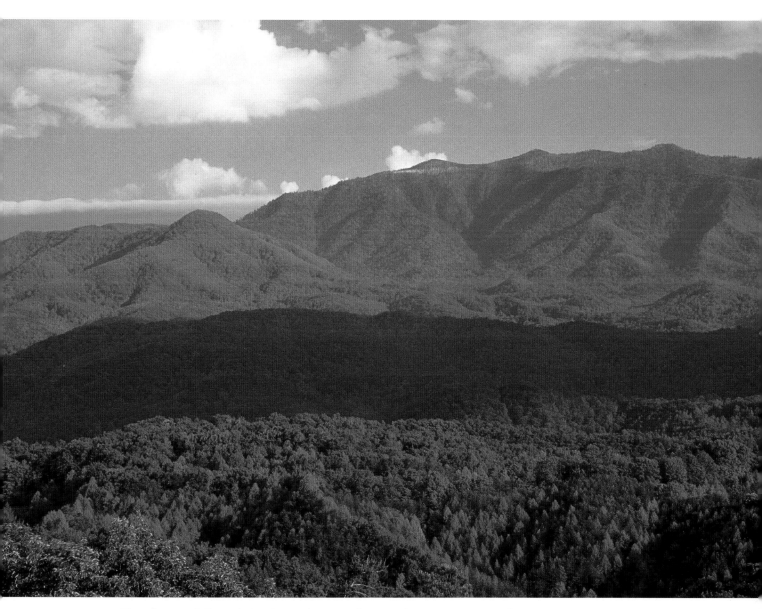

▲ The slopes of Greenbrier Pinnacle, seen here with Mount Winnesoka, are among the steepest in the park. Much of the south slope drainage, along Middle Prong of Little Pigeon River, is covered with old-growth forest.

▶ ▶ This is an autumn view from Mount Harrison southeasterly across the valley of West Prong to Mount Le Conte. Among the trees providing the variety of fall colors are red maples, sugar maples, tulip trees, sourwoods, dogwoods, sweetgums, blackgums, white oaks, scarlet oaks, yellow birch, and hickories.

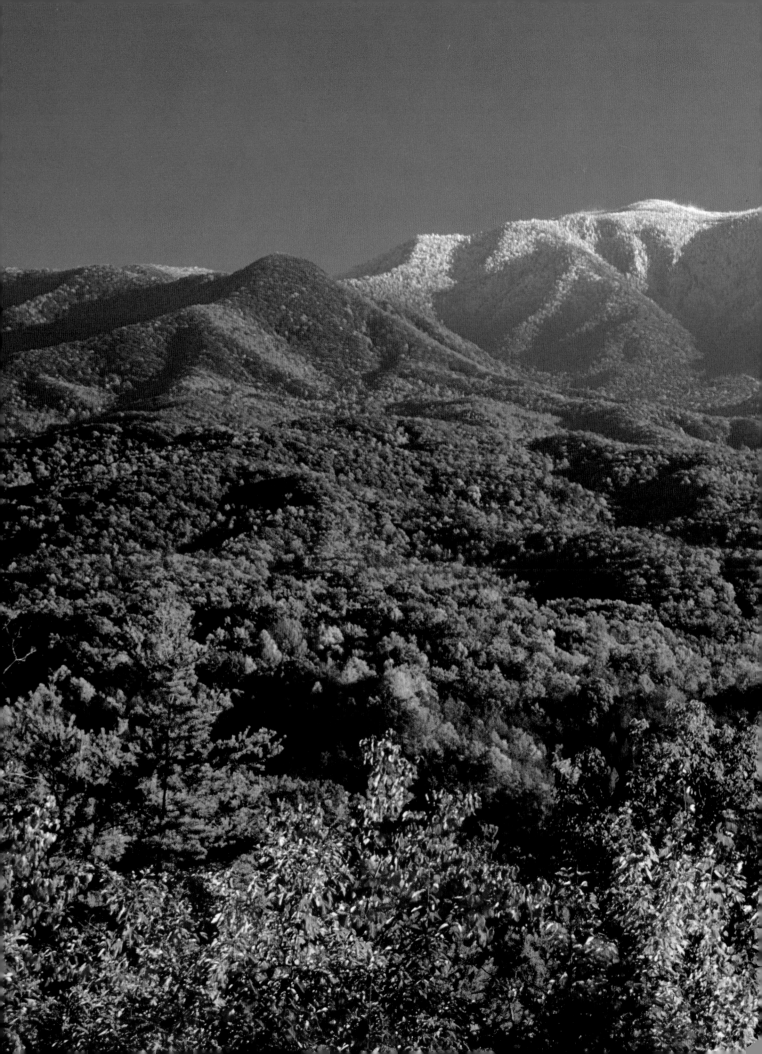

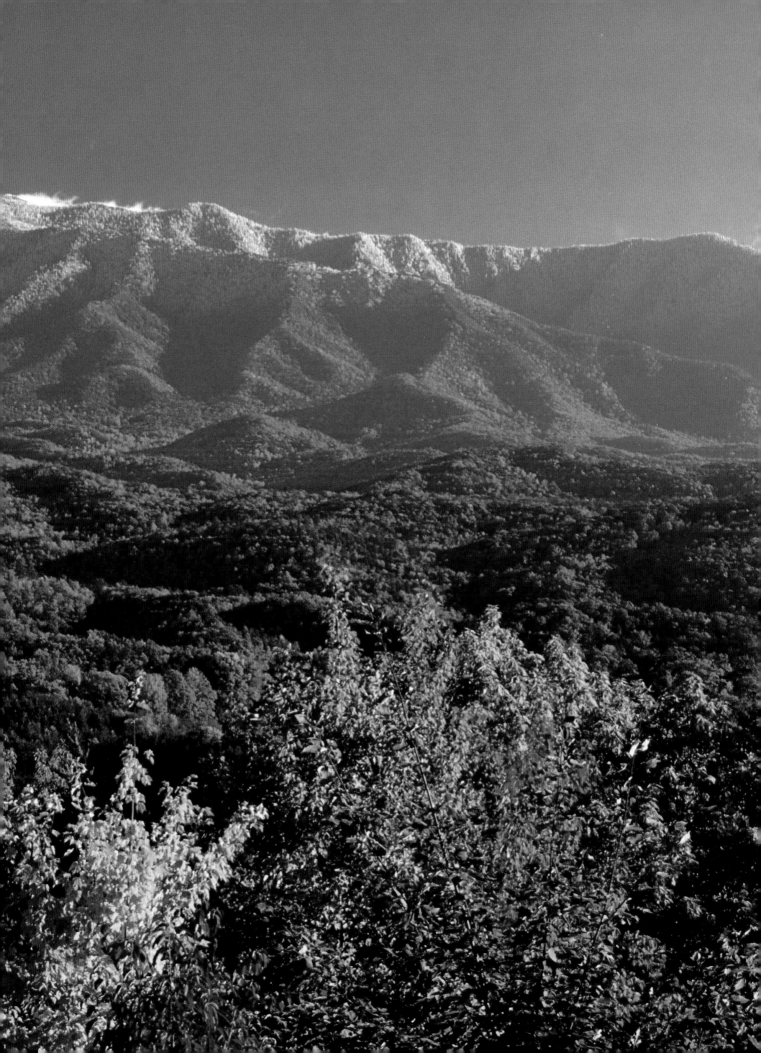

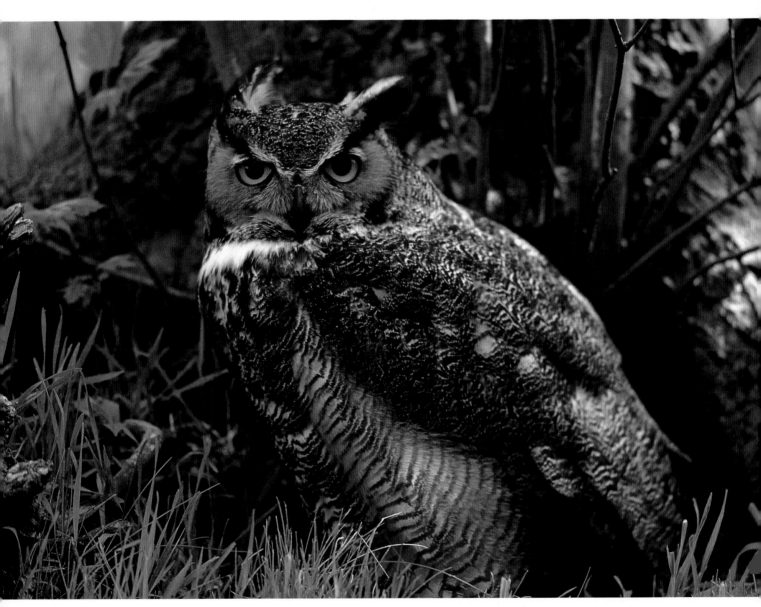

▲ The great horned owl is one of four owl species in the Great Smokies. Others are the barred owl, Eastern screech owl, and Northern saw-whet owl. The saw-whet is the smallest of the owls in the park. Birders who want to hear its soft, clear call usually stop at night along Clingmans Dome Road.

Asia and released at Hooper Bald, south of the Great Smokies, in 1912. In the early 1950s, they crossed the Little Tennessee River and entered the park, expanding their territory over the park. (More later about them.)

No affection is wasted between bears and boars. A big boar can kill a small bear, and a big bear can kill just about any boar. There is little doubt that each has dined on the other, but probably not frequently.

In the summer of 1982, Jonathan Pierce, a seasonal park technician, was checking the Appalachian Trail shelter at Mount Collins, near the crest, when he thought he heard a woman scream. He ran toward the sound, but he saw no woman, just a bear and a boar. The bear had the boar's neck in its mouth and was holding the boar up in the air and shaking it. This amazed some park people, for they later weighed the boar's carcass at 175 pounds. (The bear escaped unweighed, but Pierce estimated its weight at about 200 pounds.)

Pierce said the bear saw him running toward the scene of the fight and appeared to have conflicting emotions: fear of the man, opposed to a desire to stay and finish killing the boar. The bear finally dropped the hog and left.

Pierce radioed Park Headquarters, and Bill Cook, then the biologist in charge of wildlife matters, and others hurried to the fight scene.

When they arrived, the hog was not quite dead. With its hindquarters on the ground, it was propped up on its front legs. It apparently was paralyzed from the shoulders back. Cook thinks the "scream" Pierce heard was the pig's squeal when the bear severed its spinal cord. They put the pig out of its misery.

This primeval brawl apparently had lasted several minutes. Cook said the two had leveled all the low-growing vegetation within a hundred-square-yard area of the spruce-fir forest. The bear clearly had been the aggressor. By nature, the hog, when attacked, backs up to a tree or log. This one had backed up to several trees and logs in brief stands against the bear. He apparently had stayed longer in one spot, for the bear had worn a path there with its repeated charges.

Although no one examined the bear closely, Pierce said he saw no wounds on it. And they found no bear hair at the fight scene, but there was plenty of hog hair and bits of hog tissue. In their examination of the carcass, the park biologists discovered some old laceration scars on the hog's hindquarters. Cook felt they could have been inflicted by a bear.

Could these two have been old feudists?

The combatants were more evenly matched in a story told by eighty-five-year-old Oliver Huskey, who says his grandfather, Jim Ownby, told it to him. Huskey does not know exactly when his grandfather saw this fight, but it was back in the 1800s. He said it is a true story, not some tale dreamed up on a winter night in the flickering light of the fireplace.

Ownby, who lived in the Greenbrier section of what is now the park, hunted in the narrow valley of Ramsey Prong. He walked upstream on an old trail used by cattle in summer. When he glanced across the stream, he saw a panther lying on a log. Ownby raised his rifle to shoot. But before he pressed the trigger, he noticed movement in the rhododendron bushes behind the panther. He held his fire, waiting to see the cause of the shaking bushes.

Out of the rhododendrons walked a bear. Straight to the panther he walked. And with a blow of one of his forepaws, he knocked the panther into the creek.

The panther came up snarling out of the creek and back onto the log, where he launched himself at the bear. Jim Ownby told his grandson he had seen lots of animal fights, but never one to equal the violence of this match of the bear and the panther.

Toward the end, the bear held the panther in a fearsome embrace. At the same time, the panther was using the claws of his hind feet on the unprotected belly of the bear. The crushing hug of the bear finally had its intended effect; the panther went limp. The bear dropped the dead panther and "wobbled" out of sight behind the rhododendrons. Jim Ownby followed. And there lay the bear, dead. The panther's claws had proved to be as deadly as the bear's embrace.

▶ ▶ *The deer population of the Great Smokies was down to an estimated thirty in the early 1930s, but with park protection, they multiplied greatly.*

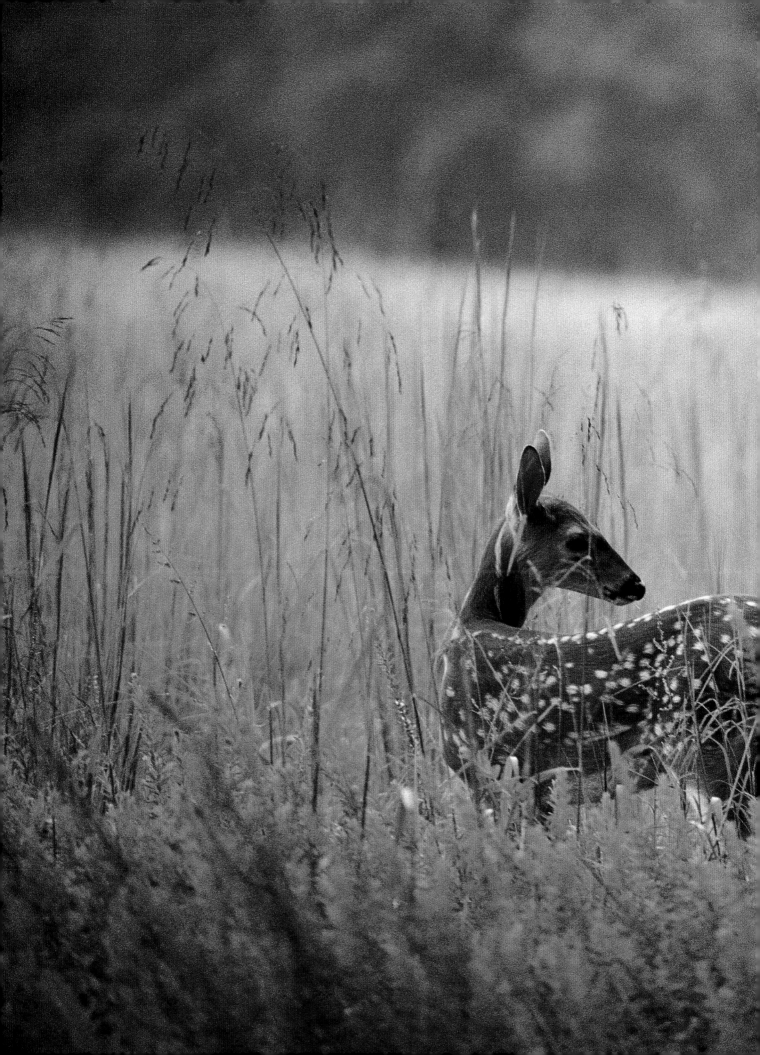

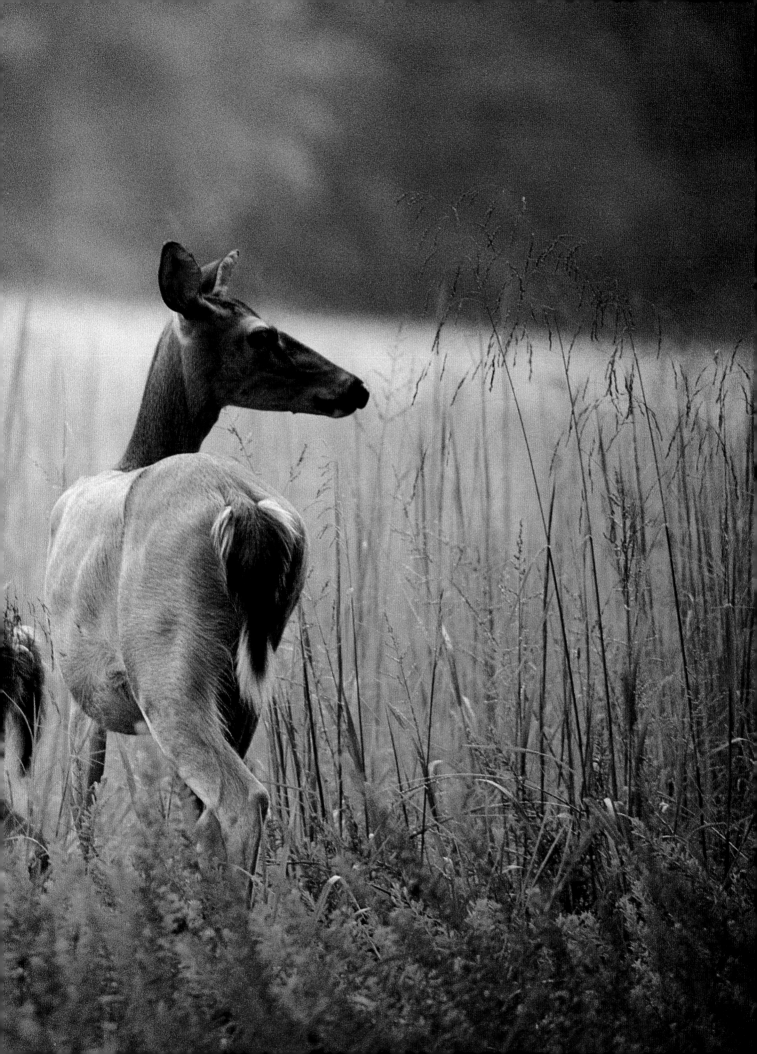

Jim Ownby carried home the skins of both animals, plus one of the bear's hindquarters.

Bears and poisonous snakes probably are the park creatures humans most fear. Of the park's twenty-three snake species, only copperheads and timber rattlers are poisonous. I have never heard of a confrontation between a bear and a snake. Neither has Mike Pelton. Nor has he seen evidence that bears eat snakes. But it would not surprise him to find that they do, since they eat nearly everything available.

I have heard two eye-witness accounts of fights between rattlers and other animals. In one of these, the snake lost its life to an aggressive bobcat. In the other, the rattler was the loser to a deer that jumped up the down on the snake with all four of its sharp hooves.

Cherokees once thought their relationship with bears was unlike that with other animals. In his *Myths of the Cherokee,* James Mooney said one of the myths was that bears were transformed Cherokees. The bears' chief was the White Bear who lived at Kuwa-hi (Mulberry Place), their name for one of the high places in the Great Smokies. The Cherokees said the bears congregate at bear town houses and hold dances every fall before retiring to their dens.

Later, bears and park visitors (non-Cherokees) seemed to think they, too, had a special relationship. It centered on food: visitors had it; bears wanted it. Against the warnings of park officials, visitors fed bears, even posed for pictures beside them. Bears quickly learned to associate food with people and with cars. They injured some people, broke into some cars.

Bears raided garbage cans at picnic areas and campgrounds and at pullouts along park roads. Many became nuisances, particularly along the transmountain road between Gatlinburg and Cherokee. Any bear that wandered into view of a motorist quickly caused a "bear jam," as more motorists stopped to look. Rangers carried pick handles to break up jams. A ranger would walk toward the bear, and if the animal did not flee into the forest, the ranger would bop him on the nose with the pick handle. Bears quickly learned to identify uniforms, or maybe they learned to

identify pick handles. Bear jams ended quickly after a ranger arrived.

There is no record of a bear killing a person in the park. But bears have injured numerous careless visitors.

Park officials, with a good deal of time and patience, have improved the bear-visitor relationship. They have educated visitors against being buddy-buddy with bears. The park also now uses bear-proof garbage cans. Park officials transfer problem bears to distant areas of the park, or to areas far outside the park. But they are trying to use this solution as little as possible, for they find that bears taken outside the park often are killed, one way or another.

But despite all precautions, a few bears still come to picnic areas, drawn by food scraps and greasy wrapping paper. In 1990, park workers had to move twenty-two problem bears from the Chimneys Picnic Area. Hoping to improve on that record, Kim Delozier decided to adopt a method Georgia officials had used to minimize bear raids on apiaries.

Concentrating on the Chimneys Picnic Area in 1991, Delozier made certain that every food scrap was picked up before bears came calling in early evening. He said the bears made only about sixty visits to the picnic area in the summer of 1991, and only two bears were considered pesky enough to be problems. Park workers tranquilized these, clipped identification tags to their ears, and tattooed their lips. Then they released the bears at the site of capture. Delozier said they ceased being problems. He thinks the experience of capture, tagging, and tattooing was so unpleasant that the bears preferred staying away from the scene.

Back when more emphasis was placed on moving problem bears, the most-traveled bear in park history was Bear 75. He broke into the Cable Mill in Cades Cove, possibly searching for corn, in July 1988. After a trip to the University of Tennessee Veterinary Hospital for treatment of a laceration, 75 was trucked to the Cataloochee area of the park, then released. Cataloochee is more than forty straight-line miles from the scene of 75's crime. Ten days later, someone

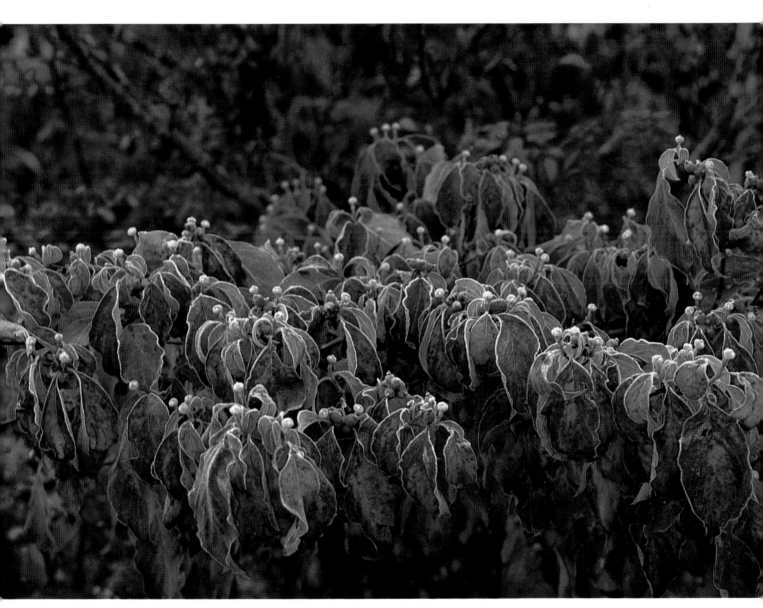

▲ The bright red berries produced by the dogwood tree are a welcome harvest to the myriad populations of birds that migrate through the park, as well as the many species that are year-round residents of this island of wilderness.

saw 75 traveling west across the lawn of Park Headquarters, more than halfway back to Cades Cove. Park people recaptured him, this time calling the Tennessee Wildlife Resources Agency. TWRA hauled 75 far south to the Ocoee Wildlife Management Area, near the Georgia border. The bear quickly headed back toward the Great Smokies and Cades Cove, some sixty straight-line miles, three river crossings, and many highway crossings to the northeast. A park employee spotted him in Cades Cove twenty-three days later. It is possible that he had returned earlier and stayed out of sight for a few days.

No TWRA people were available this time. So 75's captors took him back to Cataloochee. This was on September 1, near time for 75 to go into his feeding frenzy, after which would come his two or three months of dormancy. This probably explains why he was not seen back in Cades Cove until June 23, 1989. Again, he was taken to Ocoee. He was seen back in Cades Cove twenty-nine days later. TWRA this time moved him north to a release area in Sullivan County, near the Virginia border. He soon was traveling south toward the Great Smokies. Within less than two weeks, someone in Johnson City told TWRA that a bear was traveling through the city. TWRA picked up 75 again, this time releasing him in Carter County, Tennessee, on August 4. Another feeding frenzy and another dormancy period passed before 75 was spotted again, this time on May 11, 1990, in—of course—Cades Cove.

This time, 75 was taken for a long ride, about four hundred miles, to the George Washington National Forest, in Virginia. Delozier said he was told 75 headed south the instant his feet touched the ground. Virginia wildlife workers recaptured him a month later in Pearisburg, Virginia. He had a neck wound, apparently made by a bullet. They took him back to the national forest.

A Roanoke humane officer, more accustomed to dealing with dogs and cats, captured 75 in that city in the middle of June. The bear was released in nearby mountains.

The next time Delozier heard of the traveling bear was when TWRA officers captured him again back in Tennessee, in Johnson City. He was traveling south, toward the Great Smokies. TWRA relocated him in Carter County. He traveled south again.

Delozier received one more call on 75. Three days after he was released in Carter County, 75 was found dead in Unicoi County, first county southwest of Carter. A poacher had shot him. A $1,250 reward for information leading to the arrest of the killer remains unclaimed.

The death of 75 came nine days short of two years after he broke into the grist mill. Delozier estimates that the bear's travels back toward his home covered about fifteen hundred straight-line miles. But neither bears nor humans travel in straight lines in the rugged hills of the Southern Appalachians. His actual mileage was far greater. And keep in mind that he had to take time out of his travels to forage for food and find crossings for rivers and highways; he also had to spend four or five months in his two winters of dormancy.

In his various encounters with humans, 75 never harmed anyone. He easily could have, for he was of above-average size for Great Smokies male bears. His captors weighed him once, and he tipped the scale at 367 pounds.

Nearly all of my encounters with bears in the Great Smokies backcountry have been pleasant. Backcountry bears usually run when they see humans. But there was an exception. I was hiking alone on the Appalachian Trail, between Pecks Corner and Tricorner Knob, when I came upon a bear and three cubs. She had two of her cubs on the same side of the trail with her, but the third was on the opposite side of the trail. I waited until she got the third one with her, but then she sent all three up a tree close to the trail. Though I felt uneasy, I walked on past them.

I had gone no more than ten or fifteen yards when I heard mama coming after me. She was popping her teeth and breathing in angry snorts. I knew I could not outrun her. I had no ranger's pick handle, but I carried a strong hickory hiking staff about five feet long. I suddenly turned and ran *toward* her, yelling at the top of my lungs and waving the stick. We were closing fast when she turned and went back to her cubs. I turned and walked very fast in the opposite direction.

▶ *Dogwoods and tulip trees are reflected in the windows of an old pioneer cabin. The National Park Service maintains this cabin along with others.*

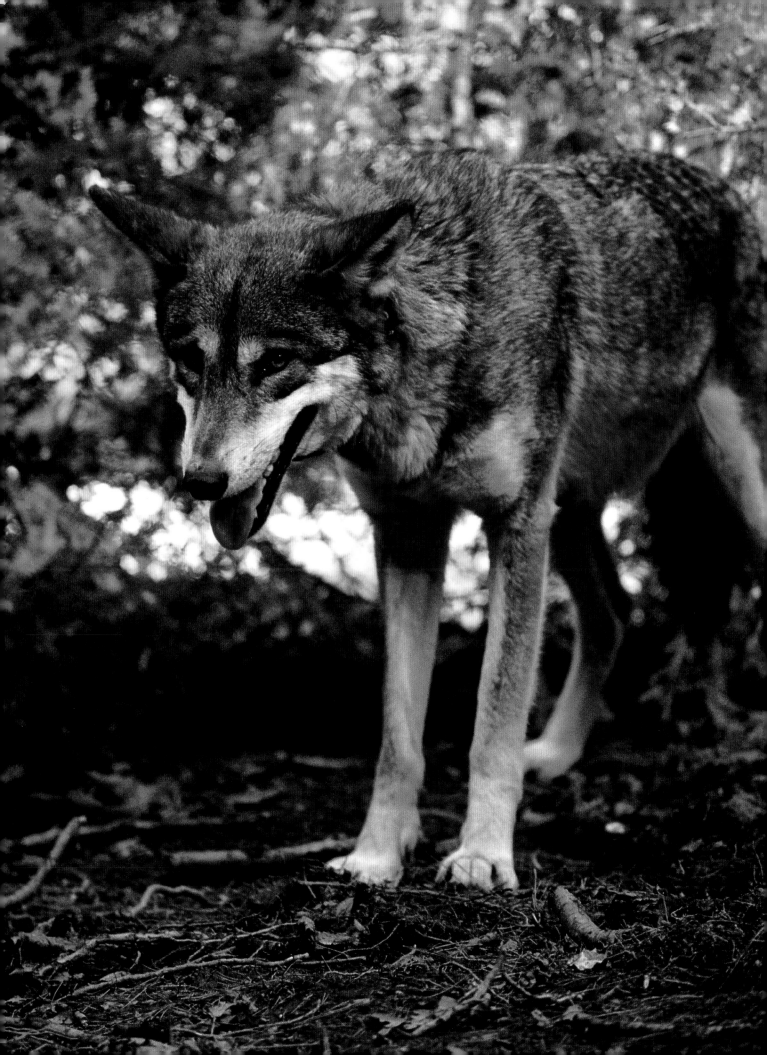

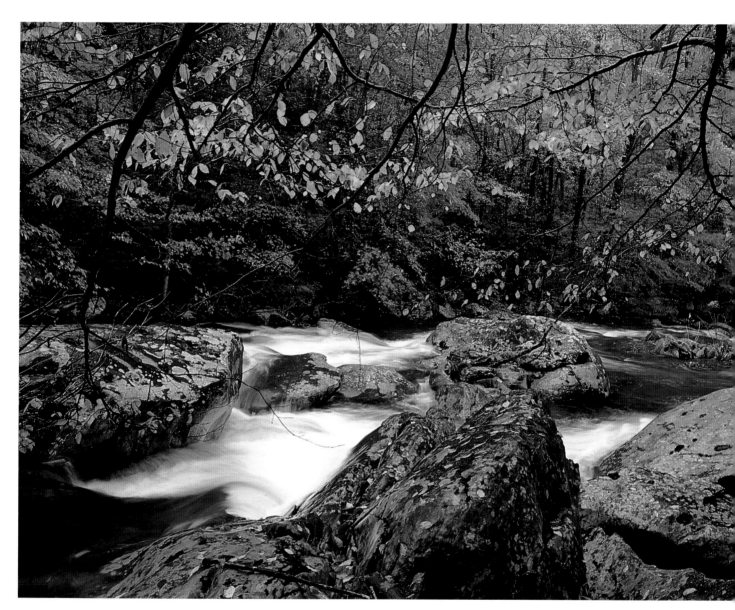

◄ The first adult male red wolf released in the park preferred domestic poultry to wild prey, so he and his family were removed. Two other wolf families killed a sixty-pound wild boar, a park pest that requires constant effort to control.
▲ Deep Creek, near Bryson City, draws hikers and campers. The vicinity is the starting point for hikes on the south slopes of the mountains. Some three hundred thousand campers use the park's developed campgrounds annually, with nearly another hundred thousand camping in the backcountry.

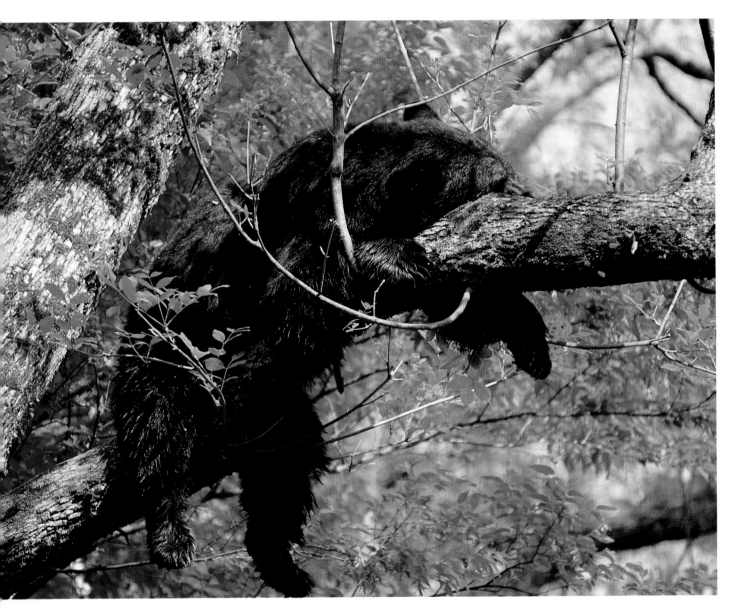

▲ Though bears go in the park's rivers and streams, there is no evidence that bears catch fish here. Apparently, they just like to refresh themselves on a hot day. This female bear walked out of Rabbit Creek and climbed a tree to dry.

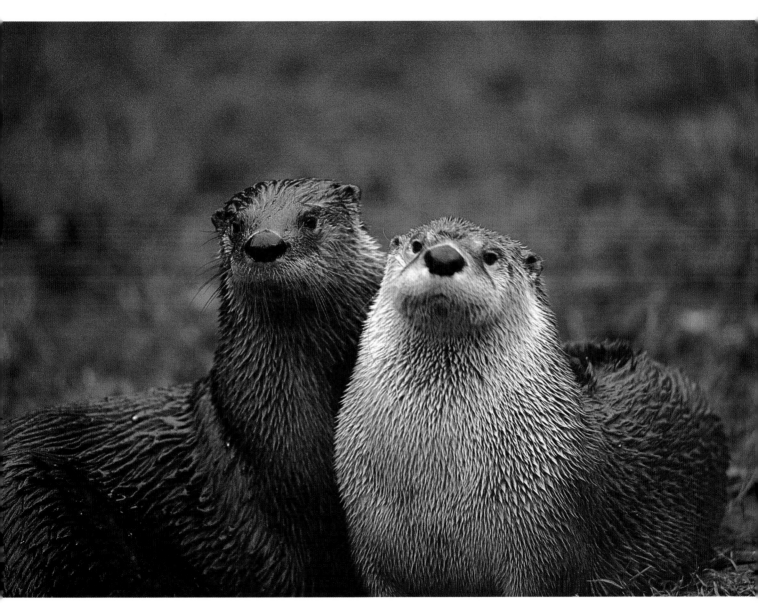

▲ River otters are natives of the Great Smokies, but the last one of the original population was killed in the 1920s. Otters were successfully reintroduced to the park in the 1980s, and the number of otters may now reach into the fifties.

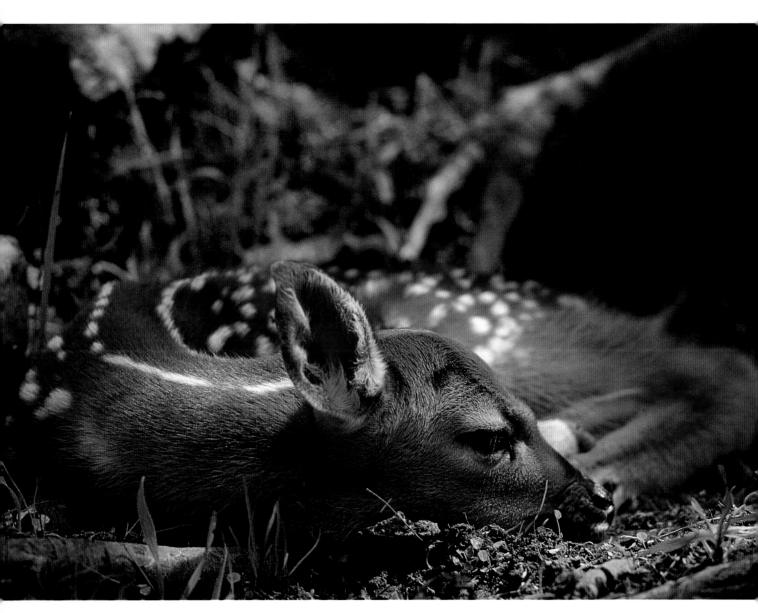

▲ Deer, ruffed grouse, and other creatures may try to lure predators away from their young. A ruffed grouse mother may will feign a broken wing and run along the ground, hoping a fox will follow her away from her young. A mother deer will try similar tricks to lure danger away from her fawn. Ruses like these can make the young, such as this fawn, especially hard to spot.

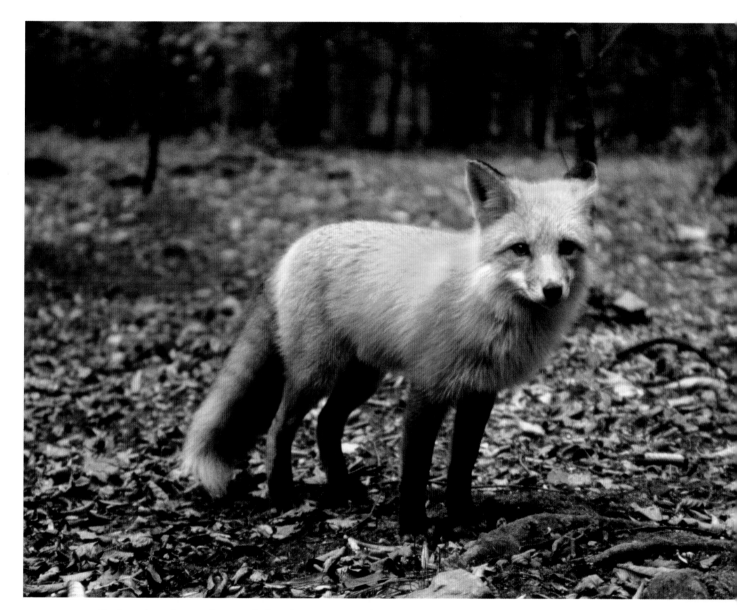

▲ Both red and gray foxes inhabit the Great Smokies. This is a red one. Grays also have some reddish hair, but it is blended with gray. Reds have white tips on their tails; grays have black tips. Grays climb trees; reds do not. Both eat a wide variety of food, ranging from crickets to rabbits and fruit.

► ► Grasses and tree leaves comprise much of a deer's diet. Many animals, including deer, also count acorns an important part of their diet in the fall.

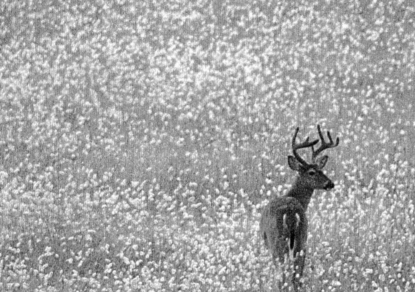

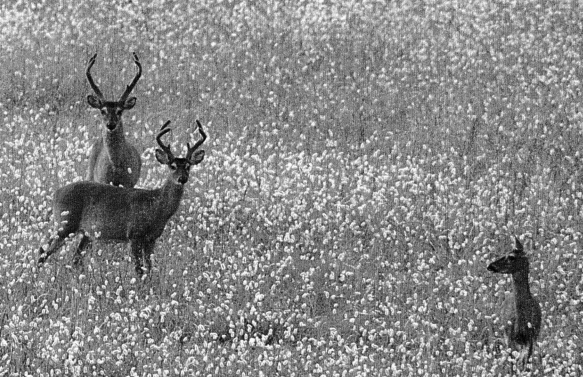

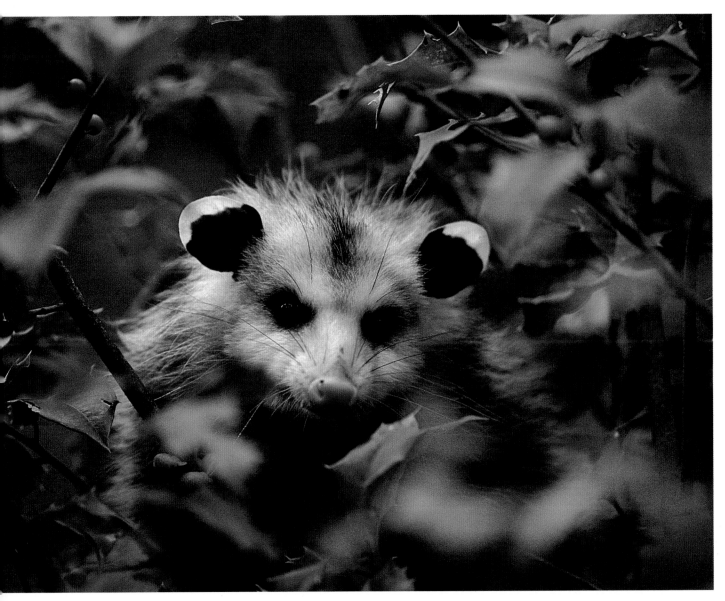

▲ Opossums are more often associated with persimmons, which they prize, rather than with holly berries. This one may want refuge, not food. The opossum, North America's only marsupial, is common in the Great Smokies.
▶ Indian paintbrush is rare in the park and is found mostly in the Balsam Mountain area. The color is in the plant's top leaves, not in its tiny flowers.
▶ ▶ Early settlers felt they had found their utopia in Cades Cove. They grew a variety of crops: flax, cotton, corn, tobacco, vegetables, peaches, and apples.

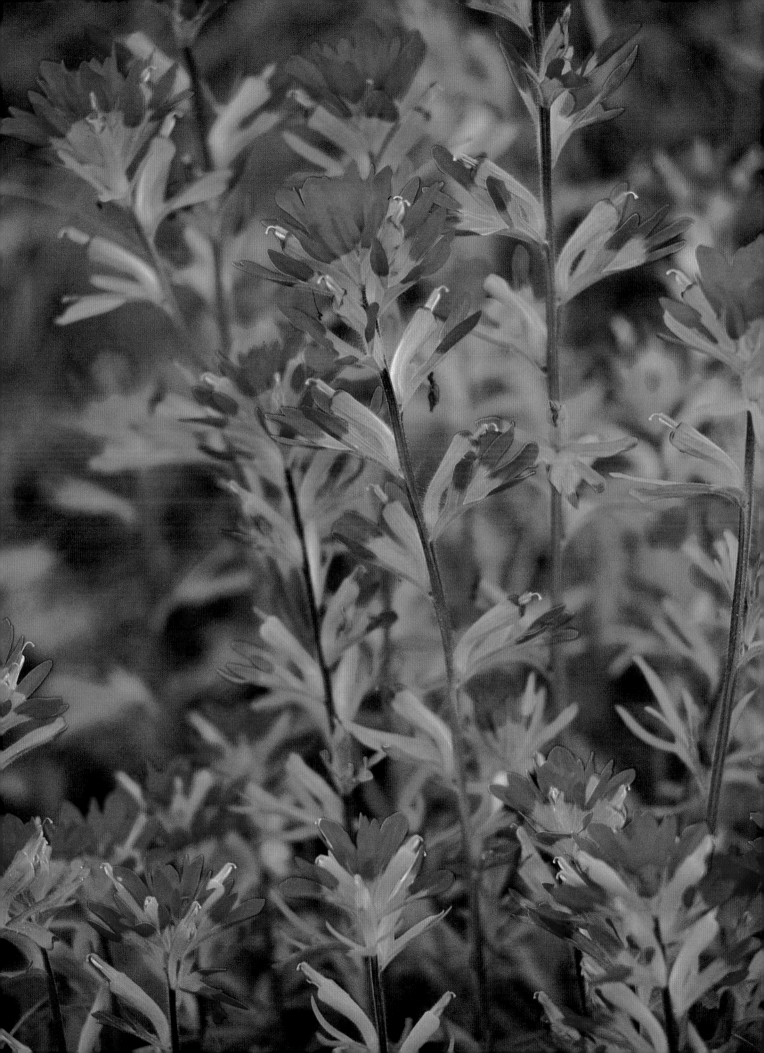

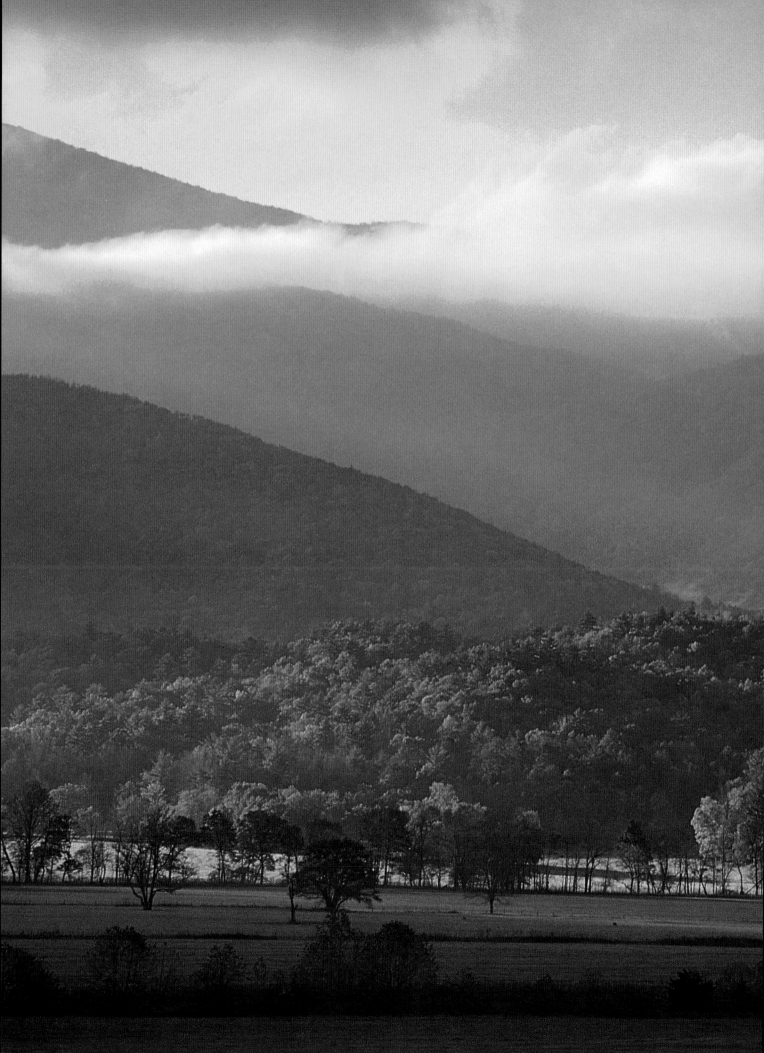

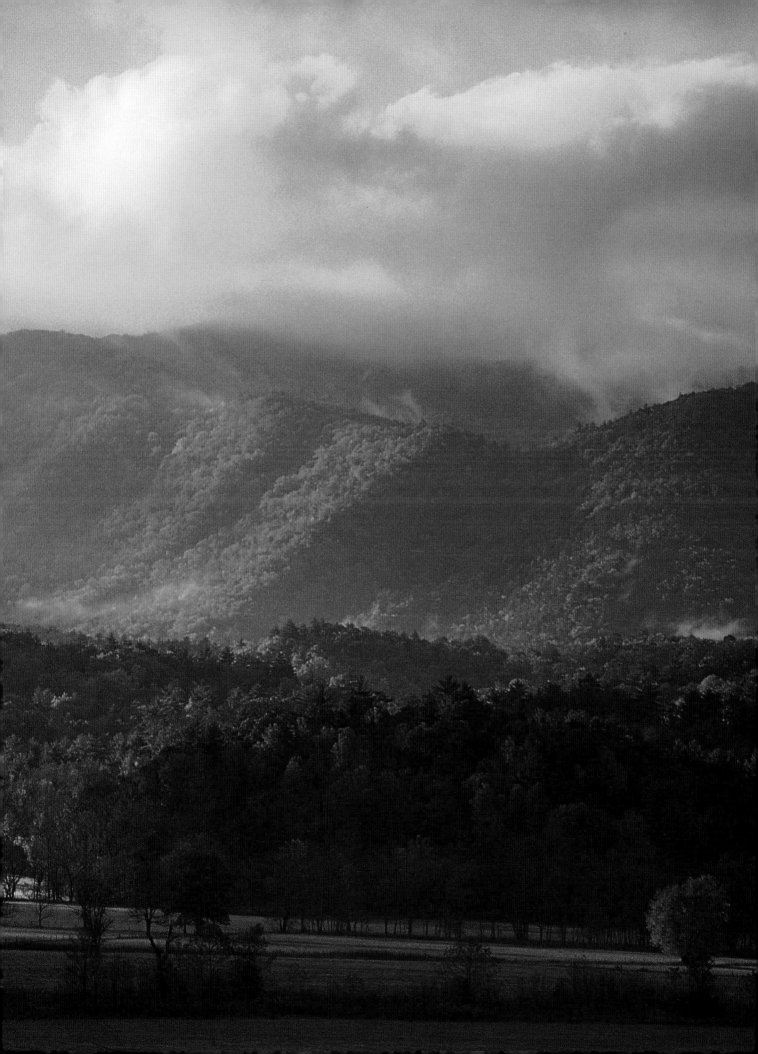

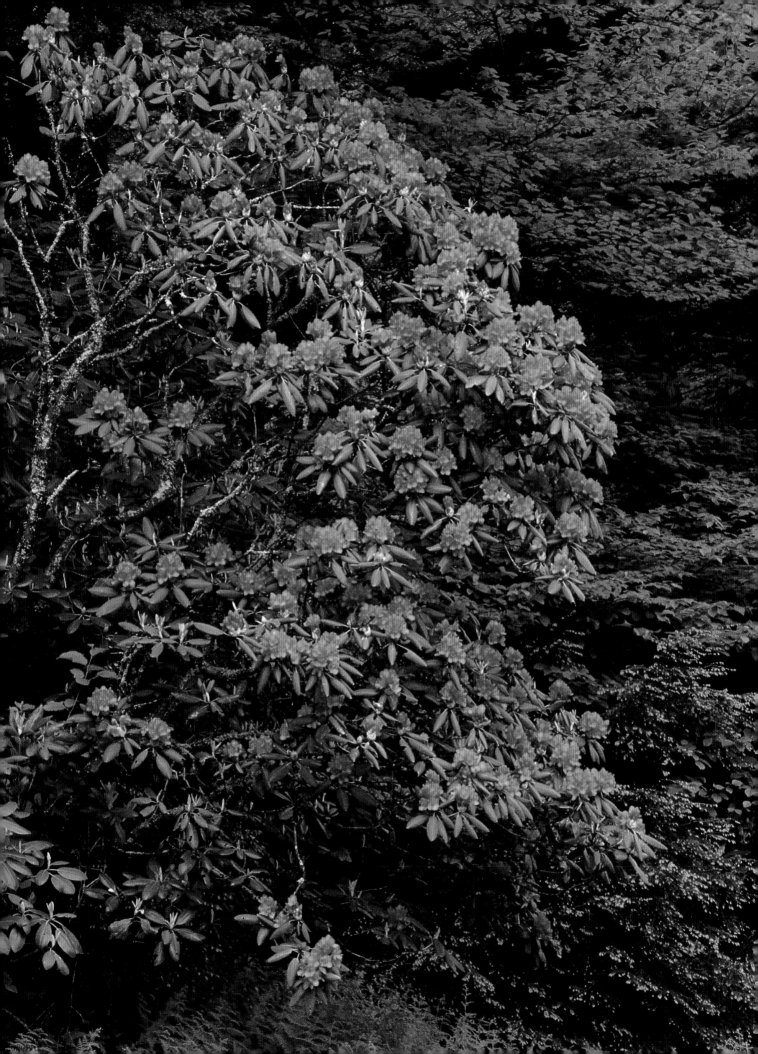

◄ From mid to high elevations in the Great Smokies, among the loveliest blooms are the Catawba rhododendron. Dwarf rhododendron and white rhododendron also grow in the park. The Catawba blooms in June and July.
▲ A male goldfinch, brilliant in his breeding colors, sits in a rhododendron bush. These little birds flock together, apparently bent on nothing more than having a good time. Not until mid or late summer do they get around to building nests and rearing young. They line their nests with thistledown.

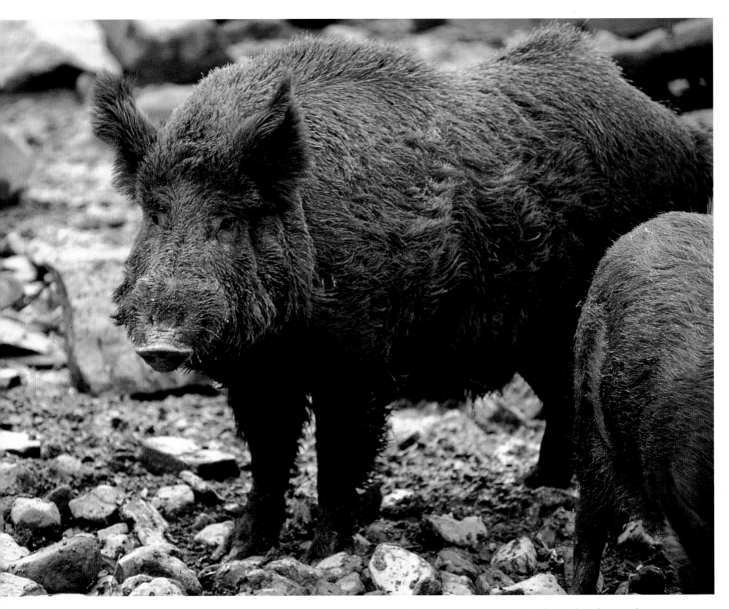

▲ The European wild boar wallows in streams, which degrades the quality of the water. It also roots up vegetation and has done extensive damage to plantlife. This exotic pest has been in the park since the early 1950s.
▶ Roaring Fork races down the north slope of Mount Le Conte, as it heads for Gatlinburg to join West Prong of Little Pigeon. Several families once lived along lower Roaring Fork, and nine structures still stand as historical exhibits.

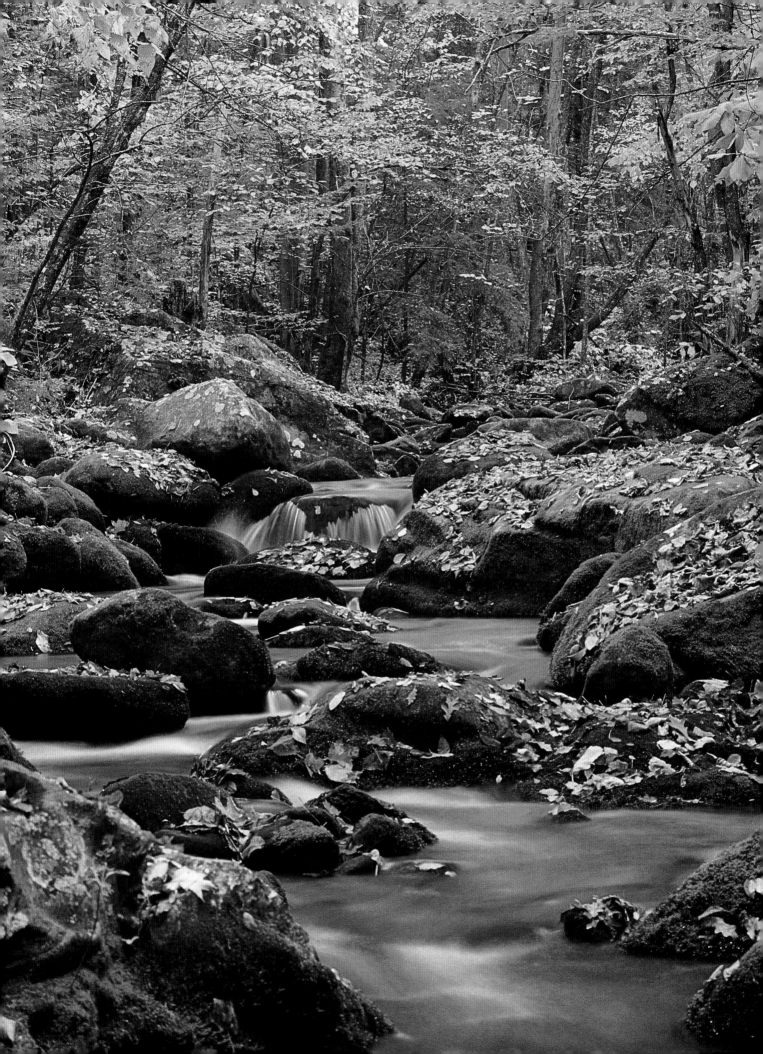

◄ The groundhog supposedly comes out of hibernation on Groundhog Day, February 2. If he sees his shadow, there will be six more weeks of winter. He is also known as the woodchuck. He dines on grasses and other vegetation.
▲ The park is home to two kinds of skunks, the spotted skunk and the striped skunk. This apparently is a variation of the striped skunk, though it has more white than is typical. This fellow lives near Kephart Shelter, in North Carolina.

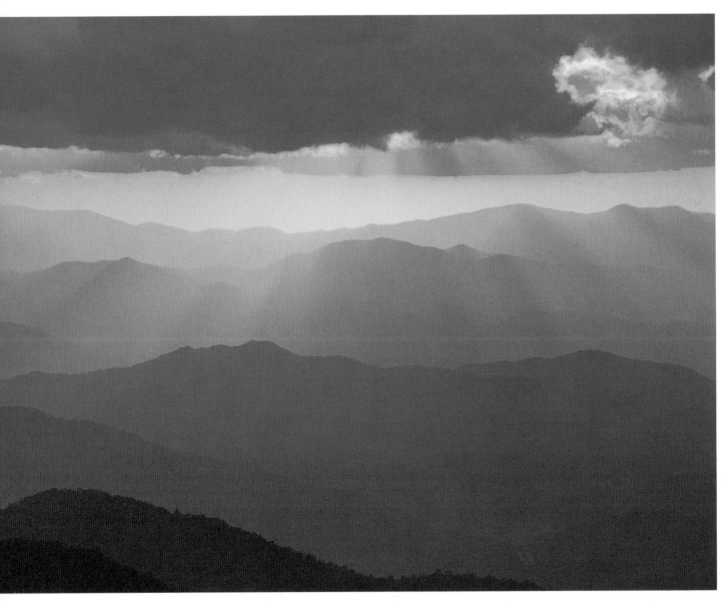

▲ Where do mountains end and clouds begin? The highest point in the Smokies is Clingmans Dome, at 6,643 feet; the lowest, the mouth of Abrams Creek, at 840 feet. The view looking south, from near Silers Bald on the Appalachian Trail, seems to go on forever, with mountains sliding into mist changing back to mountains, becoming backlit clouds turning to brilliant sky.

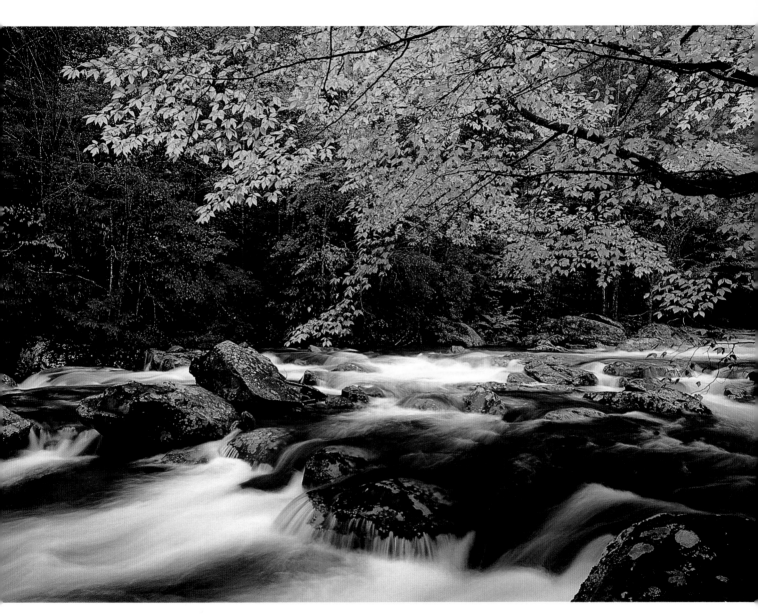

▲ Middle Prong of Little Pigeon River, carries water from Ramsey Prong, Buck Fork, and Porters Creek, draining much of the northern Smokies, from Mount Kephart and Boulevard Ridge to Mount Guyot and Greenbrier Pinnacle.

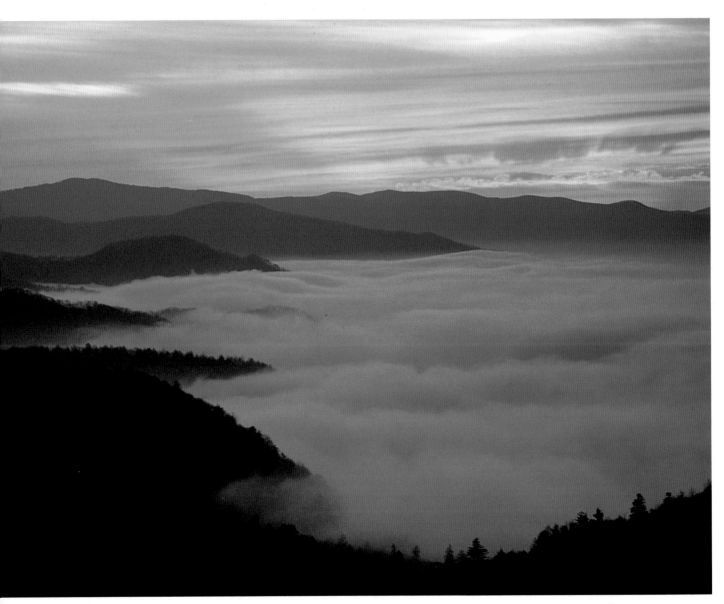

▲ Clouds, like an ocean of smoke, show how the Smokies got their name.
► The rising sun puts golden light on stones and pool below Spruce Flats
Falls. Spruce Flats Branch enters Middle Prong of Little River near Tremont.
Above this waterfall, in the small watershed of Spruce Flats Branch, Little
River Lumber Company did the last logging in the park in the late 1930s.
► ► Crimson bee balm lends a spot of brilliant color to a Balsam Mountain
ridge. Nearly sixteen hundred species of wildflowers are found in the park.

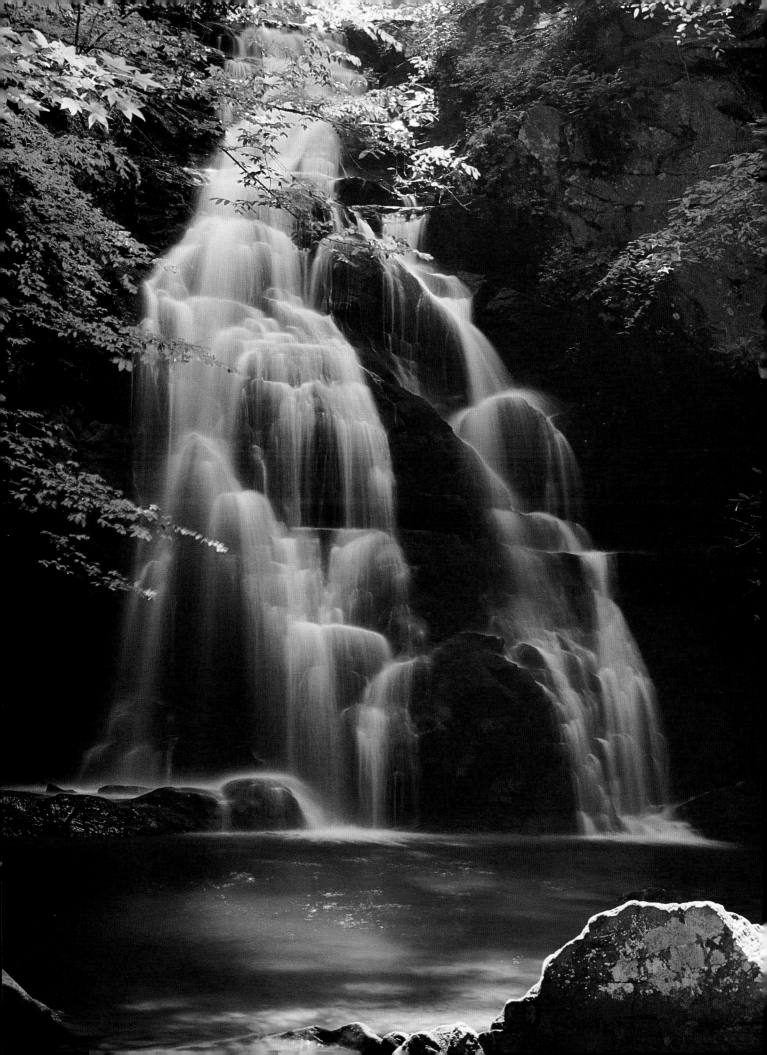

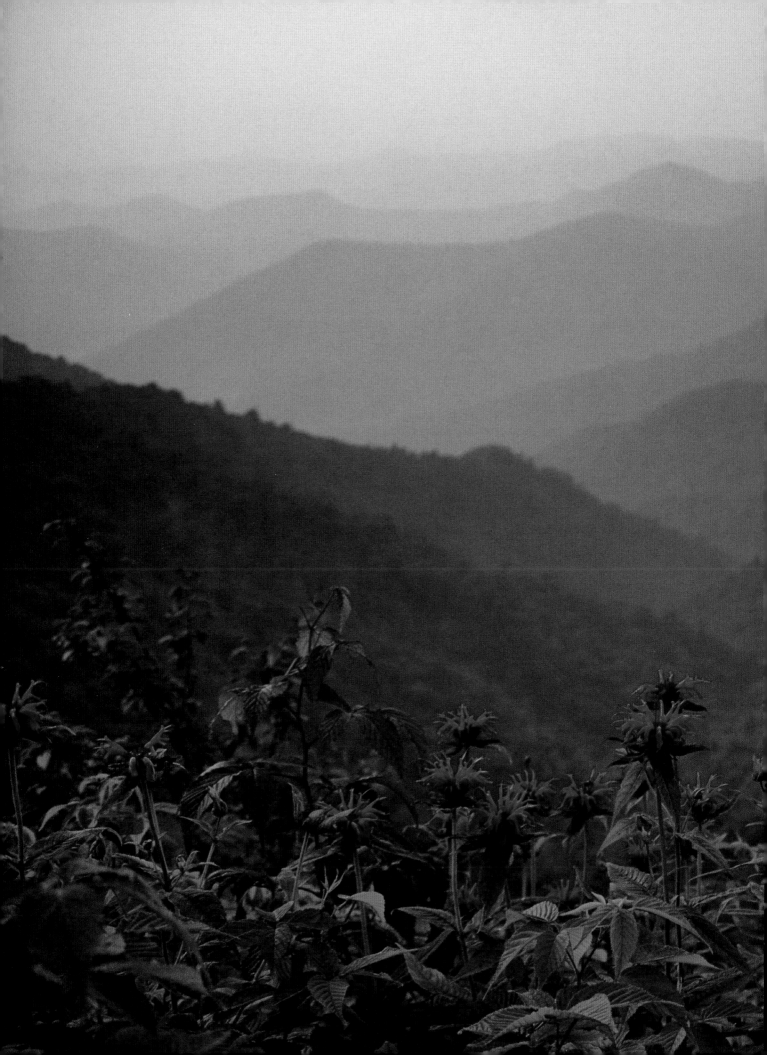

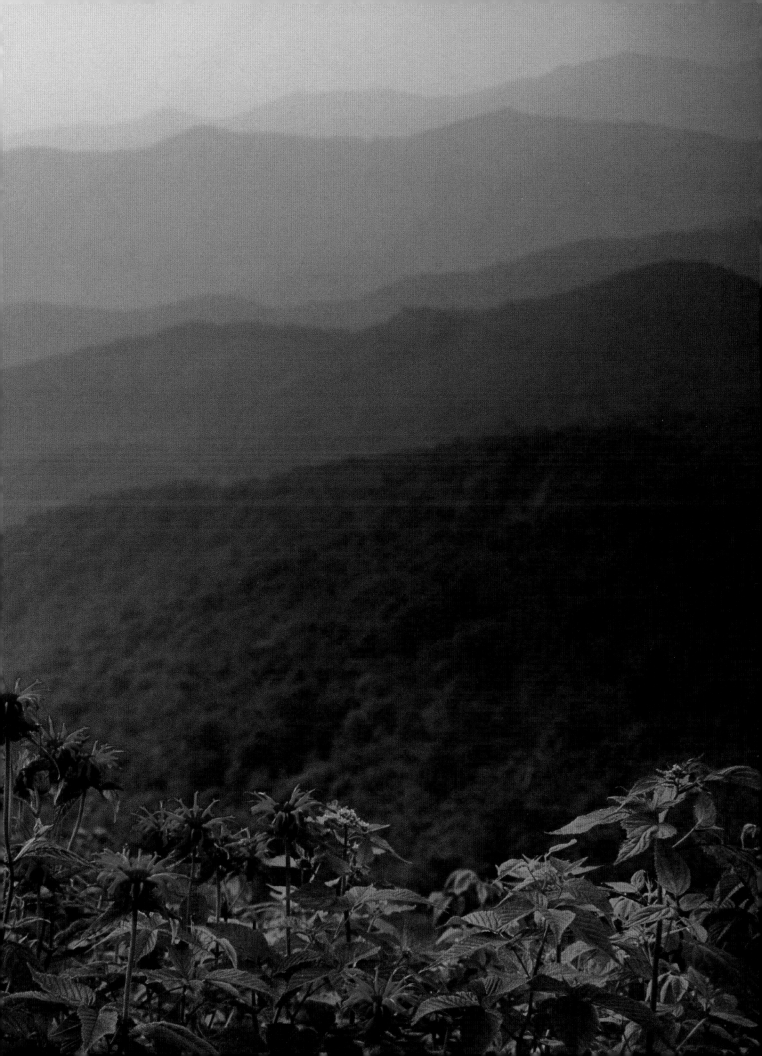

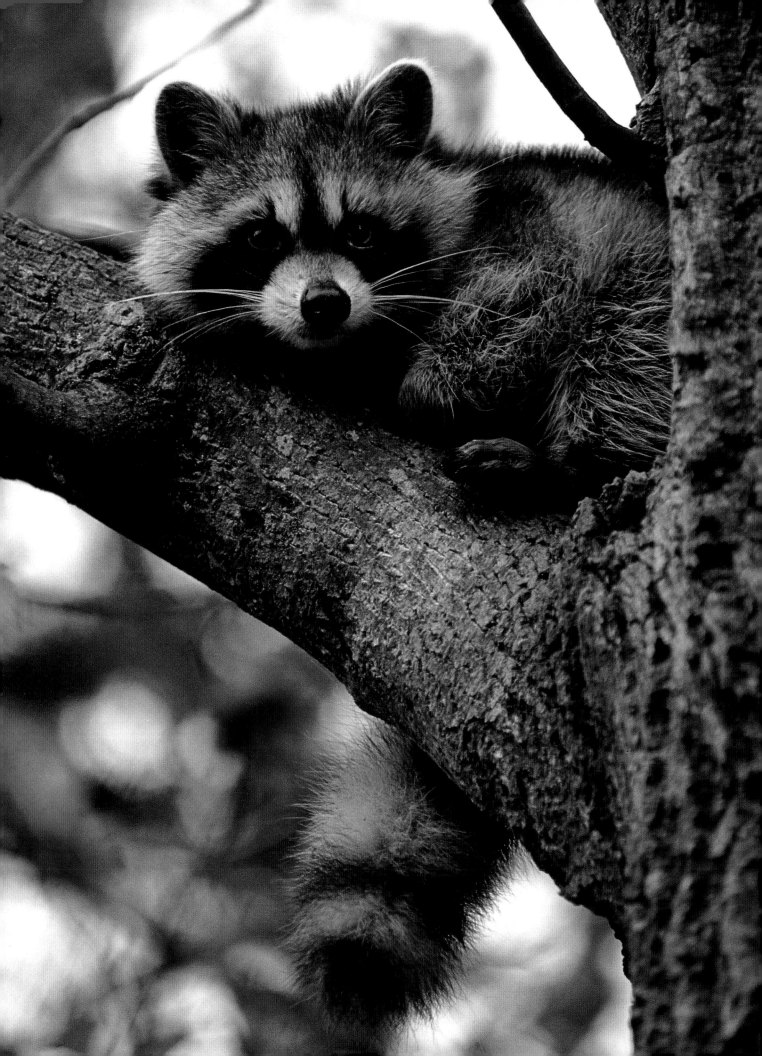

◄ A raccoon's diet is almost as varied as a human's. Salamanders, birds' eggs, crayfish, fruits, berries, and beech seeds—among other things—are examples.

▲ Low-growing foliage along the Trillium Gap Trail wears autumn colors, just as do the forest giants. Roaring Fork plunges down about fifteen feet onto the trail at Grotto Falls. Hikers can walk behind the falls and keep dry.

► ► Blue phlox blooms above white fringed phacelia on the Cove Hardwood Nature Trail, out of the Chimneys Picnic Area, just off Newfound Gap Road.

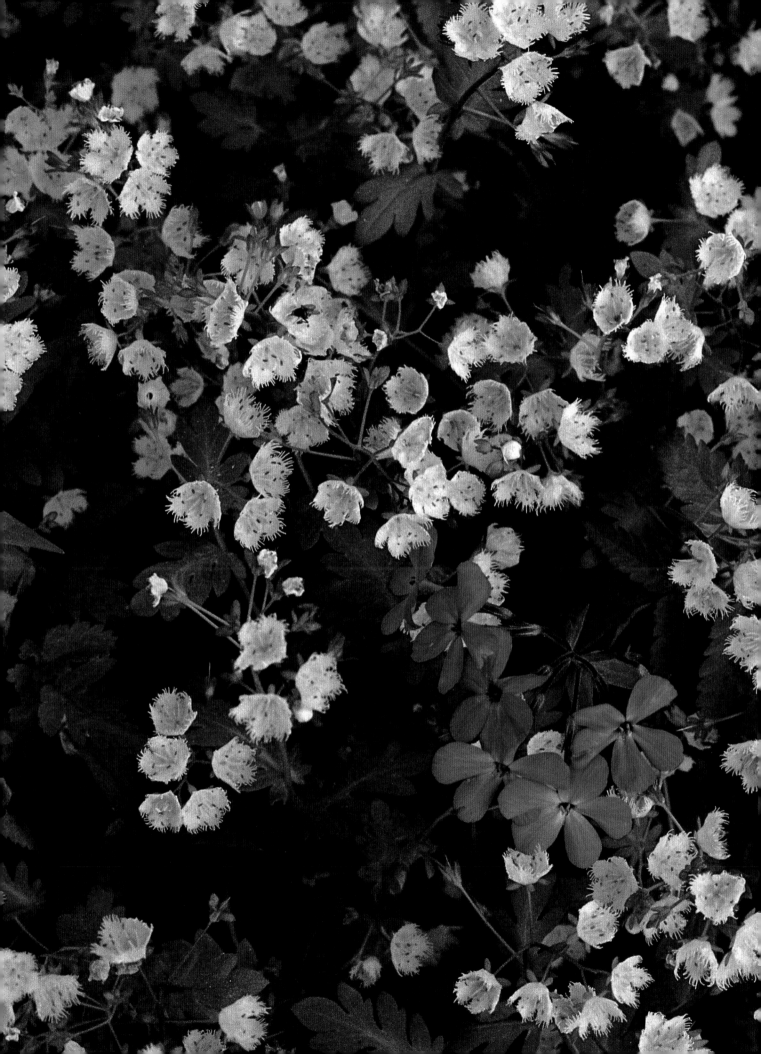

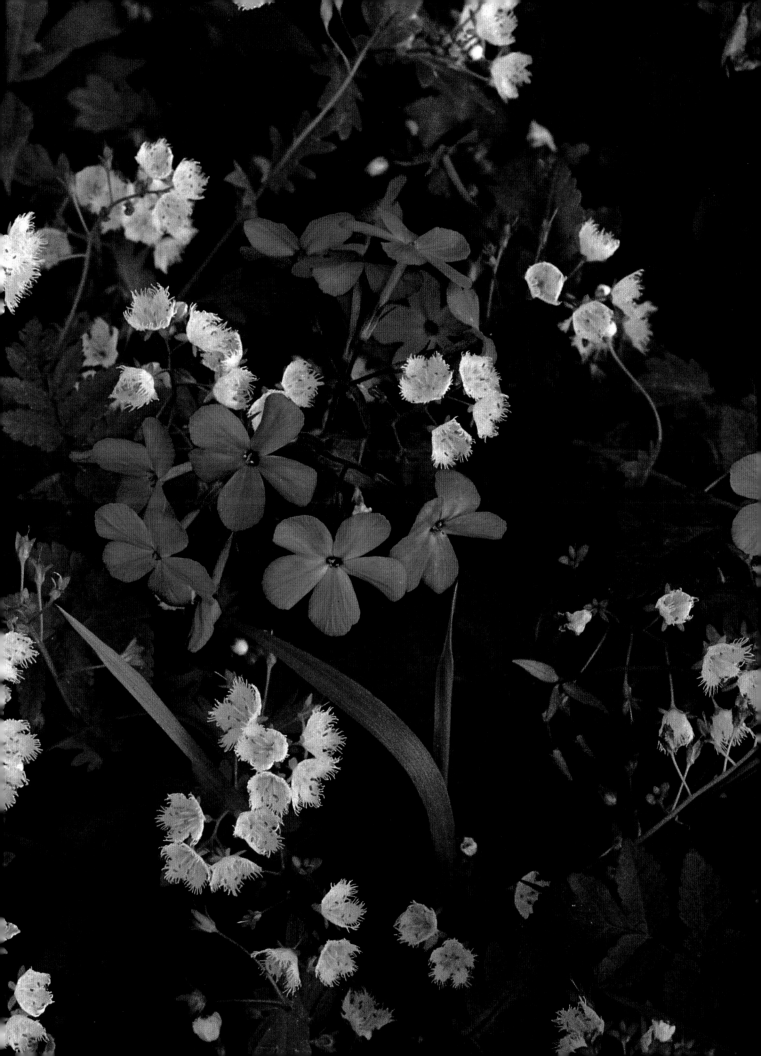

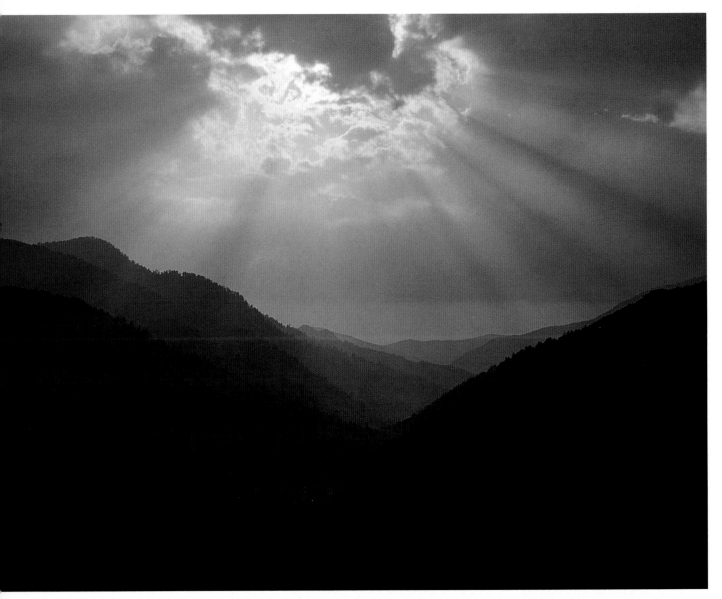

▲ The valley of the West Prong of the Little Pigeon demonstrates the fog and mountain ridges for which the Great Smokies are famous. The Little Pigeon runs through Gatlinburg and is one of the sources of water for the community. Heavy rains have caused soil to slide off some of the steep ridges.
▶ When leaves drop, most lie where they fall, but some land in streams and get long rides before they sink or lodge between rocks. Water in the Smokies tends to be acidic partly because of numerous leaves decaying in the streams.

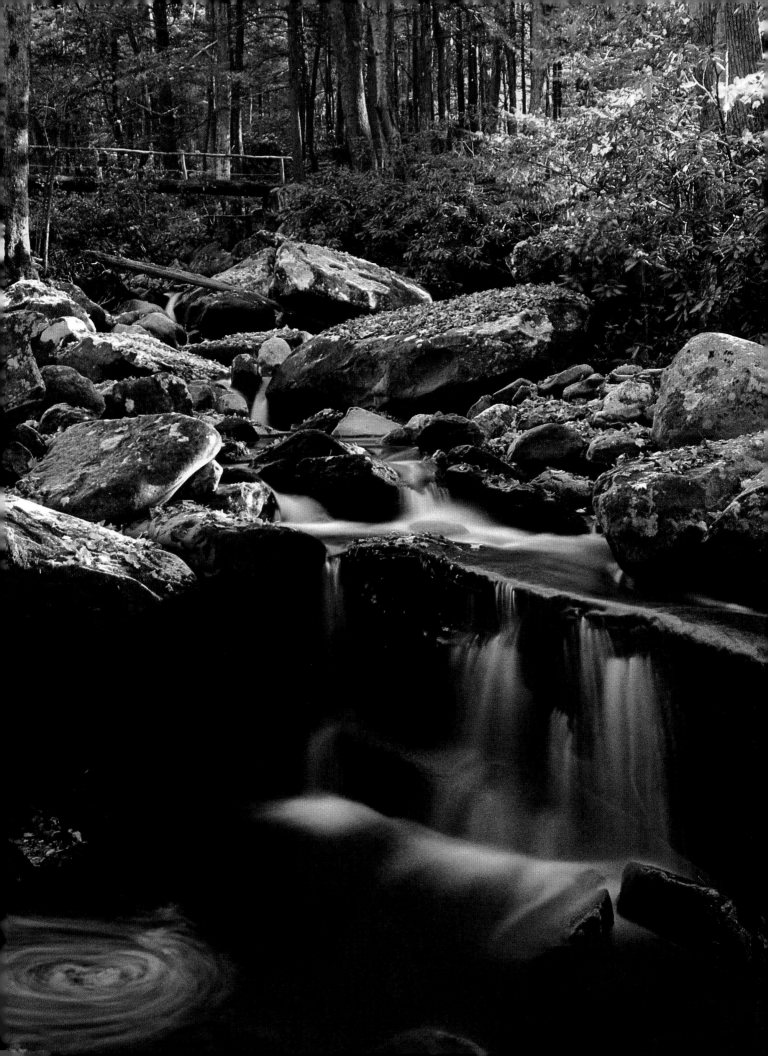

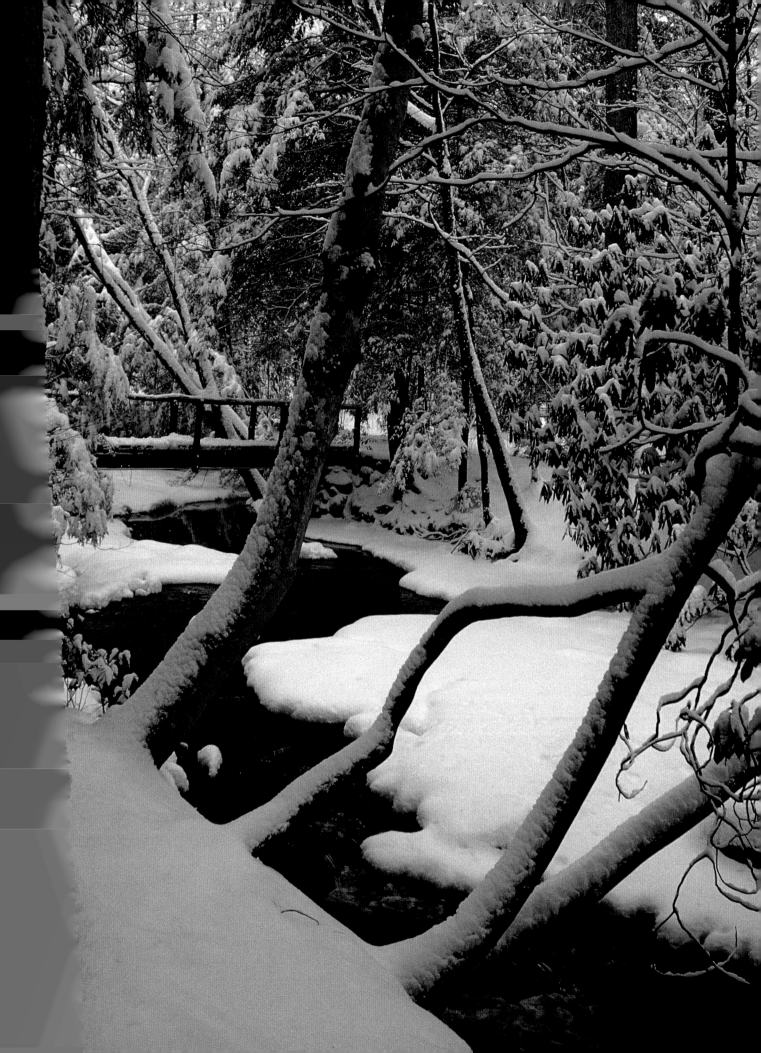

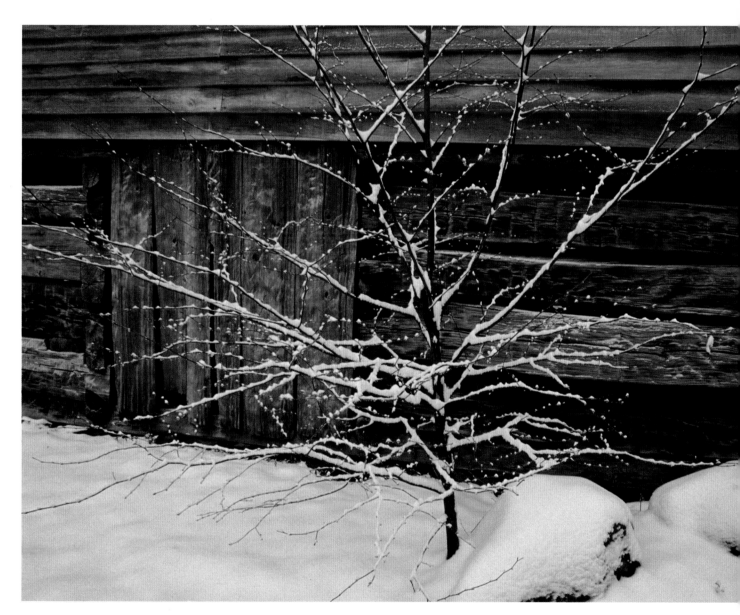

◄ Fighting Creek wanders behind Sugarlands Visitor Center. Near the Center, the half-mile Sugarlands Nature Trail crosses the stream on the footbridge.
▲ Noah Ogle, known as Bud, moved to the Great Smoky Mountains in 1879. It is presumed that he built his cabin the following year, and this barn probably around the same time. Adz marks are still visible on some of the hewn logs.

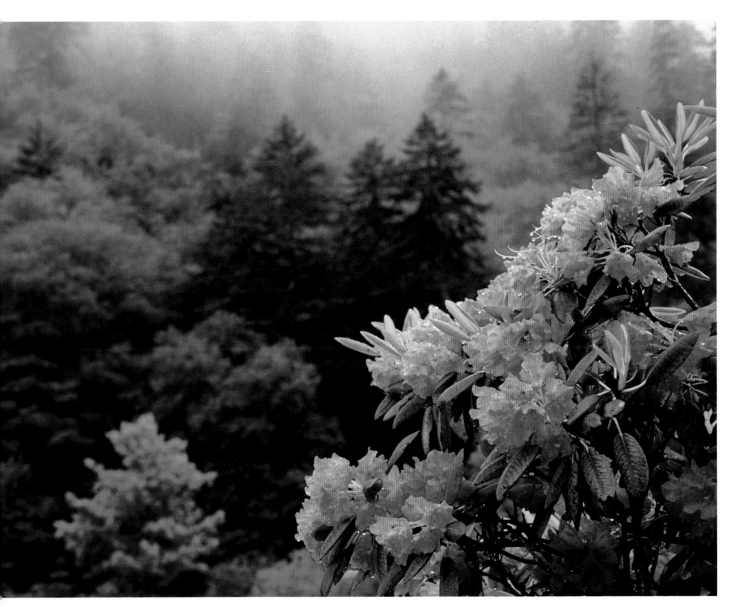

▲ Hikers on the Appalachian Trail in June are treated to bursts of color such as this Catawba rhododendron between Mollies Ridge and Doe Knob. The 2,147-mile Appalachian Trail, which runs from Maine to Georgia, reaches its highest elevation at 6,643-foot Clingmans Dome, in the Smoky Mountains.
▶ A May snowfall on Mount Le Conte contrasts with spring green on the lower ridges. In pre-park days, cattle on the balds sometimes died in late snow and bitter cold. Summer lightning and wild animals also killed sheep and cattle.

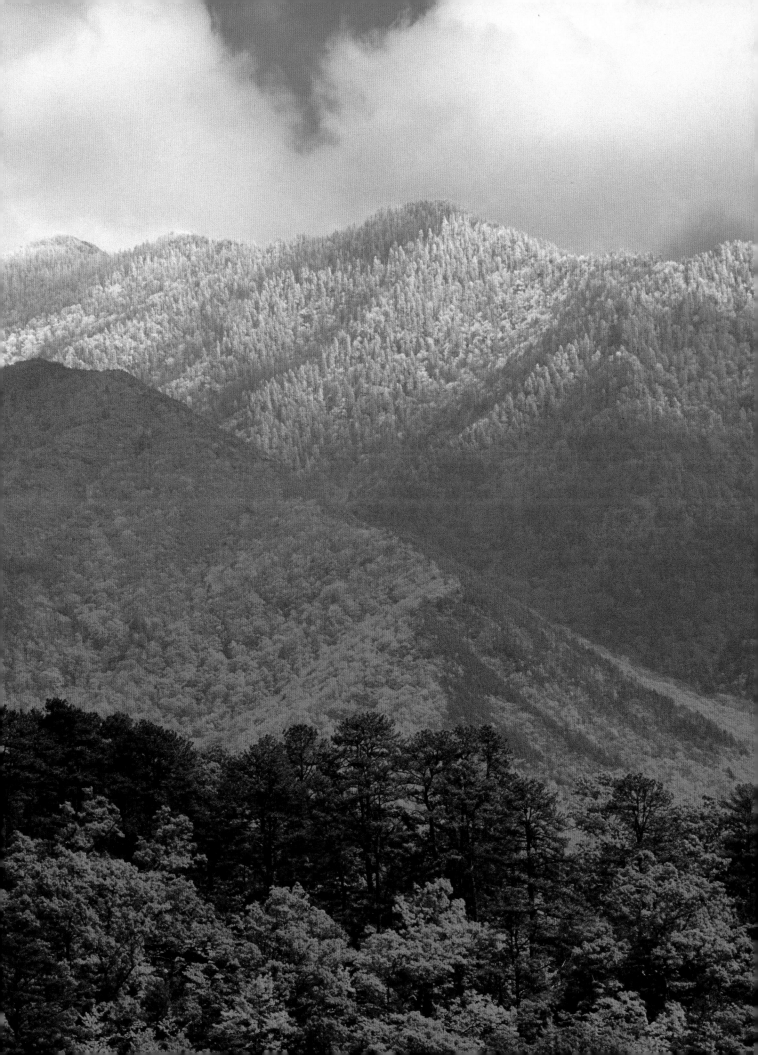

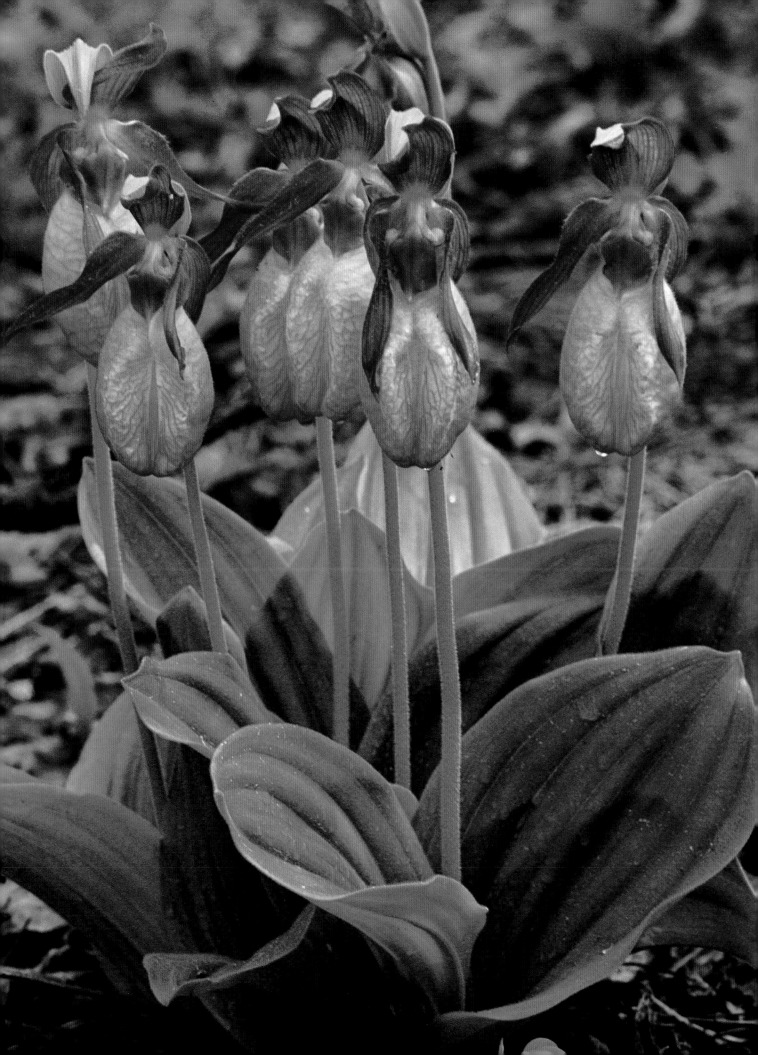

As a bear is covered with hair, so is Great Smoky Mountains National Park covered with vegetation. Nearly 98 percent of the park is clothed in one of the finest forests in the world's temperate zones.

A total of 142 species of trees grows in the park's 520 thousand acres, more than any other park in North America. The next highest number is in a Southern Appalachian park, Shenandoah, which has 129. Yellowstone, four times larger than the Smokies, has only 20 tree species.

Most of the park not covered with trees is covered with grass, grape thickets, and heath balds. There are a few acres of highways, building sites, and water courses. A small percentage of the park is bare rock. Down the north side of the mountain from Newfound Gap to Gatlinburg are several knife-edged bare-rock ridges left that way by landslides. More bare rock can be found on Mount Le Conte's Myrtle Point and Cliff Top, at Alum Cave Bluff, Charlies Bunion, the Jumpoff, and the Chimney Tops.

There are nearly 1,600 flowering plants in the park, plus 2,250 species of fungi, 284 of mosses, 305 of lichens, and 150 of liverworts.

Why are these eight hundred square miles favored with such generous plant diversity?

Abundant rainfall is one reason. Nowhere in America except the Pacific Northwest is there more rainfall than in the Great Smokies high country and the neighboring mountains. Normal annual rainfall at Clingmans Dome is more than eighty-two inches. Rainfall at the Dome and other high places in the park sometimes exceeds one hundred inches.

Another reason is range of altitude and range of temperature. The highest place in the park is Clingmans Dome, at 6,643 feet. The lowest is nearly thirty miles away at the mouth of Abrams Creek, at 840 feet—a difference of 5,803 feet. The temperature drops about four degrees for each one-thousand-foot gain in altitude, which means it is about twenty-three degrees cooler on the Dome than it is where Abrams Creek joins Chilhowee Lake at the park boundary.

Mount Le Conte, at 6,593 feet, is the third-highest peak in the park. But Le Conte fans claim

it is the "tallest" mountain in the Smokies. It rises more than a mile from its base in Gatlinburg, which is about 1,300 feet above sea level, over a straight-line distance of some 6.5 miles. Since records have been kept, the temperature has not reached eighty degrees at Le Conte.

Because of the low temperatures in the high country, some of the same species of trees grow there that grow a thousand miles northward in Canada.

The third reason for the wide range of plant diversity is the area's climatic history. Although this region was much cooler ten thousand years ago, it was not covered with glacial ice, which wiped out vegetation in the country's northern portion. The cold pushed plants southward into this region. Some stayed after the ice receded because the climate of the high Smokies is to their liking. Examples are the Fraser fir, mountain ash, and red spruce. A fourth example is the heartleaf paper birch, an oddity in the park. It was first discovered in the 1970s, north of Dry Sluice Gap, in the headwaters of Porters Creek, the route taken by the brothers Whaley when they came into Tennessee. Fewer than a half-dozen paper birches were first discovered, but Keith Langdon says more than a hundred are in the area and are reproducing. They are hundreds of miles from others of their kind, in New Jersey and Pennsylvania. The Great Smokies are a meeting place of the conventional red maple, with five-lobed leaves, and the red maple of the coastal plain, with three lobes. The latter grows mostly in Cades Cove, while the park's other red maples are the conventional variety.

The park's exceptional forest diversity contributes to the length and loveliness of the autumn color season. Dogwoods, with pink-red leaves, are among the first to change color, in late August and September. Another early turner is hobble-bush, or witch-hobble, whose big leaves turn orange, yellow, and dark wine. Hobblebush lies along high-country trails. Yellow birch usually provides its golden yellow at mid-elevations during the middle two weeks of October.

Sourwood leaves turn a rich red sometime in late September or October (when beekeepers

◄ *The pink lady's-slipper, a wild orchid, likes acid soil. It grows under oaks and pines and blooms in late April or May. The Bull Head Trail is a good area.*

start selling sourwood honey). Sugar maple and red maple leaves turn red, yellow, and orange in October. Along streams, sweet gums turn every hue from lemon to licorice. Hickories and tulip trees provide good yellows. Stands of tulip trees fifty to sixty years old grow in once-cultivated areas in the lower elevations. These taper to tips and, when the afternoon sun strikes them, they look like candle flames.

Black gum leaves turn glossy red. Sassafras leaves reach a gingery orange. The many oak species provide variations of yellow and red. White oaks and scarlet oaks provide the best oak colors. White oaks are soft russet. Scarlet oaks wind up the season, usually in November, in glittering brick-red.

Where are good places to see this splendor?

For motorists, nothing beats a drive on the one-way, eleven-mile Cades Cove Loop Road, looking up at the surrounding mountains. A problem is that hundreds of others may have the same idea, and some may not want to move as fast as you do. An option many favor is a long-range look from the Foothills Parkway. Enter it from US-321 near Walland and follow it up over Chilhowee Mountain, then down to Chilhowee Lake. For those who would rather walk, take the 11.5-mile, round-trip hike from Davenport Gap to Mount Cammerer. The view from Cammerer is in every direction, with lots of leaves on the slopes. Another good one for the second half of October is the seven-mile hike from the top of Mount Le Conte down the Bullhead Trail to Cherokee Orchard. (Of course, you have to hike to the top before you can come down. Try going from Cherokee Orchard up the Rainbow Falls Trail to the top.)

About one-third of the Great Smokies forest is virgin, or, to use a term foresters prefer these days, "old-growth." Many trees in the old-growth forest are quite large. Seven Great Smokies trees are the largest known of their species. These are a yellow buckeye, a pin cherry, a red hickory, a Fraser magnolia, a silverbell, a red spruce, and a mountain Stewartia. But the largest tree in the park, a tulip tree with a girth of twenty-five feet, three inches, measured four and one-half feet

above ground, is not a champion. At least one larger tulip tree exists near Bedford, Virginia.

Spring comes early and stays late in the Great Smokies. The same flowers that bloom in March in the lowlands may bloom nearly three months later in the high country. One of the first trees to bloom is the red maple, which shows its dark red flowers in February. Serviceberry trees bloom in March in the lowlands and in May in the highlands.

Dogwoods and silverbells follow with more white in April and May. The dogwood is a small tree that does not bloom profusely as a forest understory tree, but it puts on a great show on the forest fringe. The silverbell is a medium-sized tree with bell-shaped white flowers.

One of the rarest and loveliest trees is the yellowwood. Its range is limited, and it grows sparsely over that range. You never know when it will bloom. It skips years, but when it blooms, it is worth the wait. Long, lovely panicles of white dangle from the tree. It usually blooms in May. Look for it in the Sugarlands, along the trans-mountain highway south of Gatlinburg.

Another white-blooming tree is the black locust. See it in May, along with the big yellow bloom of tulip trees. Bees like blooms of both, and their nectars make good honey. Another good honey tree is the basswood. Its blooms are not showy, but you may become aware of them when you walk under a basswood and hear the bees buzzing above you. That premier honey producer, the sourwood, blooms mostly in July, and its white sprays of little urn-shaped flowers are lovely.

In addition to trees with showy blooms, there are the hundreds of wildflowers such as trilliums and violets, and shrubs such as rhododendrons, mountain laurel, and azaleas. Turks-cap lilies nearly ten feet tall grow in the high Smokies and produce big orange-yellow blooms in summer.

Spring beauties, bloodroot, trillium, fringed phacelia, trout lilies, hepaticas, toothwort, wood anemone, Dutchman's-breeches, several kinds of violets, wild iris, foam flower, rue anemone, wild phlox, trailing arbutus, showy orchis, pink lady's-slippers, and yellow lady's-slippers are among

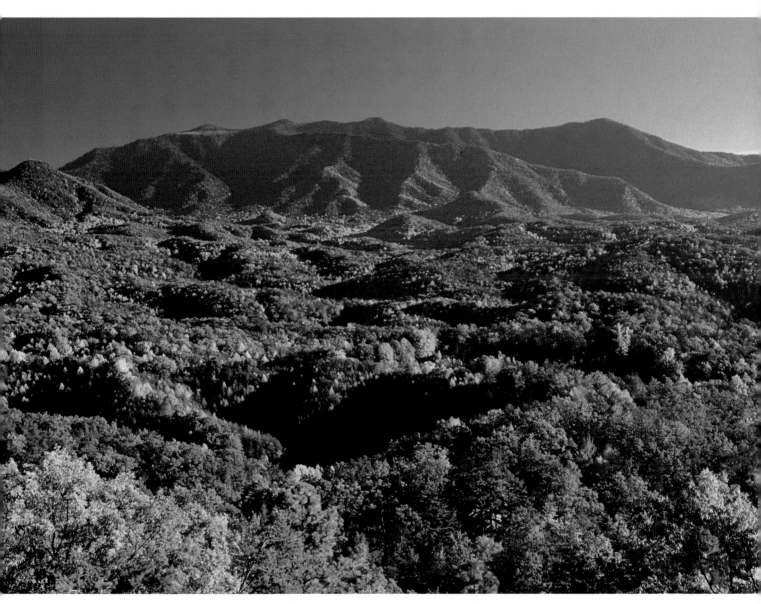

▲ October colors cover the ridges and valleys extending northward from Le Conte toward Gatlinburg and Pittman Center. Maples, poplars, oaks, hickories, sourwoods, dogwoods, and blackgums provide most of the color.
► ► Blooming dogwood trees flank the Middle Prong of Little River, near Tremont. This is one of the streams frequented by fishermen in search of rainbow and brown trout, both exotic species stocked decades ago in Great Smokies streams. The National Park Service no longer stocks them.

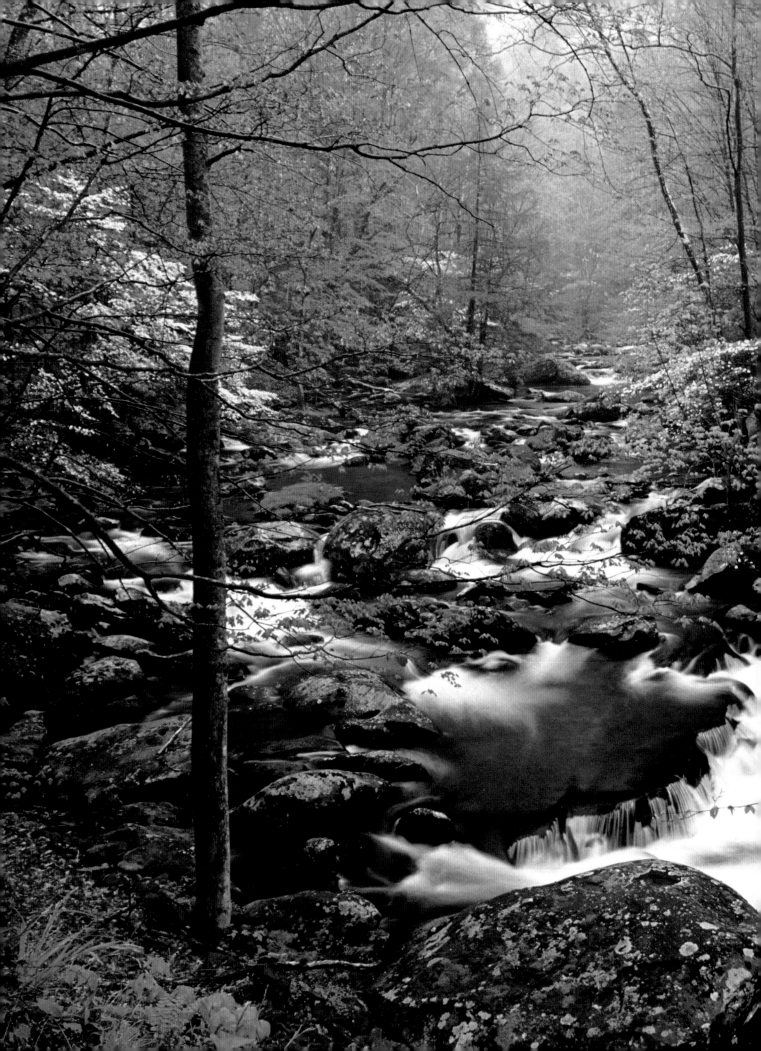

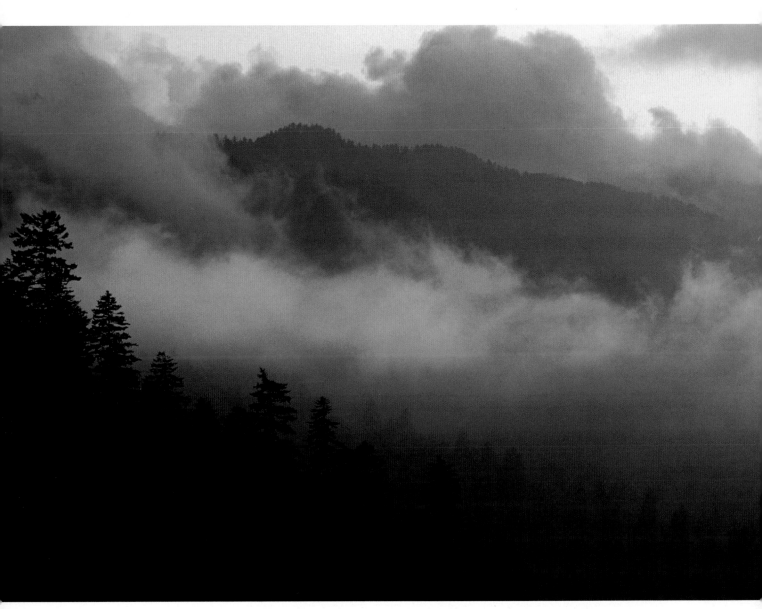

▲ A low cloud tinted by the sunrise hovers over the slopes of 5,802-foot-high Mount Mingus. Low clouds, or fog blankets, often cover the crest of the Great Smoky Mountains, which receive some of the heaviest rainfall in the nation.

the many spring wildflowers that make the Great Smokies a wonderful place for walking from February into June.

Both hiking trails and roads offer exposure to the wildflowers of the area. From the Chestnut Top Trail, with trailhead near the Y at the park's Townsend entrance, are hepaticas, bloodroot, bishop's cap, two varieties of trillium, and four of violets.

White trillium may be seen on the drive along Little River Road, from the Y to the intersection of the road to Elkmont.

The Cove Hardwood Nature Trail, starting in the Chimneys Picnic Area, off the transmountain road, is good for fringed phacelia, yellowwood and silverbell trees, trillium, spring beauties, and trout lilies.

The Balsam Mountain Nature Trail, at Balsam Mountain Campground offers spring beauties and trout lilies.

When the serviceberry trees bloom, usually in May at this altitude, Spence Field is excellent. The first time I saw Spence Field probably was in the early 1950s, about eighteen years after grazing was banned there. It was still mostly in grass. By the 1960s, low, stubby serviceberry bushes were scattered over it. They were different from the taller, slender serviceberry bushes and trees that grow in the forest. By the 1980s, Spence Field was one big orchard of mature serviceberry trees, acres of beauty at bloom time. For a bonus, you may see both Dutchman's breeches and their cousin, squirrel corn, beside the Bote Mountain Trail just before you reach Spence.

Gregory Bald offers azalea bloom, usually in the second half of June. Azalia blooms here are white, pink, red, sand, lemon, pale orange, and deep orange-red. A park official once said he had counted more than a dozen distinct hues among these blooms. The orange ones are called flame azaleas. The whites and some pinks are fragrant. This show on Gregory, covering several acres, is the nation's best example of naturally hybridized azaleas. A mile to the south is Parson Bald and more azaleas, but the variety there is limited.

Mountain laurel may be seen at Abrams Creek in May. If you are a hiker, not a fisherman, walk the trail along the creek from Cades Cove to Abrams Falls. You will see lots of laurel bloom. But a better way to see it is to put on your felt-soled wading shoes, take your trout rod, and fish around the off-trail portion of the creek called the Horseshoe. The better view of laurel bloom is from the creek. Besides, you may catch a fish.

It is general Park Service policy to let nature take its course on park lands. But this has not been done everywhere in the Smokies.

If nature had its way, Cades Cove now would be covered with forest fifty to sixty years old. But several residents here accepted less money for their land and remained on life leases. Thus, this farmland did not go back to forest immediately. By the time all the people were gone, National Park Service officials had decided to maintain the cove as a "historic district."

Encompassing sixty-eight hundred acres, the district extends some distance up the forested mountainsides. Less than half is open meadow. The idea was that visitors could see how East Tennessee farm folk once lived. It has not worked out exactly that way. There are several historic buildings, including three churches, the cabin of first settler John Oliver, the old Cable Mill, the Becky Cable House, and others. But after farmers on life leases died or changed their minds and left, the land was no longer cultivated as it had once been. No wash-day clothes flapped on the line. Nobody killed hogs or plowed fields or harvested corn, wheat, and tobacco.

Still, visitors like what they see; the cove probably is more attractive than if it were historically accurate. The National Park Service decided to keep much of the cove in grass by leasing it to agricultural permittees for grazing. The rights were leased for fifteen hundred cattle. But this turned out to be too many. The cattle polluted Abrams Creek, which drains the cove. The Park Service modified its plan. Only five hundred cattle and about sixty-five horses, plus hundreds of wild white-tailed deer, now graze in the cove. The cattle and horses are fenced away from Abrams Creek, but they have access to selected places on tributary streams. They are confined within fences, but the fence-jumping deer come

▶ ▶ *Spruce Flats Falls is a double falls; the top falls drop into a relatively flat streambed, flow a few yards, then plunge into Middle Prong of Little River.*

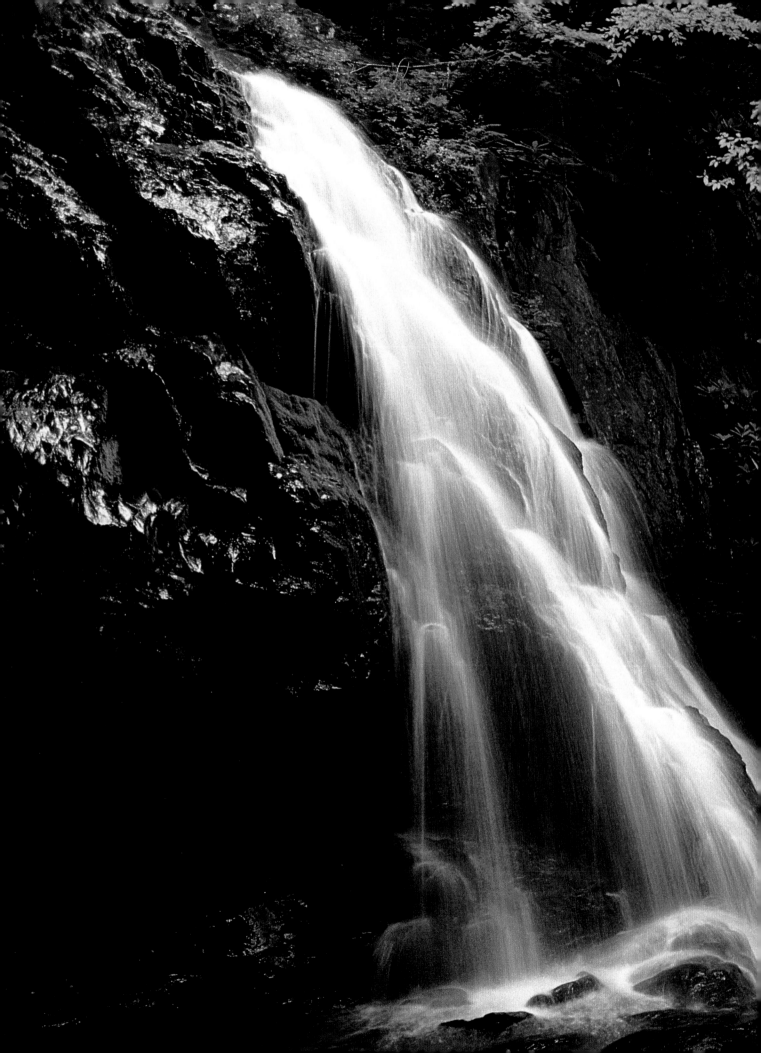

and go as they wish. They are usually in the fields on early mornings and late afternoons. Visitors also see flocks of wild turkeys early in the day. Fingers of forest intrude into the grassland, giving grazing deer a place to find cover if they become alarmed. Cattle and horses find shade in the same woodland.

The National Park Service also leases haying rights on more than five hundred acres of the cove. The grazing and haying keep the forest at bay and produce some revenue.

Kermit Caughron, who was born in the cove more than eighty years ago, has lived nearly all his life there. The cattle in the cove belong to him. He and his wife are the only family still living on the loop road. Kermit's parents were among those who remained in the cove on life leases, and he was one of the first to become an agricultural permittee. He has seen the transition from a mountain farming community to one of the most popular places in the nation's most-visited national park. He and Randolph Shields herded the last cattle on Gregory Bald in 1934, before the Park Service banned grazing.

The Great Smoky Mountains Natural History Association operates the little Cable Mill as a demonstration exhibit from spring to autumn. Sorghum molasses making is also demonstrated near the mill in autumn.

The park also has four much smaller historic districts, in Cataloochee valley, in Oconaluftee valley, on the Roaring Fork Motor Nature Trail (southeast of Gatlinburg), and at the Noah (Bud) Ogle House at Cherokee Orchard.

Nature also has been foiled on the crest of Mount Le Conte. The Great Smoky Mountains Conservation Association, the Tennessee group that led the movement to establish the park, in 1925 employed a young man named Paul Adams to build a camp atop Le Conte. Mount Le Conte was chosen, rather than some other place in the Great Smokies, because it is the most spectacular mountain in the chain.

Two Le Conte peaks, Myrtle Point and Cliff Top, offer excellent mountain wilderness views. Myrtle Point is for sunrises; Cliff Top, for sunsets. Le Conte is about four miles north of the main ridge of the Great Smoky Mountains. The two are connected by Boulevard Ridge.

Adams erected tents for the camp in summer 1925 and added a small log building the following winter. In spring 1926, a young Gatlinburg man, Jack Huff, took over the operation and made it into a commercial lodge.

Huff wanted his semi-invalid mother to see the top of Le Conte, but she was not able to hike or ride a horse to the top. So he strapped her to a chair, strapped the chair to his back and carried her to the top. He and his wife, Pauline, were married at sunrise on Myrtle Point in 1934.

Le Conte Lodge, accommodating fewer than fifty guests, is now operated as a National Park Service concession by Le Conte Lodge Limited Partnerships. William B. Stokely III and Tim Line, the lodge manager, are the partners. The lodge is the highest hostel east of the Mississippi and one of the most popular. Five major trails lead to Le Conte. The shortest route is about five miles; the longest, nine. Though the ideal way to do Le Conte is to hike up one day, spend the night at the lodge and hike down the next day, a good hiker can go up and down the same day.

In fact, some do it two, three, even four times in a day. The four-timer is Bill Sharp, an East Tennessean who used a long day in June 1992 to walk more than forty-one miles in four round-trips up and down the steep, rocky Alum Cave Bluff Trail.

For him and a few others, Le Conte has become a challenge of numbers. So far, Paul Dinwiddie of Knoxville has the highest number. He made his 735th hike to Le Conte in the summer of 1992, before a prolonged illness temporarily stopped his hiking. Eighty-year-old Margaret Stevenson made her 535th hike in 1992. On her first 1993 start to Le Conte, she turned back because the trail was icy.

The late Rufus Morgan, an Episcopal minister of North Carolina's mountain country, probably was the oldest person to hike to the top of Le Conte. He made his 174th and last climb to the top in 1978 on his ninety-third birthday. I was in groups that went with him on some of his birthday hikes. What I remember best is the old

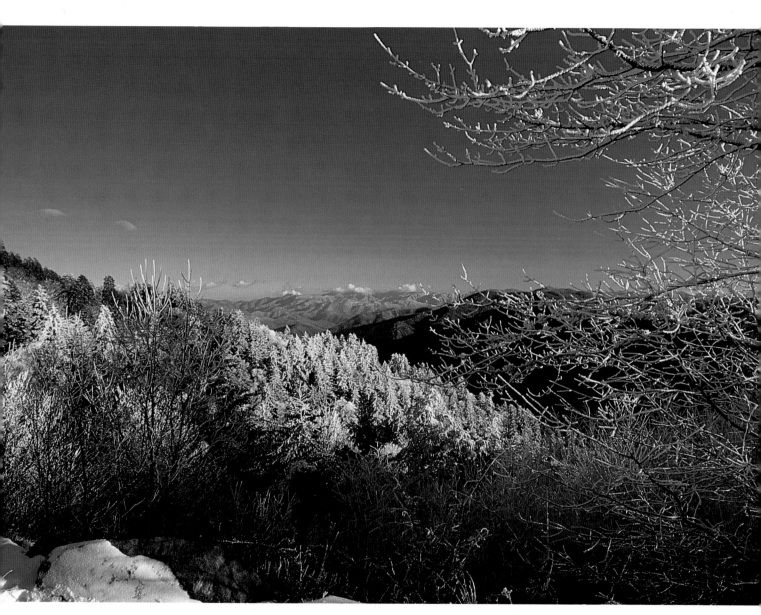

▲ At Newfound Gap, red spruce trees are outlined by snow, while multiple mountains, like sleeping dinosaurs, extend southward over western North Carolina. Trees are almost everywhere in the Smokies, except on the balds.

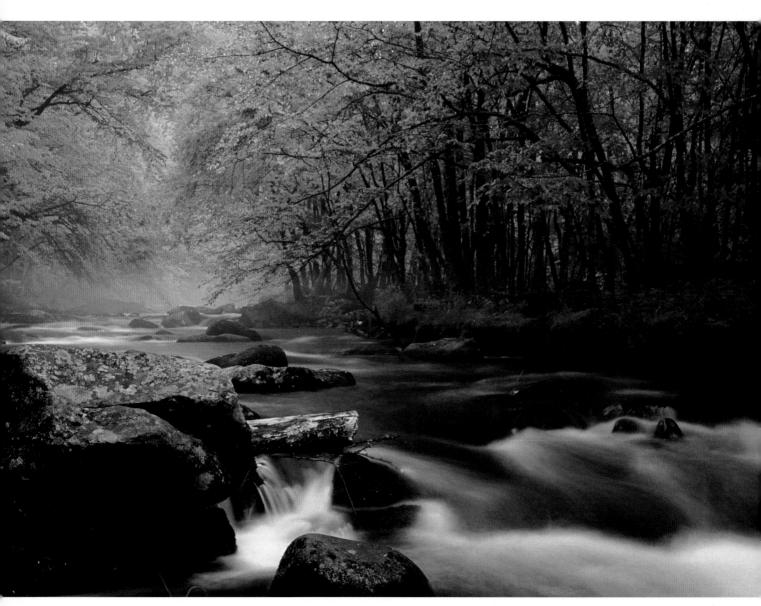

▲ Little River flows through a tunnel of mist and greenery. Running near Little River Road, the stream is used by fishermen, tubers, swimmers, canoeists, and kayakers—as well as those who just want to sit on a river boulder on a hot day.

man, with his fellow mountain lovers, sitting on the rocks of Cliff Top, leading hymn-singing as the sun sank gloriously.

Two other places where nature's intentions are purposely thwarted are Andrews and Gregory balds. Year by year, the forest intruded into all the grassy balds. The National Park Service asked for public comment when it was putting together a new general management plan for the park in the early 1980s. More than 90 percent of those who commented favored protecting those two balds from the encroaching forest. So the general rule for Andrews and Gregory is to foil forest and favor grass and azaleas. Blueberries are also permitted on both balds.

The fact that the park was officially established in 1934 did not mean that all logging ceased then. Little River Lumber Company sold its land with the provision that it finish logging it. Little River cut its last trees in the small valley of Spruce Flats Branch in 1938. The branch is the stream that jumps down a waterfall into Middle Prong of Little River beside the Tremont Road.

But you need not wield an ax to damage a forest. Human-caused destruction did not end when Little River cut its last tree. Some of the worst was yet to come. However, most of those who did the damage did not do so with evil intent; they simply were careless with exotic organisms and pests.

The first to arrive was the chestnut blight, an Asian fungus brought to this country in the early 1900s. It spread down the Appalachians and reached the Great Smokies in the 1920s. Nearly every mature American chestnut in the park died before 1950. It was a disaster of immense proportions. Chestnut trees constituted nearly a fourth of the forest. They were among the largest trees in the region, in the same league with tulip trees, Eastern hemlocks, and the largest oaks.

No other forest bounty was comparable with the drop of sweet chestnuts each autumn. They were the food of choice for nearly every creature from the smallest white-bellied mouse to the largest black bear. In pre-park days, many people who lived near the mountains harvested chestnuts, driving down the mountains with loaded wagons. Some mountain children bought shoes before frost with money they made gathering and selling chestnuts. There was almost never a crop failure because chestnuts bloomed well after the latest killing frost. Nectar from chestnut blooms made excellent honey. Chestnut wood was long-lasting and had many uses.

Though the blight kills the portion of the tree aboveground, it does not kill the root system, which continues to send up sprouts. The sprouts grow for a few years before the blight girdles their trunks and kills them. Some sprouts grow large enough to bear a few chestnuts before they die. Most sprouts die by the time their trunks reach the size of a man's ankle. But I have seen three with trunk diameters in the six- to ten-inch range. Two were loaded with chestnuts. Some scientists, trying to bring back the American chestnut, use cuttings from these big sprouts.

The identity of the person who brought or sent the chestnut blight to this country is not known. But the man responsible for bringing European wild boars to the region was George Gordon Moore. He was an eratic American businessman, sometimes flying high, sometimes flying low. He conceived the idea of establishing a hunting preserve in the mountains of western North Carolina and stocking it with big-game animals, some from foreign countries. He thought he would impress his customers by inviting them to hunt his animals.

Moore established his preserve on and near Hooper Bald, near Robbinsville, about twelve miles south of the Great Smokies, in 1912. Few of his business prospects were eager to come, and he eventually tired of the place himself. In one of his low-flying periods, he failed to pay Garland (Cotton) Mcguire, manager of the preserve. McGuire went to New York to see Moore, and Moore then deeded the preserve to him.

Most of the animals that were introduced by Moore did not last. Only the wild boar remains. It multiplied greatly and found a home in the Tennessee and Carolina mountains. For decades, the boar did not go north of the Little Tennessee River. In the early 1950s, however, it crossed the river and entered the Great Smoky Mountains.

One of the first indications that the hogs had entered the park was overturned sod on Gregory Bald, a result of their rooting. This may have been a factor in the invasion of trees on the bald, for tree seeds landing on the unprotected soil probably had a better chance to germinate than if they had landed on the thick grass mat.

Each wild hog is a little bulldozer, rooting up vegetation in its search for food. A dozen foraging together can devastate a wildflower area. Like bears, hogs eat nearly anything available. But they eat some things not eaten by bears. For instance, the corms of the lovely little spring beauties and the bulbs of Turk's-cap lilies.

Park service people did little except worry about the hog problem for some twenty-five years. But in 1977, they began a program of shooting and trapping hogs. They gave most of the trapped hogs to the states of North Carolina and Tennessee for stocking in public hunting areas. They removed 501 hogs in the three-year period from 1977 to 1979; 802 from 1980 to 1982; and 1,162 from 1983 to 1985.

These removals probably did not hurt the hog population much; possibly they just sharpened the animals' survival skills. A wild sow can—but seldom does—produce two litters of piglets per year. It is not unusual for her to have eight or nine piglets per litter. Contrast this with a black bear which normally produces cubs only once every two years, usually two or three per litter.

Beginning in 1986, the Park Service put more money and effort into the hog program. That year, 1,146 hogs were removed—nearly twice as many hogs as the estimated maximum total park bear population, which fluctuates between four hundred and six hundred. This was a significant dent in the boar population. The same effort in 1987 resulted in the removal of 723 hogs. In the next four years, the number dropped to an average of fewer than 350 per year—all with the same effort each year. These years also evidenced less visual damage done by the animals.

Another hog-control measure was "exclusion" fences. Park service people built fences around areas containing rare plants and outstanding wildflower displays. One such fence protects a wildflower area less than a half-mile east of Indian Gap, on the Appalachian Trail. Other park animals can go through the fence or over it; it keeps out only the hogs.

Someone accidentally brought the balsam wooly adelgid into this country from Europe in 1908. In 1963, the insects were noticed in the Great Smokies, killing Fraser fir trees on Mount Sterling. Since then, they have killed nearly all these high-country conifers. Keith Langdon estimates that 95 to 99 percent of mature firs have been killed.

These were the firs of the park's highly prized thirty-eight-thousand-acre spruce-fir forest that stretched about twenty-five miles along the crest of the Smokies from Cosby Knob southwest to about three miles west of Clingmans Dome. Firs also grow off the main ridge, on Mounts Le Conte and Sterling, and on Balsam Mountain. Firs grew in almost pure stands at the top of Clingmans Dome and on Mounts Guyot and Le Conte. At lower altitudes they were mixed with another high-country evergreen, red spruce.

The Park Service has tried to save the firs at Clingmans Dome by spraying them with an insecticidal soap solution. The effort slowed the work of the adelgids. However, the Park Service had to cut back on the spraying program in 1992 because of a decrease in funding. A major shortcoming of the spraying is that it is limited to where a tank truck can go. Aerial spraying is not effective.

The insects mostly kill trees that are several years old. Lots of young trees grow in some areas. Some live long enough to produce seed. And as long as seed is produced, there will be young firs coming along.

A few small stands of mature firs remain on Mount Le Conte and elsewhere in the park. Meanwhile, the National Park Service is propagating Fraser firs, to keep the species alive to thrive again in the high country, if somebody comes up with a solution to the adelgid problem.

One important park tree is the dogwood. Its flowers provide springtime beauty, and its leaves do their bit for autumn color. Birds eat lots of dogwood berries. But a relatively new ailment,

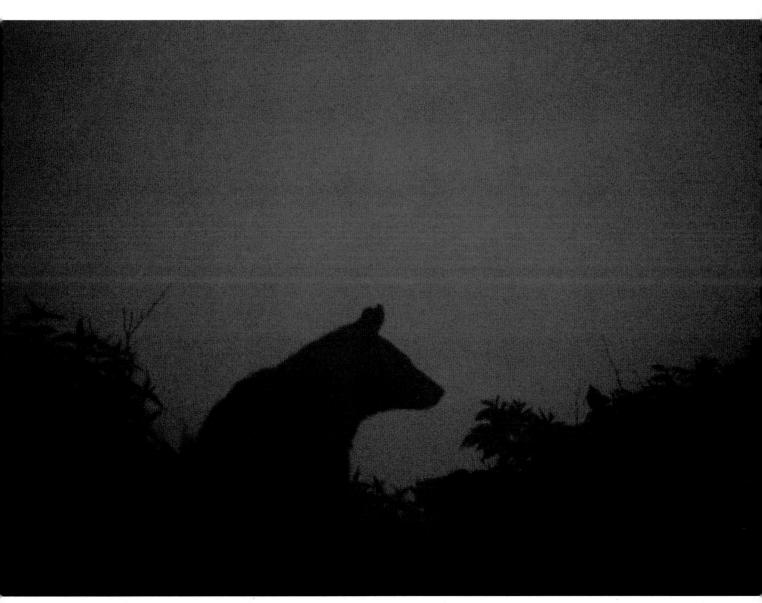

▲ A black bear, his silhouette softened by fog, sits near Le Conte Lodge. Late lodgekeeper Herrick Brown told about a face-to-face meeting of an adult bear and a tiny domestic kitten. The kitten went "pfft," and the bear took to his heels.

▲ This oak growing in an open field would wear a different look if it were growing in the forest. It has room here for its canopy to spread. In the forest, crowded by other trees, it would grow taller, but have a narrow canopy.

dogwood anthracnose, is killing some of the park's dogwoods. The anthracnose is a fungus. It was first noticed in America at Seattle in 1976 and turned up in New York a year or two later. Scientists think it came from outside the country, probably from Asia.

Langdon says it is killing dogwoods in the park's cool, wet areas. But dogwoods that get lots of sunshine resist the fungus. Langdon was stationed at Maryland's Catoctin Mountain Park (the site of Camp David, the relaxing place of presidents) before he came to the Great Smokies. He said dogwood anthracnose was first noticed at Catoctin in 1983 and that by 1987 nearly 90 percent of the dogwoods were dead.

The mountain ash sawfly reached Canada from Europe several decades ago. Langdon says it found the mountain ashes atop the Smokies in the 1980s, killing half of the ashes in some high-country plots. The tree's red berries and foliage are lovely in autumn, and the berries are food for ruffed grouse and other birds.

Dutch elm disease has killed many elms in America, including the Great Smokies. Brought from Europe in about 1930, the disease began killing park trees in the 1950s. The park has three elm species: American, slippery, and winged.

Butternuts, also called white walnuts, are not numerous in the park; a foreign fungus called butternut canker is making them still less so. The butternut canker hinders the tree's ability to reproduce by penetrating the nuts and killing the embryos. The fungus is believed to have come to this country from Asia twenty-five to thirty years ago.

Not all the damage in the Great Smokies has been caused by foreigners. In 1957, sixteen years before passage of the Endangered Species Act, biologists of the National Park Service, Tennessee Wildlife Resources Agency, and the U. S. Fish and Wildlife Service cooperated on a project to rid lower Abrams Creek of carp, that ugly foreign fish from Asia.

Abrams Creek runs into the Little Tennessee River a short distance upstream from where the Aluminum Company of America was completing construction of Chilhowee Dam. That portion of the river was good for trout fishing. So biologists felt the new impoundment, Chilhowee Lake, would be an excellent trout lake, but they also thought the trout would do better if the carp in the river and creek were killed.

So they poisoned Abrams Creek from Abrams Falls to the river—more than fourteen miles. In addition to carp, they killed twenty-eight native species of fish that are duplicated in no other park stream. Most were small fish, not fish that fishermen think much about. One of those lost was a tiny fish called the Smoky madtom, then thought to live nowhere else in the world. Later, in 1980, Smoky madtoms were discovered in Citico Creek, which enters the Little Tennessee below Chilhowee Dam, on the opposite side of the river from Abrams Creek.

Smoky madtoms from Citico have since been restocked in Abrams Creek. With its limited range and small population, this small fish is listed as endangered. Two other species wiped out of Abrams in the poisoning also have been replaced. These are the spotfin chub and the yellow-fin madtom, both listed as "threatened" under the Endangered Species Act.

Following the impoundment of the lake, eight Little Tennessee River fish species not previously in the park entered Abrams Creek, according to the park's fisheries biologist, Steve Moore. The poisoning of the river, the impoundment of the lake, the entry of new fish species, and the restocking of three species resulted in a net loss of seventeen native fish species from the park, which now has fifty-three. No other such drastic loss of species is known in the history of the park.

How is trout fishing in Chilhowee Lake?

Fishermen take some trout from Chilhowee, but it has not turned out to be the superior trout lake the biologists envisioned.

One good thing that came out of the whole episode was the eradication from the park of the ugly foreigner, the carp, and another foreigner, the goldfish.

While adelgids are killing fir trees, at the same time something is happening to the fir's fellow high-altitude conifer, the red spruce, according to Jim Renfro, a plant physiologist and air quality

specialist working out of the park's Uplands Field Research Laboratory.

In a 1985-89 study of red spruces, according to Renfro, scientists found 80 percent of the tree crowns were healthy in 1985, but this dropped to about 50 percent in 1989. He said the unhealthy trees have fewer needles and their crowns are thinning and dying back. Even a layman can see that the spruce are not as attractive and healthy looking as they once were.

Renfro says the park's spruce-fir forest receives a heavy load of acidic deposits from coal-burning electric power plants, automobiles, and other industrial plants. It falls in rain water, as dry matter that washes into the soil when rain comes, and it exists in "cloud water" that envelops the highland forest much of the time. More nitrogen falls on the Great Smokies than on any other national park, Renfro says, adding that the park is second only to Shenandoah in the sulfur compounds it receives.

Some scientists suspect a link between the nitrogen and sulfur pollution and the poor health of the spruce trees. But Renfro says that cause-and-effect link has not been established.

Another air pollutant, ozone, is hurting park forests. Renfro says that "ozonelike symptoms" appear on ninety-six park plant species. Among them are black cherry, tulip tree, sassafras, and sweetgum trees, in addition to milkweed, blackberry, and cutleaf coneflower herbs. Among the symptoms to look for are purple, brown, or black spots on the top surface of the leaves of older foliage and between the veins of the leaves. Ozone is formed from the oxides of nitrogen and hydrocarbons, both automobile exhaust gases, in sunlight.

Ozone pollution is worst in the high-elevation portion of the park, Renfro says. He says ozone intensity varies considerably from one part of the day to another at low altitudes. But in the high country, "We never get a break."

Another air pollutant—this time ammonium sulfate particles suspended in air—cuts visibility in the park. Renfro says that visibility has been reduced 30 to 40 percent in the past thirty years. This pollutant comes mostly from the burning of fossil fuels. Visibility, of course, is of primary importance to park visitors.

One visibility test is the quality of pictures taken at Look Rock on the Foothills Parkway, of Gregory Bald, about ten miles to the south. Images are made at 9 A.M., noon, and 3 P.M. each day. Pollution is so bad that, one day out of twenty, Gregory does not even register on the film; visibility is limited to six miles.

The Great Smokies are resilient. Other trees filled gaps left by the deaths of the chestnuts. If all Fraser firs die, something else will grow where they grow. But what replaced the chestnuts is not as beneficial as chestnuts were. Nor will the firs' replacements be as lovely as the firs.

Someday, man or nature may bring back the chestnut and save the firs and other threatened species. Something can be done about air pollution and wild boars, but that is not saying it will be. Kim Delozier had $197,000 for control of hogs in fiscal 1992. Despite repeated pleas by park officials, the 1993 Great Smokies budget had no money for the hog program. With one good breeding season, the hog population could bounce back strongly. Finally, Delozier was permitted to take $65,500 from other Great Smokies programs to continue a limited hog program.

What happens in the Great Smokies is important, or should be, to those who govern, for this park is one of the brightest of what some call the nation's "Crown Jewels." It was one of the first places in the world designated by the United Nations as a biosphere reserve. Year after year, the nation's people make more visits to this park than to any other national park. They come to relax, to learn, to be inspired, and to be awed by the loveliness of nature's creations.

Perhaps it is time for a shift in priorities. The 1993 fiscal year budget for the entire National Park Service is $983,995,000. For the same year, more than three times that amount was budgeted for four B-2 bombers (a $2,690,000,000 appropriation, plus $670,000,000 of unspent money from a previous year). If Kim Delozier had just one-hundredth of one percent of that B-2 money, he could do more to combat the foreign enemy that is rooting up one of those "Crown Jewels."

▶ *This falls has no name. Some bear names of animals or Cherokee names.*
▶ ▶ *Not all maples have such bright colors; they differ from one to another.*

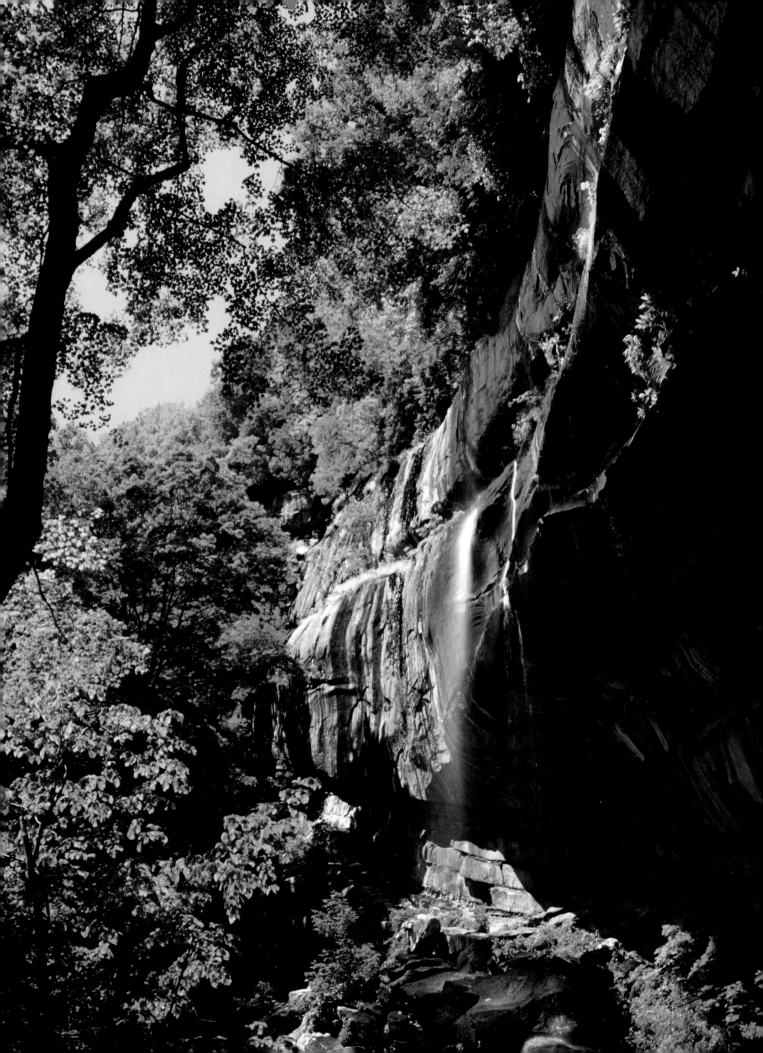

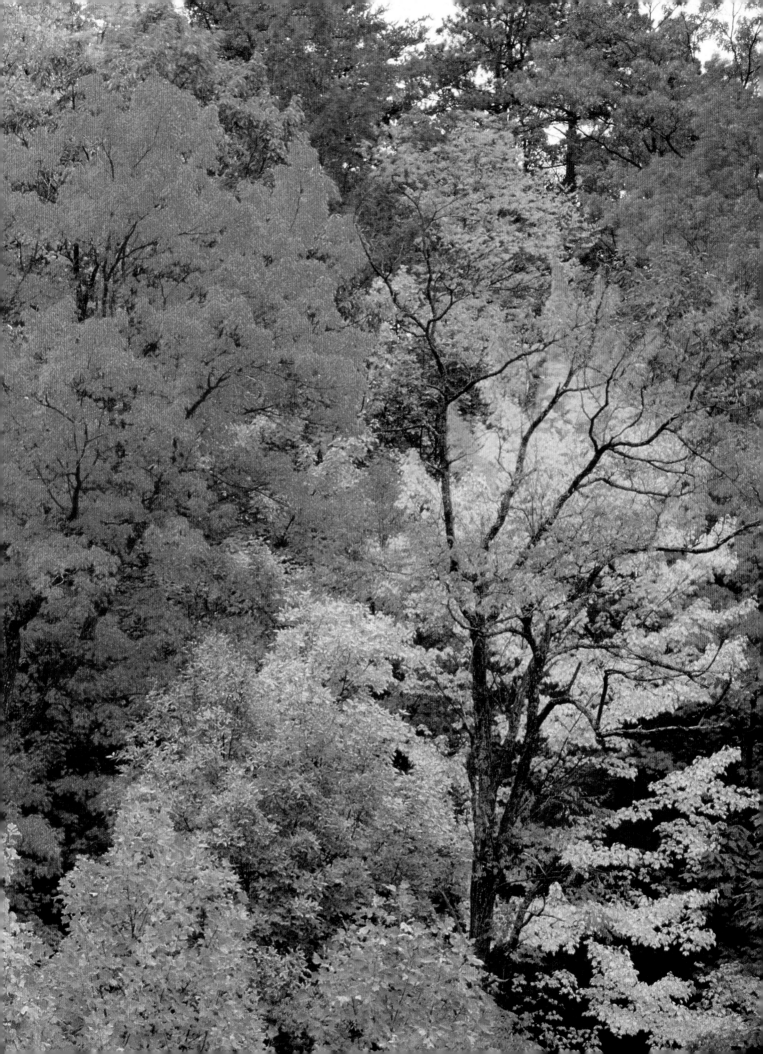

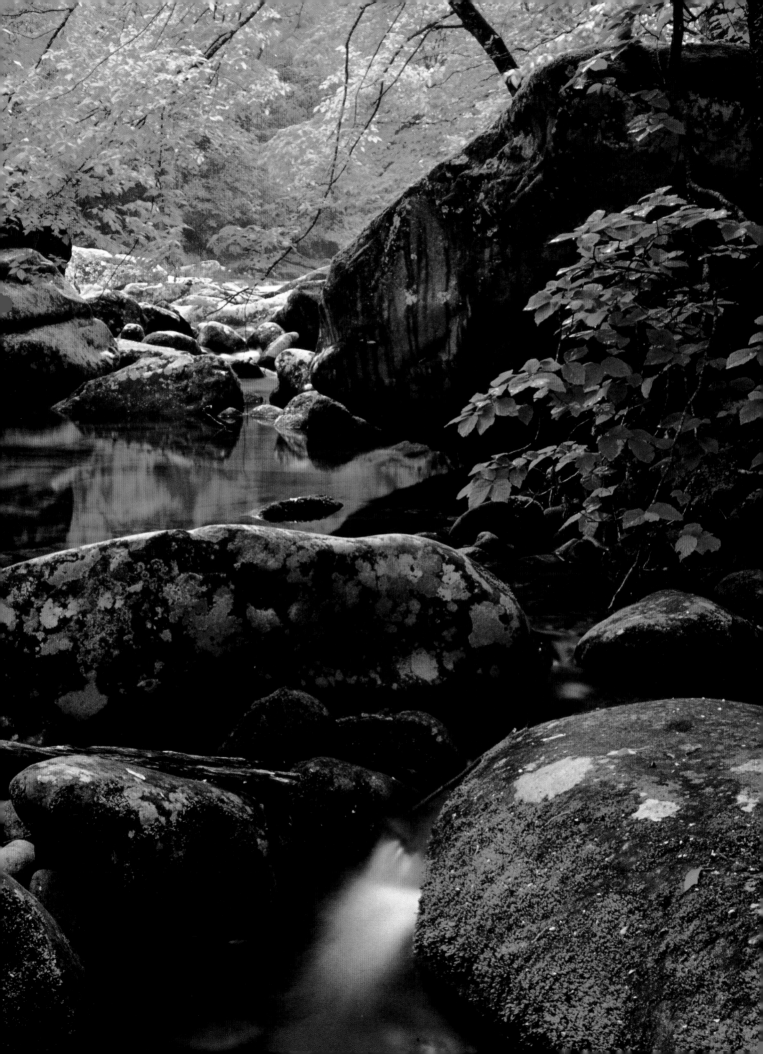

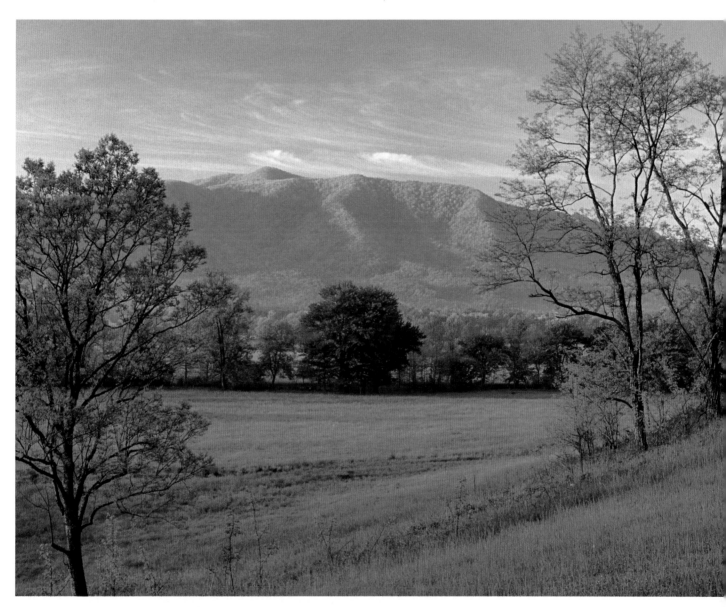

◄ Little River, above the old village of Elkmont, drains the north slopes from Mount Collins to Cold Springs Knob. In 1951, a Labor Day weekend flood swept some Elkmont residents away; they climbed trees to save themselves.

▲ Cades Cove is home to grazing cattle, horses, and deer, as well as skunks, groundhogs, wild turkeys, and—infrequently—even a red wolf or a wild boar.

► ► Scientists have listed the species of mammals, reptiles, amphibians, and fish in the park. They have hardly begun listing spiders, beetles, ants, and flies.

▲ In pre-park days, these meadows were cultivated by farmers who lived in Cades Cove. As few as thirty deer once lived in the mountains above the cove.
▶ The maker of this web may collect breakfast from it before some creature—deer, cow, fox, rabbit, groundhog, crow, skunk, or human—breaks the web.

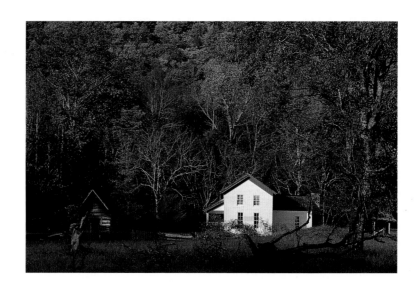

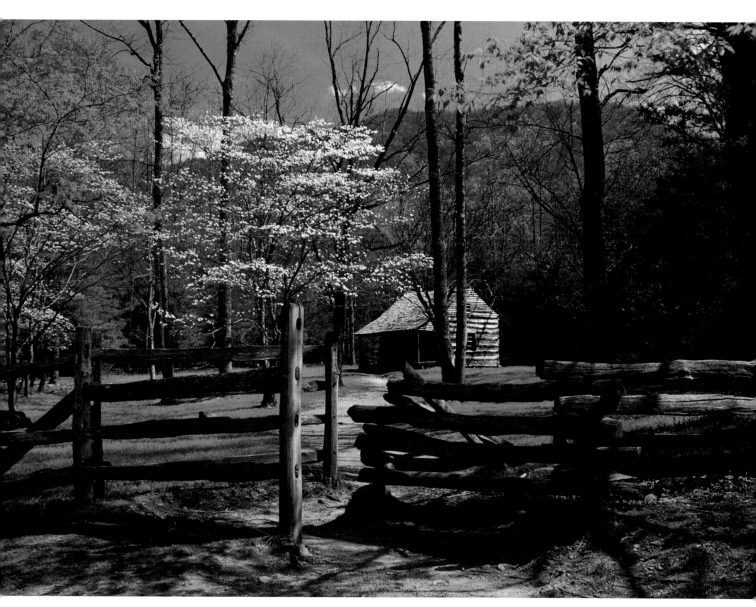

◄ The Becky Cable House was home to a tall, strong Cades Cove spinster. Intelligent and hardworking, she amassed substantial wealth, including some five hundred acres of land. She helped raise a brother's children after his wife died and he was incapacitated. Becky died in 1940 at the age of ninety-six.

▲ Dogwoods bloom at the Carter Shields home in Cades Cove. No one has lived here for many decades, but it is maintained as a historical exhibit.

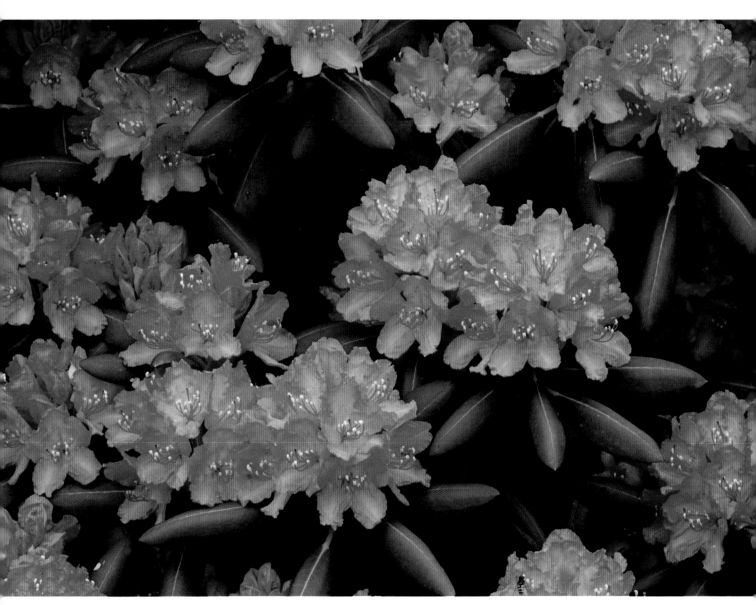

▲ Not every year is a good one for the various flowers that bloom in the Great Smokies. Exceptionally good years often are followed by bad ones, and vice versa. This, obviously, was a good year for Catawba rhododendron.

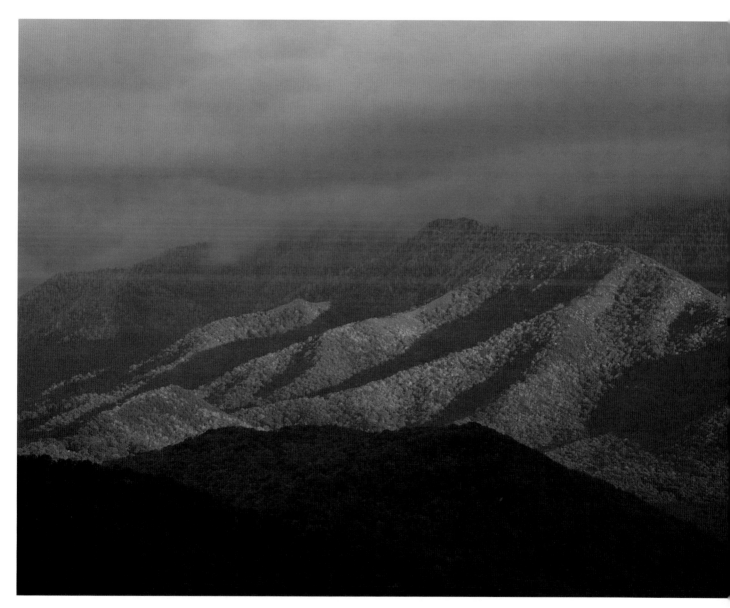

▲ Storm clouds gather over Bull Head Mountain, the western lead to Le Conte.
▶ ▶ More than nine hundred miles of trails in the park are available to hikers. This is a fern-bordered section of the Appalachian Trail, which runs about seventy miles through the park, from Fontana Dam to Davenport Gap. The AT gets heavy use from spring to fall, but fewer hikers brave the cold in winter.

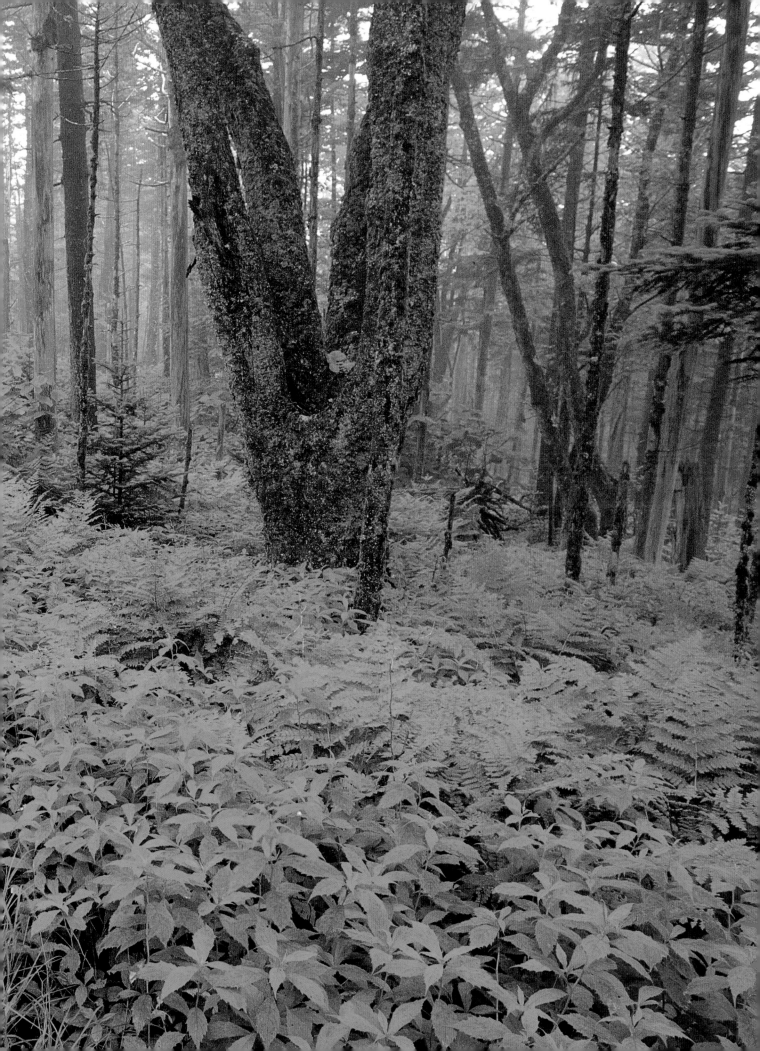

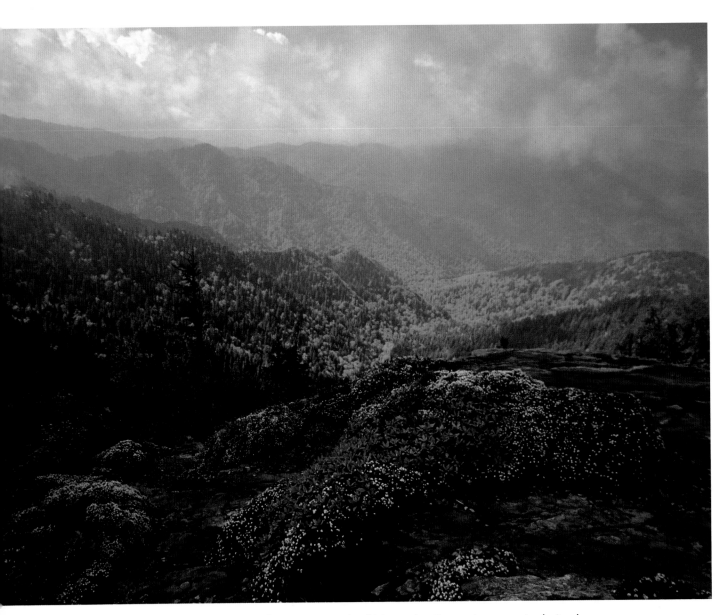

▲ Myrtle Point is the eastern peak of Mount Le Conte. Its name is derived from the mountain myrtle that blooms profusely here. Myrtle often grows with mountain laurel and dwarf rhododendron, all members of the heath family.

▲ White fringed phacelia blooms along the Bull Head Trail to Le Conte.
▶ ▶ Mount Cammerer—named for Arno Cammerer, once associate director of the National Park Service—offers one of the best panoramas in the Smokies.

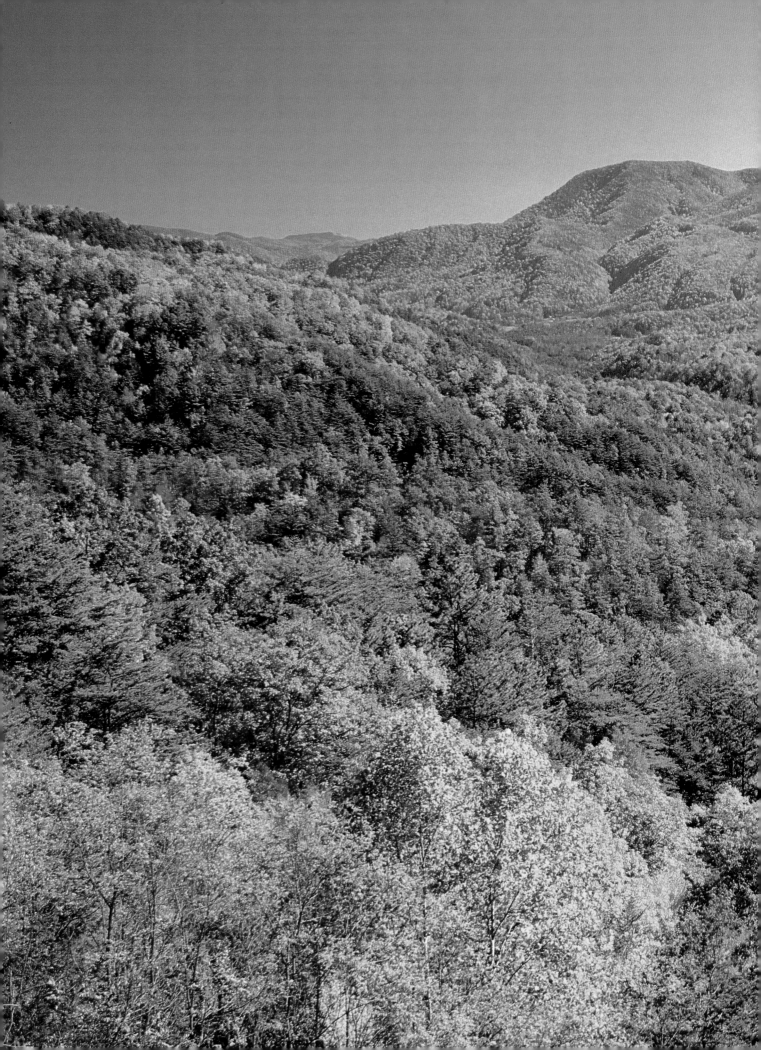

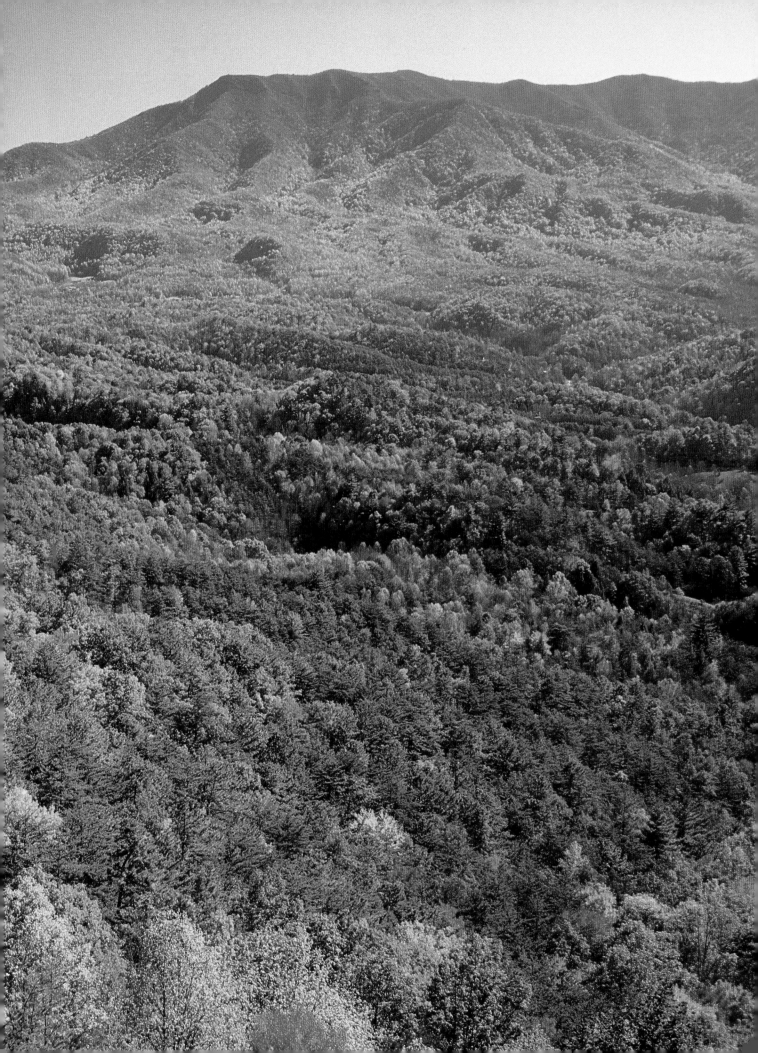

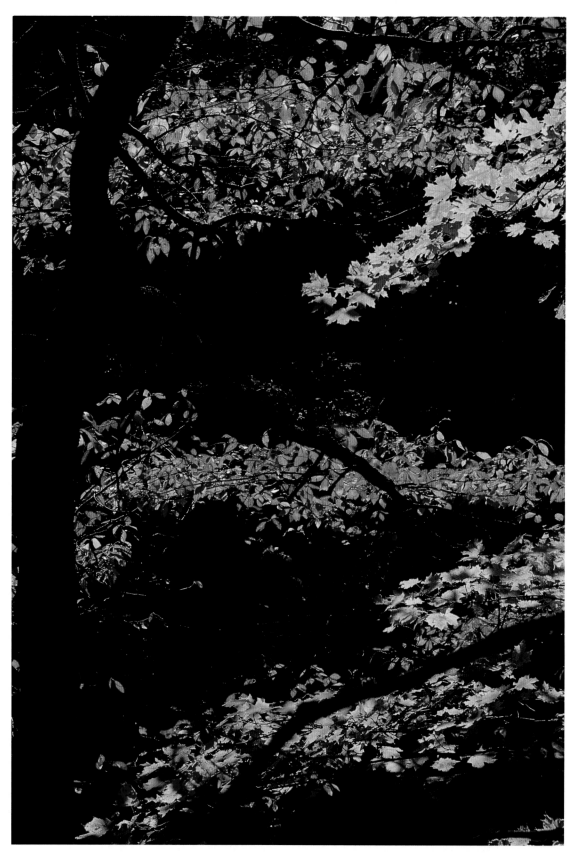

▲ Kephart Prong, with its narrow valley, and Mount Kephart were both named
for Horace Kephart, author of *Our Southern Highlanders.* He was one of those
who fought for establishment of the Great Smoky Mountains National Park.

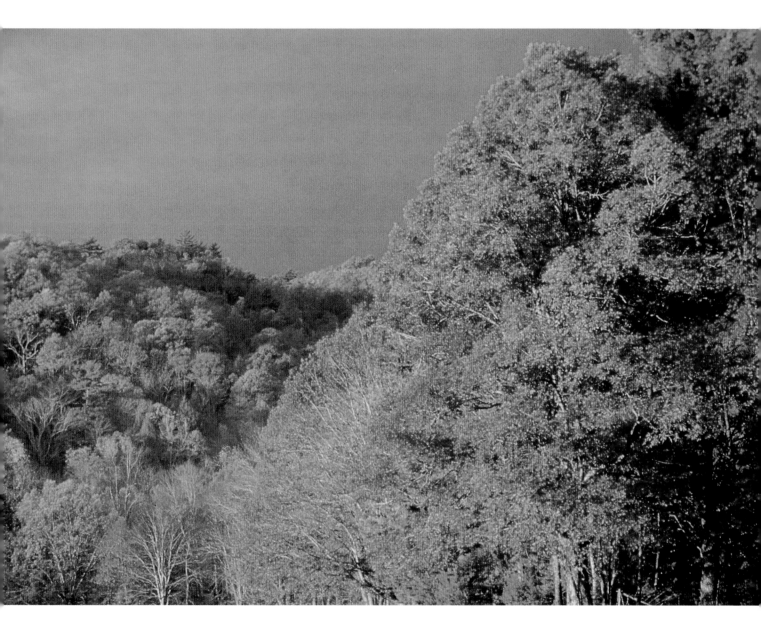

▲ Cataloochee Valley is one of the most remote sections of the park. Before the national park was created, Cataloochee was a prosperous farming community. It is situated in the southeastern section of the park, in North Carolina.

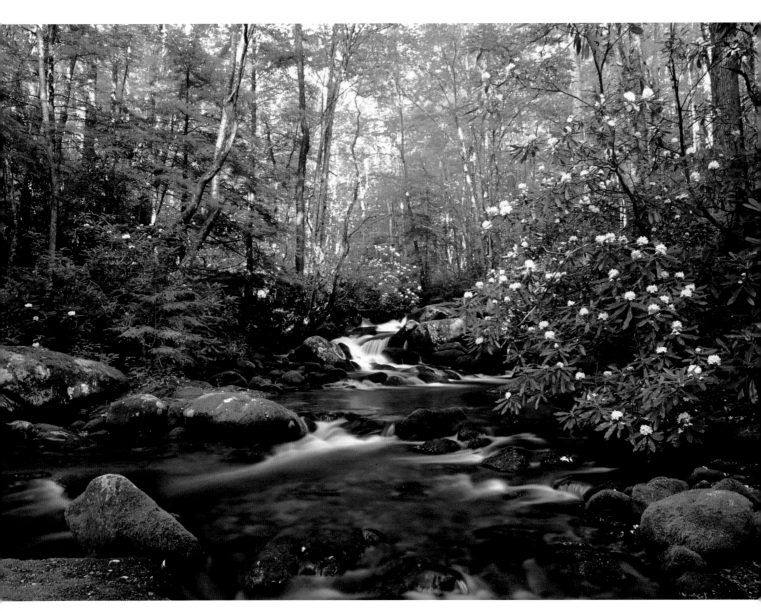

▲ White rhododendron blooms in early July along Roaring Fork. Often found along streams at lower elevations than the Catawba rhododendron, white rhododendron flourishes in dense thickets nearly impossible for a human to walk through. Its blossoms usually are not as numerous as those of Catawba.

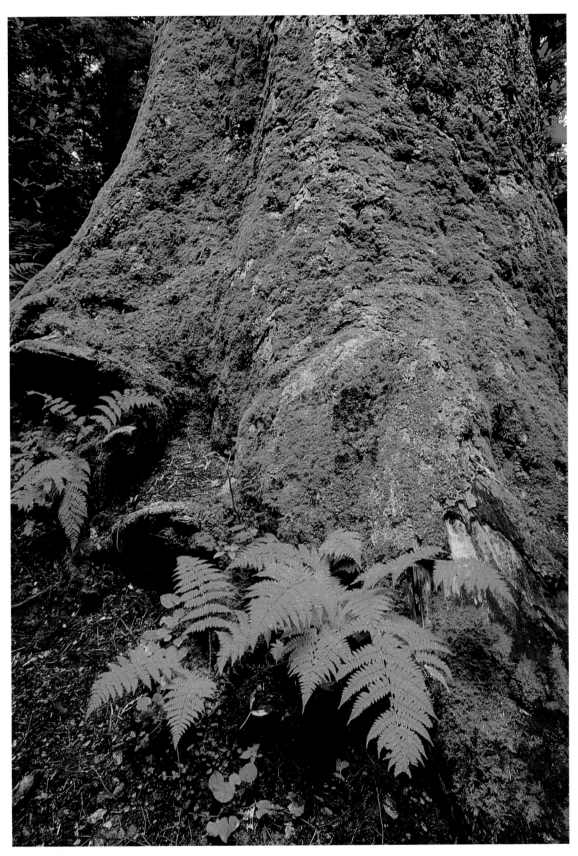

▲ This huge tulip tree is in the Albright Grove, named in honor of Horace M. Albright, second director of the National Park Service. He was director during much of the long effort to establish a national park in the Great Smokies.

▲ Trees mark an old road. All the early Smoky Mountains roads were narrow, used by horse-drawn wagons and buggies, and later by a few early cars.
▶ Seen from Balsam Mountain, shafts of light pierce a Great Smokies storm.

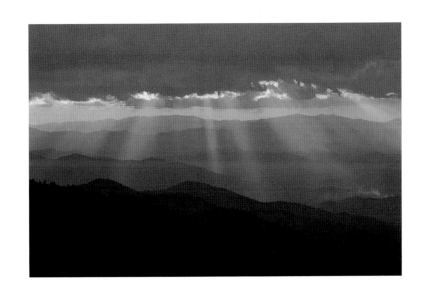

Index